THE CLARK

Selections from the

Sterling and Francine

Clark Art Institute

Steven Kern

Rafael Fernandez

Beth Carver Wees

Jennifer Gordon Lovett

Patricia R. Ivinski

John H. Brooks

David S. Brooke

J. Dustin Wees

Susan Roeper

Sarah S. Gibson

Hudson Hills Press,

New York

Selections from the

Sterling and Francine

Clark Art Institute

©1996 by Sterling and Francine Clark Art Institute

Editor and Publisher: Paul Anbinder

Copy Editor: Jacolyn Mott

Designer: Betty Binns

Composition: Angela Taormina

Manufactured in Hong Kong by Dai Nippon Printing Company.

Library of Congress Cataloguing-in-Publication Data
Sterling and Francine Clark Art Institute.
 The Clark : selections from the Sterling and Francine Clark Art Institute / Steven Kern...[et al.].—1st ed.
 p. cm.
 Includes bibliographical references and index.
 ISBN: 0-931102-35-9
 1. Sterling and Francine Clark Art Institute—Catalogues. 2. Art—Massachusetts—Williamstown—Catalogues. I. Kern, Steven.
N867.A83 1996
708.144'1—dc20 96-6039
 CIP

Contents

Foreword by Michael Conforti 7

Acknowledgments by Steven Kern 8

Introduction by David S. Brooke 9

Notes to the Reader 12

Paintings and Sculpture

Ugolino da Siena	**Virgin and Child with Saints Francis, Andrew, Paul, Peter, Stephen, and Louis of Toulouse** c. 1317–21	16
Piero della Francesca	**Virgin and Child Enthroned with Four Angels** c. 1460–70	18
Hans Memling	**The Canon Gilles Joye** 1472	20
Domenico Ghirlandaio	**Portrait of a Lady** c. 1485	22
Joachim Wtewael	**The Wedding of Peleus and Thetis** 1612	24
Claude Lorrain	**Landscape with the Voyage of Jacob** 1677	26
Adam Pynacker	**The Ferryboat** c. 1657	28
Jacob van Ruisdael	**Landscape with Bridge, Cattle, and Figures** c. 1660	30
Giovanni Battista Tiepolo	**The Chariot of Aurora** c. 1734	32
François Boucher	**Vulcan Presenting Arms to Venus for Aeneas** 1756	34
Thomas Gainsborough	**Miss Linley and Her Brother** c. 1768	36
Jean-Honoré Fragonard	**The Warrior** c. 1769	38
Francisco José de Goya y Lucientes	**Asensio Juliá** 1814	40
Joseph Mallord William Turner	**Rockets and Blue Lights (Close at Hand) to Warn Steamboats of Shoal Water** 1840	42
David d'Angers	**Philopoemen** 1837	44
Ammi Phillips	**Portrait of Harriet Campbell** c. 1815	46
Théodore Géricault	**Trumpeter of the Hussars on Horseback** c. 1815–20	48
Camille Corot	**The Bathers of the Borromean Isles** c. 1865–70	50
Honoré Daumier	**The Print Collectors** c. 1860–63	52
Jean-François Millet	**The Shepherdess: Plains of Barbizon** c. 1862	54
Alfred Stevens	**The Four Seasons** 1878	56
Jean-Léon Gérôme	**The Snake Charmer** c. 1870	58
William Bouguereau	**Nymphs and Satyr** 1873	60
Camille Pissarro	**The River Oise near Pontoise** 1873	62
Camille Pissarro	**Port of Rouen: Unloading Wood** 1898	64
Edouard Manet	**Manet's Family at Home in Arcachon** 1871	66
Hilaire Germain Edgar Degas	**Self-Portrait** c. 1857	68
Hilaire Germain Edgar Degas	**The Dancing Lesson** c. 1880	70
Hilaire Germain Edgar Degas	**The Entrance of the Masked Dancers** c. 1884	72
Hilaire Germain Edgar Degas	**Little Dancer of Fourteen Years** modeled 1880–81, cast 1919–21	74
Lawrence Alma-Tadema	**The Women of Amphissa** 1887	76
Winslow Homer	**Two Guides** c. 1875	78
Winslow Homer	**Undertow** 1886	80
Winslow Homer	**Eastern Point** 1900	82
Winslow Homer	**West Point, Prout's Neck** 1900	83
James Jacques Joseph Tissot	**Chrysanthemums** c. 1874–75	84
Claude Monet	**Seascape: Storm** 1866	86
Claude Monet	**The Duck Pond** 1874	88
Claude Monet	**The Cliffs at Etretat** 1885	90
Claude Monet	**Rouen Cathedral, Façade** 1894	92
Berthe Morisot	**The Bath** c. 1885–86	94

Pierre-Auguste Renoir	**At the Concert** 1880	96
Pierre-Auguste Renoir	**Blonde Bather** 1881	98
Pierre-Auguste Renoir	**The Onions** 1881	100
Pierre-Auguste Renoir	**A Girl with a Fan** c. 1881	102
Pierre-Auguste Renoir	**Venus Victorious** 1914	104
Mary Stevenson Cassatt	**Offering the Panal to the Bullfighter** 1873	106
Mary Stevenson Cassatt	**Woman with Baby** c. 1902	108
Paul Gauguin	**Young Christian Girl** 1894	110
Vincent van Gogh	**Terrace in the Luxembourg Garden** 1886	112
John Singer Sargent	**Portrait of Carolus-Duran** 1879	114
John Singer Sargent	**Smoke of Ambergris** 1880	116
John Singer Sargent	**A Street in Venice** 1880 or 1882	118
Frederic Remington	**Dismounted: The Fourth Trooper Moving the Led Horses** 1890	120
Frederic Remington	**The Wounded Bunkie** 1896	122
Henri de Toulouse-Lautrec	**Jane Avril** c. 1891–92	124
Pierre Bonnard	**Women with Dog** 1891	126

Decorative Arts

Maker's Mark IV with a star below	**Basin** 1618	130
George Lewis	**Basket** c. 1700	132
Peter Archambo I	**Wall Sconce** 1730	134
Paul de Lamerie	**Two-Handled Cup and Cover** 1730	136
Paul de Lamerie	**Two-Handled Cup and Cover** 1742	138
Paul Crespin	**Pair of Sauceboats** 1746	140
Paul Revere II	**Sugar Urn and Cover** c. 1795	142
Vincennes Porcelain	**River God** c. 1747	144
Worcester Porcelain	**Covered Basket and Stand** 1770–75	146

Prints and Drawings

Jean Bourdichon	**Saint Mark** c. 1510	150
Attributed to Giovanni Boltraffio	**Head of a Woman** undated	152
Albrecht Dürer	**Sheet of Studies with Sketches of Animals and Landscapes** 1521	154
Peter Paul Rubens	**Portrait of Thomas Howard, Earl of Arundel** c. 1629–30	156
Rembrandt Harmensz. van Rijn	**Christ Finding the Apostles Asleep** c. 1654	158
Antoine Watteau	**Woman in Black** c. 1719	160
Giovanni Battista Tiepolo	**The Flight into Egypt** c. 1750–60	162
Joseph Mallord William Turner	**Brunnen, from the Lake of Lucerne** 1845	164
Hilaire Germain Edgar Degas	**Two Portrait Studies of a Man** c. 1856	166
Winslow Homer	**An October Day** 1889	168
Edvard Munch	**Madonna** 1895	170
Pablo Picasso	**The Frugal Repast** 1904	172

Illustrated Books

Crispijn de Passe II	**L'Instruction du roy, en l'exercice de monter a cheval...** 1625	176
Eugène Delacroix	**Faust** 1828	178
Pierre Bonnard	**Les Pastorales de Longus, ou Daphnis et Chloé** 1902	180

Works Listed Alphabetically by Artist 183

Foreword

The permanent collection of the Sterling and Francine Clark Art Institute is unusual. It began with Robert Sterling Clark's purchase of some exceptional old master paintings and drawings shortly after he began a ten-year residence in Paris, about 1910. By 1955, when the museum he founded with his wife opened in Williamstown, the Clark collection had grown to include an important group of nineteenth-century paintings (with special concentrations in French impressionism and works by American masters—Winslow Homer and John Singer Sargent, among others), a wide-ranging selection of works on paper, and a representative collection of English seventeenth- and eighteenth-century silver. Following the 1961 appointment of the first Robert Sterling Clark Professor at Williams College, John Pope-Hennessey, and during the directorships of George Heard Hamilton (1966–77) and David S. Brooke (1977–94), the collection grew to include works that were often slightly outside the boundaries of the original Clark collection, but never in conflict with it. In this way paintings such as Ugolino da Siena's *Virgin and Child with Saints Francis, Andrew, Paul, Peter, Stephen, and Louis of Toulouse* and Jean-Honoré Fragonard's *The Warrior* were added in the 1960s; Pierre Bonnard's *Women with Dog* and Paul Gauguin's *Young Christian Girl* and the Rosewater Basin were purchased in the 1970s and 1980s; and Adam Pynacker's *The Ferryboat,* Joachim Wtewael's *The Wedding of Peleus and Thetis,* and James Tissot's *Chrysanthemums* were acquired in the early 1990s.

This book is published on the fortieth anniversary of the opening of the Sterling and Francine Clark Art Institute. The Clarks' generosity, manifested through their desire to share their collection with others, has resulted in one of America's unique art institutions, now not only a museum but an important research and educational center as well. It is with pride and pleasure that we present in this volume its greatest treasures.

MICHAEL CONFORTI
Director

Acknowledgments

In 1981 the Institute published *Highlights of the Sterling and Francine Clark Art Institute.* It was reprinted in 1985 and by 1990 had again sold out. A third edition was suggested but there was curatorial consensus that an expanded and updated version was necessary. Not only had there been advancement in scholarship, but significant acquisitions had been made in all departments of the Institute.

The project has been both exciting and daunting. The wonderful collection presented terrific possibilities to the team of authors who had the pleasure of presenting some of the finest works in the Clark collection. In production for several years, the catalogue survived changes in the Institute's computer system thanks to the technical expertise and assistance of Martha Asher, registrar; Ben Hogue, systems manager; and Sherrill Ingalls, public-relations assistant. Perhaps the greatest challenge was the coordination of the project. With the work of ten authors and an editor to orchestrate, Mary Jo Carpenter, director of public relations and membership, was an ideal partner whose critical eye and attention to detail kept the project on track. We both thank editor Jacolyn Mott for her thoroughness and thoughtful questions and the authors for their hard work, patience, and even for their endurance over the last three years: David Brooke, director emeritus; John H. Brooks, associate director; Rafael Fernandez, curator of prints and drawings emeritus; Sarah Gibson, librarian; Patricia Ivinski, assistant curator; Jennifer Gordon Lovett, former associate curator of paintings and sculpture; Susan Roeper, associate librarian; Beth Carver Wees, curator of decorative arts; Dustin Wees, photograph and slide librarian. I am grateful to Brian O'Grady, museum shop manager, for his encouragement in this project and his assistance in refining the newly conceived book. I would like to extend special thanks to Lisa Jolin, curatorial secretary, for her cheerful, timely, and diligent assistance with the manuscript as well as her ability to keep track of my frequent requests for new photography. On that same subject, thanks to Arthur Evans, photographer, and Merry Armata, photo facility manager, for their great work. Above all, it was a privilege to be able to discuss all of the color work for the catalogue with Catherine Waters and Kathy Quirk, both of whose familiarity with printing, scanning, and color separation is profound. Their much-valued observations contribute greatly to the success of this catalogue.

This project witnessed several staff changes, the most notable of which was the retirement of David Brooke. I would like to thank him sincerely for his support of this catalogue from the very beginning. When Michael Conforti joined the staff as director in November 1994, this catalogue—nearly ready for production—was one of the first projects he encountered. I would like to thank him for renewing our vision and for offering his encouragement; most importantly, I would like to thank him for directing us to Paul Anbinder at Hudson Hills Press, who is publishing the catalogue. Finally, I would like to thank my wife, Joséphine, for her patience with me and this project, which I have known longer than I have known her.

STEVEN KERN
Curator of Paintings

Introduction

One of the heirs to the Singer sewing machine fortune (his grandfather had been Isaac Singer's business partner), Robert Sterling Clark (1877–1956) also inherited from his father a lively interest in art collecting. After graduating from Yale's Sheffield Scientific School in 1899, he served in the army until 1905, winning a silver star in action against the Boxer forces at Tientsin, China, in 1900. In 1908–9 he led a scientific expedition to northern China, the results of which were published in 1912.

In 1911 Clark settled in Paris to the life of an enthusiastic collector. Francine Clary (1877–1960), whom he married in 1919, was a former actress with the Comédie Française. She shared his enthusiasm for collecting; they visited the dealers together and she freely gave her opinions. Mr. Clark called her his "touchstone in judging pictures." He once wrote to a friend that she was "an excellent judge, much better than I am at times, though I have known her to make mistakes on account of charming subjects."

In the early 1920s the Clarks moved their principal residence from Paris to New York, with country houses first in Cooperstown, New York, and then in Upperville, Virginia. The Second World War, culminating in the dropping of the atomic bomb in 1945, caused Mr. Clark to become increasingly concerned with finding a safe home for their by then extensive collections. In 1949 he settled on Williamstown, where both his father and grandfather (Williams Class of 1831) had been trustees of Williams College.

While the collection continues to grow by purchase and gift, it still bears the distinct stamp of the Clarks' taste. Mr. Clark's appetite as a collector was undoubtedly encouraged by the pictures that he and his three brothers inherited from their parents after their mother died in 1909. While living in Paris from 1911 until 1921, he laid the foundations of his own collection, buying many of the old master paintings and the first examples of some of his favorites—Sargent, Homer, Degas, and Renoir. At the same time he was also building a choice collection of silver, of prints and drawings, and of illustrated books. After 1920 the Clarks concentrated primarily on later nineteenth-century French paintings, which dominate the collection.

Clark's diaries and letters reveal a man who loved pictures and very much enjoyed the business of collecting, which, in his case, involved

Emile Friant, *Mrs. Clark* **and** *Mr. Clark,* **1919 (pencil)**

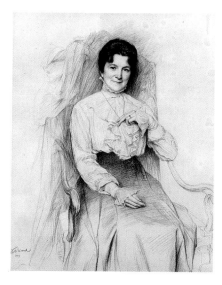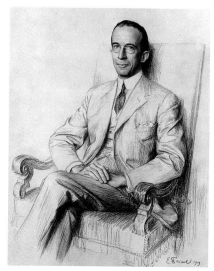

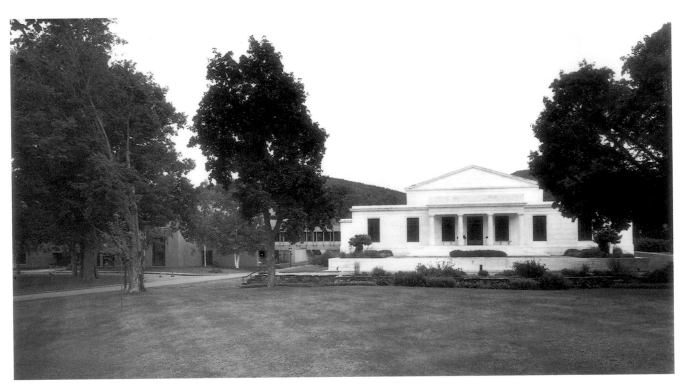

**Sterling and Francine Clark
Art Institute, Williamstown,
Massachusetts**

numerous conversations and amusing arguments with his favorite dealers,
Knoedler and Durand-Ruel. He relied on no outside advisers, was associ-
ated with no museums and, indeed, took a somewhat jaundiced view of
directors, critics, and art historians. During his lifetime the pictures were
lent only occasionally to dealers and few people saw the collection, much
of which was in storage until the Institute opened in 1955. "Going public"
after a lifetime of privacy was both an excitement and a nuisance. Clark
wrote to a friend, "Do not mention the opening of the Institute to anyone,
as you will treat me to a cloud of newspapermen to the detriment of my
health."

The original white marble building with its classical portico, large
central gallery, and smaller rooms opening off long halls seems to have
been designed very much to Mr. Clark's wishes and is a suit of clothes
well cut to his collection. He dismissed two architects before engaging
Daniel Perry of Port Jefferson, Long Island, in 1952. Early designs show
an open central court which was subsequently enclosed to provide more
hanging space. The domestic scale of the smaller galleries suited that of
the pictures the Clarks had collected, while the court (popularly known
as the Renoir Room) and adjoining gallery served as grander spaces for
the display of the larger impressionist and American paintings. Gallery
space was fashioned into an apartment for the Clarks (and later converted
back to galleries). Their small octagonal sitting room with Alfred Stevens's
paintings of the *Four Seasons* still survives.

A large addition designed by Pietro Belluschi and The Architects
Collaborative was opened in 1973. It contains a major art historical research
library that houses the Williams College Graduate Program in the History
of Art, offered in collaboration with the Institute, as well as an auditorium
and additional exhibition space. Also in this building is the Bibliography

of the History of Art, a part of the Getty Art History Information Program and the Centre National de la Recherche Scientifique. To the rear of the complex is the 1964 service building that contains the Williamstown Art Conservation Center, founded in 1976, providing conservation services to museums and private collections throughout the northeastern United States.

In the early 1960s, after the deaths of Mr. and Mrs. Clark, the trustees turned again to the acquisition of objects—mainly paintings as well as a notable print collection—with a view to strengthening certain aspects of the collection. The Ugolino da Siena altarpiece, the Fragonard, and the Monet *Rouen Cathedral* were all bought at this time. By the late 1960s, with the building addition in the planning stages, a moratorium on purchases was declared until the new wing opened in 1973, though it should be noted that Renoir's bronze *Venus Victorious* was acquired for the new entrance court in 1970.

Acquisitions after 1973, while at first relatively modest, filled important gaps; paintings by Jongkind, Morisot, and Vernet come especially to mind. In the late 1970s and early 1980s, the purchasing accelerated as more funds became available, and the Alma-Tadema, Boucher, and Bonnard—all included here—entered the collection. Purchases in the later 1980s and early 1990s were made especially to strengthen existing groups of pictures (the Pissarro, Pynacker, and Wtewael) as well as to fill a post-impressionist gap (Gauguin). During this same period, several important pieces of silver marked by Paul Crespin, George Lewis, and Peter Archambo were added, and especially to be noted is the magnificent early-seventeenth-century rosewater basin acquired in 1989. Finally, a considerable number of prints and drawings have been added to the collection in the last thirty years.

Gifts have also played an important part in the growth of the collection. A number of Flemish and Italian paintings were given by the Edith and Herbert Lehman Foundation in 1968. A striking full-length portrait of Harriet Campbell by Ammi Phillips came in 1991 and an Edvard Munch lithograph in 1992. Other gifts illustrated here include a chestnut basket from a collection of Worcester porcelain and a silver sugar urn by Paul Revere. There are many other gifts that we would have liked to include and for which we are very grateful.

We hope the readers of this book will find as much enjoyment from the objects shown as Mr. Clark and his successors have had in acquiring and caring for them. A visit to the Institute with its very personal collection, intimately scaled galleries, and frequent glimpses of the countryside without is a very special pleasure.

DAVID S. BROOKE
Director Emeritus

Sterling and Francine Clark at the opening of the Institute, May 1955

Notes to the Reader

The eighty entries that follow are separated according to the curatorial divisions at the Sterling and Francine Clark Art Institute: paintings and sculpture, decorative arts, prints and drawings, illustrated books (in the Institute library). The entries are arranged chronologically within each section, based on artist's birthdate. Multiple artists born in a single year have been arranged alphabetically. Multiple entries of work by a single artist are arranged chronologically according to the date of execution of the work. Illustrated books are aranged according to the date of publication. The text of each entry is followed by the initials of the author:

DSB	David S. Brooke, director emeritus
JHB	John H. Brooks, associate director
RF	Rafael Fernandez, curator of prints and drawings emeritus
SSG	Sarah S. Gibson, librarian
PRI	Patricia R. Ivinski, assistant curator
SK	Steven Kern, curator of paintings
JGL	Jennifer Gordon Lovett, former associate curator of paintings and sculpture
SR	Susan Roeper, associate librarian
BCW	Beth Carver Wees, curator of decorative arts
JDW	J. Dustin Wees, photograph and slide librarian

Each entry is accompanied by catalogue information for the object (or objects) discussed:

ARTIST

All of the attributions in this catalogue reflect the current status of research on the Clark collections. The illustrated books list an illustrator, followed by the author.

NATIONALITY

All artists have been assigned a nationality. This poses certain problems, especially with artists who traveled extensively, worked in areas where historical and contemporary boundaries do not match, or may have chosen to work outside of their native land for personal or political reasons. All nationalities reflect the current status of research on the artists.

TITLE

All titles are given in English. Alternate titles or original titles in foreign languages are included when they have special meaning. Book titles are given first in the language of the title page, followed by a translation.

DATE

The date of the work, when known, follows the title. A *circa* (c.) date followed by a single year indicates a leeway of five years before and/or after that date; a *circa* followed by a span of years indicates that the work was executed sometime between the two dates. The date of publication of the illustrated books, along with place of publication and publisher, follows the title.

MEDIUM

The medium and support of all objects are included.

DIMENSIONS

Dimensions are given in inches followed by centimeters in parentheses. Height precedes width; all other dimensions (in sculpture and decorative arts) are appropriately labeled. Illustrated books give page dimensions.

INSCRIPTIONS

All visible signatures, dates, and other inscriptions are included and are in the artist's hand unless otherwise noted. The use of upper and lower case letters reflects the actual appearance of the inscription. Line division is indicated by a slash.

NUMBERING AND CREDIT LINES

Each entry includes an accession number, which is expressed as a decimal. The first four digits are the year in which the object entered the collection; the numbers following the decimal point are assigned chronologically within each year. All *1955* works are part of the original Robert Sterling Clark collection. All gifts to the Institute bear a credit line that respects the wishes of the donor. The illustrated books do not have accession numbers.

ILLUSTRATED BOOKS

In addition to the information above, the illustrated books include a collation, which is the sequence of printed matter in the book, expressed in either pages, leaves, or leaves of plates. Pages are printed on both sides; leaves are printed on one side. Page numbers are given in roman or arabic numerals as used in the book. Bracketed numerals refer to unnumbered pages or leaves. Illustrative matter, printed or drawn, is fully described. Bindings are briefly described.

FOR FURTHER READING

Each entry is followed by a list of other publications for further reading, listed in chronological order.

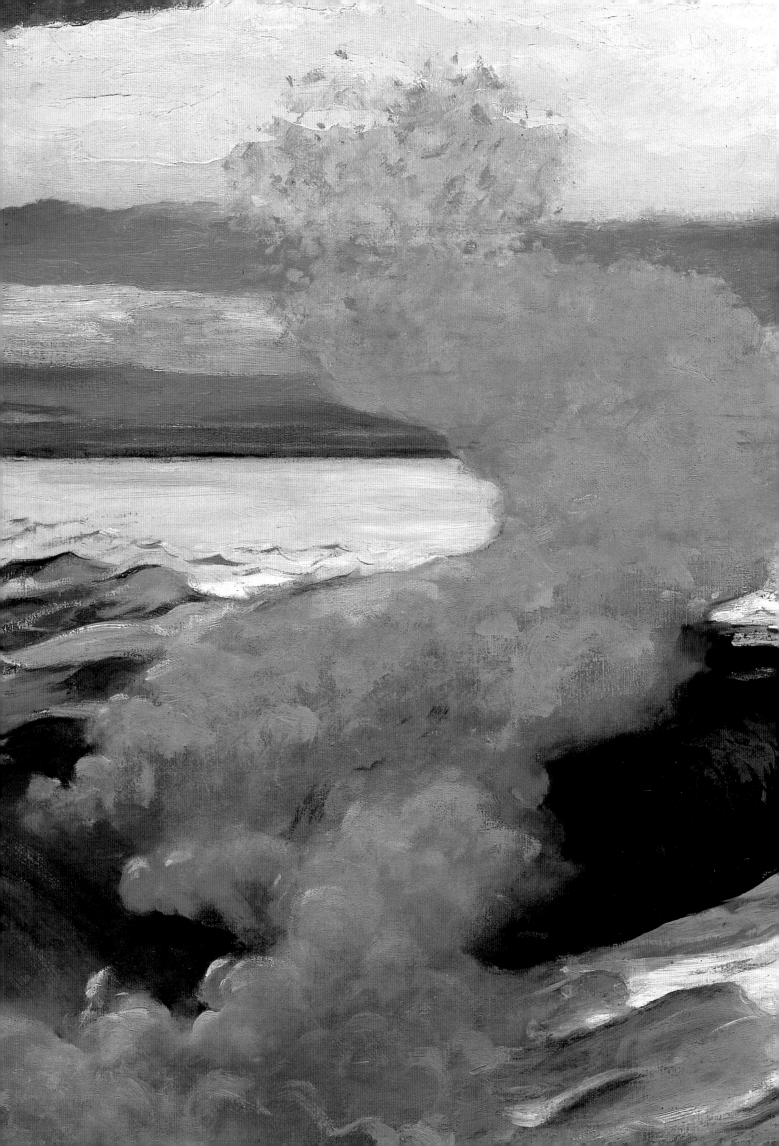

Paintings
and Sculpture

Ugolino da Siena

ITALIAN (SIENESE), ACTIVE
1317–1327

Virgin and Child with Saints Francis, Andrew, Paul, Peter, Stephen, and Louis of Toulouse c. 1317–21

Tempera on panel

64⁷⁄₁₆ × 137⁷⁄₁₆ in. overall (163.7 × 341.4 cm)

Unsigned

1962.148

This important altarpiece was the first major acquisition by the Clark Art Institute after the deaths of Robert Sterling Clark and his wife, Francine. The artist, who was a follower of Duccio, the great Sienese master of the early fourteenth century, is known by relatively few works—all of exceptionally high quality. The *Ugolino Altarpiece,* as this work is called, is characterized by simplicity of composition, psychological directness, and opulent materials, such as gold and ground semiprecious stones.

Largely illiterate, the faithful of the fourteenth century depended on images for the lessons they learned; this altarpiece symbolized the promise of redemption. The saints flanking the Virgin and Child each bear an attribute as a means of identification. Many of these attributes are still recognizable to viewers in the twentieth century. The figure at the left is perhaps the most immediately identifiable—Saint Francis, who shows

the stigmata, the wounds resembling those of the crucified Christ, on his raised hand and his side. Paul, the soldier saint, has a sword. Peter holds a key, and Louis of Toulouse has the miter and crosier of a bishop. The latter figure offers a clue to the dating of the altarpiece: Louis of Toulouse was canonized on April 7, 1317, which is, therefore, the earliest possible date for the execution of this work.

In the gables above the saints are Old Testament prophets, each holding a scroll with a message of the Incarnation. They are, from left to right, Isaiah, Ezekiel, Moses, David, Daniel, and Jeremiah. Christ the Redeemer is in the center. sk

FOR FURTHER READING
Heptatych: Ugolino da Siena, exhibition catalogue (Williamstown: Sterling and Francine Clark Art Institute, 1962).

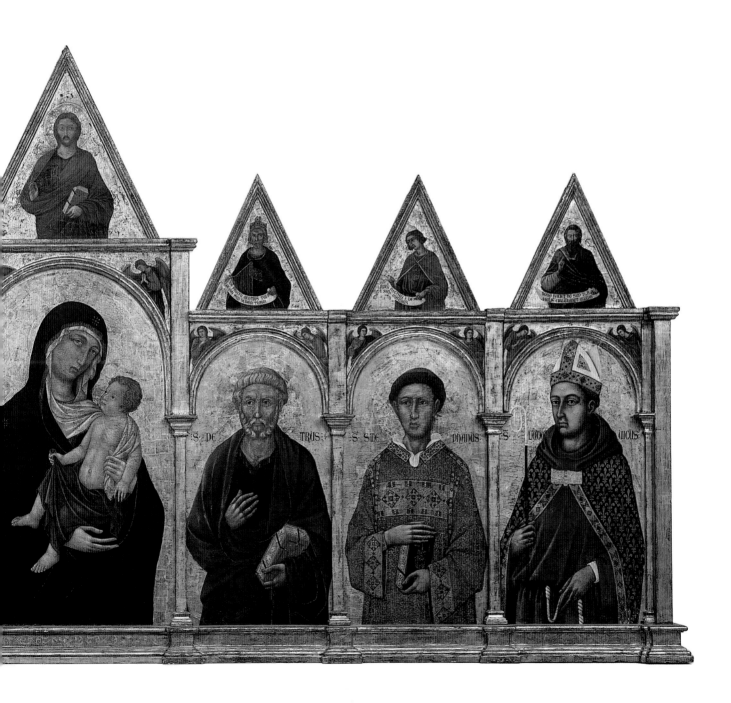

Piero della Francesca

ITALIAN (TUSCAN), C. 1420–1492

Virgin and Child Enthroned with Four Angels c. 1460–70

Oil, possibly with some tempera, on panel, transferred to fabric on panel

42⁷⁄₁₆ × 30⁷⁄₈ in. (107.8 × 78.4 cm)

Unsigned

1955.948

Piero della Francesca is one of the most important artists of fifteenth-century Italy. The artwork he produced—frescoes and panels—as well as his exploration of perspective and geometry in painting secures his place as one of the leading figures of the Renaissance.

Many of the ideas that recur throughout his work seem to have been inspired by a brief stay in Florence when he was only about twenty years old. In the 1430s Florence was one of the great powers in Europe, a wealthy cosmopolitan city that supported artists with commissions for great civic monuments. Piero worked with Domenico Veneziano (died 1461) and had the opportunity to study masterpieces by sculptors such as Lorenzo Ghiberti (1378–1455) and Donatello (1386–1466). From these works he learned, for example, about the rendering of complex relationships among figures in groups. The frescoes of Giotto (1266–1337), the great late medieval master whose career began in Florence in the late thirteenth century, taught Piero how to achieve richness and subtlety in color and clarity in the arrangement of space. The paintings of Masaccio (1401–1428) held lessons about the artistic potential of the human body and the power of gesture. The intellectualism that surrounded the architect Leonbattista Alberti (1404–1472) increased Piero's interest in theory. Everything that he encountered in Florence profoundly affected his thinking and, as a result, his painting.

This panel, one of the very few in North America by Piero, shows that as a mature painter he had fully synthesized all the ideas of his youth. The clarity, calm, and color of the painting, as well as the architectural setting, all show his debt to older masters. The spatial relationship among the figures, however, is Piero at his best.

Following his initiation to theory in the late 1430s, Piero drafted a treatise on mathematical perspective in paintings. This panel shows how Piero applied his writing to his work. His figures are conceived as volumes, constructed three-dimensional forms of spheres, cylinders, cones, and pyramids. This is further emphasized by the architecture. To achieve precision in his composition, Piero relied on some of the tools of a geometrician: the rosettes on the base of the throne, for example, have been drawn with a compass, and the outlines of the various architectural elements have been scored onto the panel.

While geometry and perspective serve as the basis for Piero's creation of the illusion of plausible space for each figure to occupy, gesture and gaze have been used to unite them. The angel on the right looks outward, engaging the viewer directly, and the angel on the left, along with the Virgin, looks at the baby Jesus. The Virgin also holds a rose, a symbol of the Passion. The baby reaches for the flower—a sign he embraces his destiny of crucifixion and, ultimately, redemption of the faithful. SK

FOR FURTHER READING
Ronald Lightbown, *Piero della Francesca* (New York: Abbeville Press, 1992).

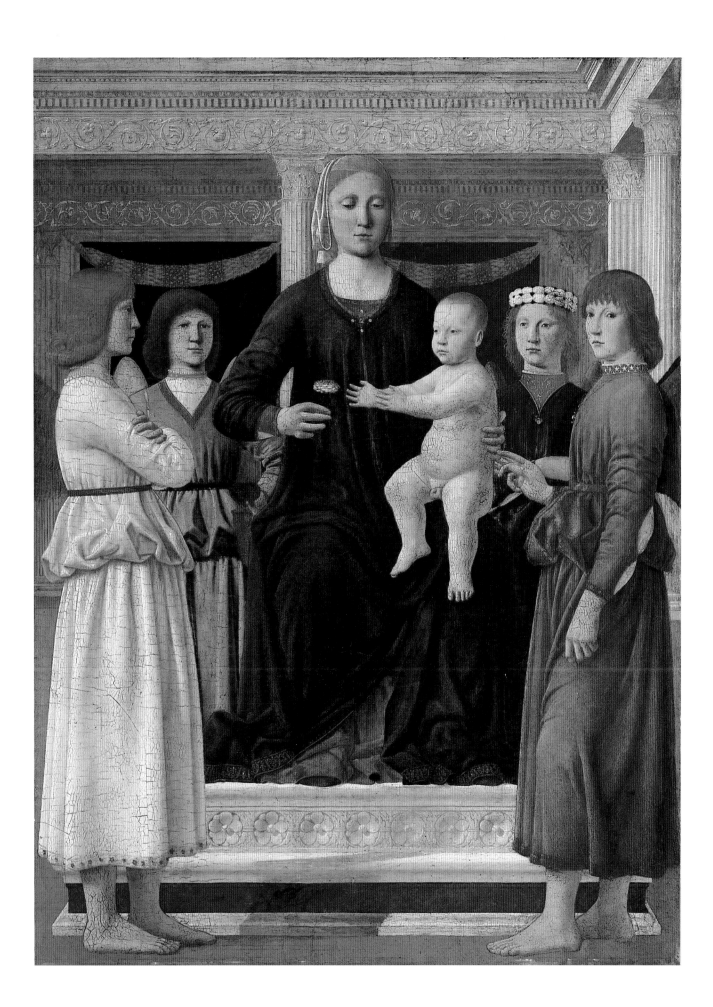

Hans Memling

NETHERLANDISH, 1430(?)–1494

The Canon Gilles Joye

1472

Tempera and some oil on panel

14¹³/₁₆ × 11⁷/₁₆ in. (37.6 × 29.1 cm)

Unsigned; dated on frame, at top:
ANNO DOMINI 1472 **(Year of Our Lord
1472); inscribed on frame, at bottom:**
ETATIS SUE 47 **(His Age 47)**

1955.943

Long thought to be an anonymous man in prayer, the canon Gilles Joye was identified by the coat of arms on the frame, which is actually an integral part of the painting, and on one of the rings that he wears. Born in 1425, he served as a priest in the diocese of Tournai and was then appointed a canon at the church of Our Lady in Cleves. In 1459 he was at the church of Saint Donatus in Bruges. Joye later became the pastor of the church of Saint Hippolitus in Delft. A composer and musician, he was also attached to the musical chapel of the court of Burgundy, where he served the dukes Philip the Good and Charles the Bold from 1462 to 1469, first as clerk and later as chaplain. Joye retired to Bruges in 1469 and died on December 31, 1483. He was buried in the church of Saint Donatus.

Hans Memling was certainly one of the most gifted painters in Bruges in the fifteenth century. He was in great demand for both portraits and church pieces, and his work was much copied. Typical of Memling's portraits, *The Canon Gilles Joye* is a masterpiece of natural detail and precision. Though modest in its composition, the painting shows Memling's brilliance in the treatment of Joye's facial features and hair, his fur collar, and the rings that he wears. Memling also captured the serenity, humility, and dignity of a man of the canon's experience and position. SK

FOR FURTHER READING

Frans van Molle, *Identification d'un portrait de Gilles Joye attribué à Memlinc* (Brussels: Centre national de recherches "primitifs flamands," 1960).

Charles D. Cuttler, *Northern Painting from Pucelle to Bruegel: 14th, 15th, 16th Centuries* (Fort Worth: Holt, Rinehart, and Winston, 1991).

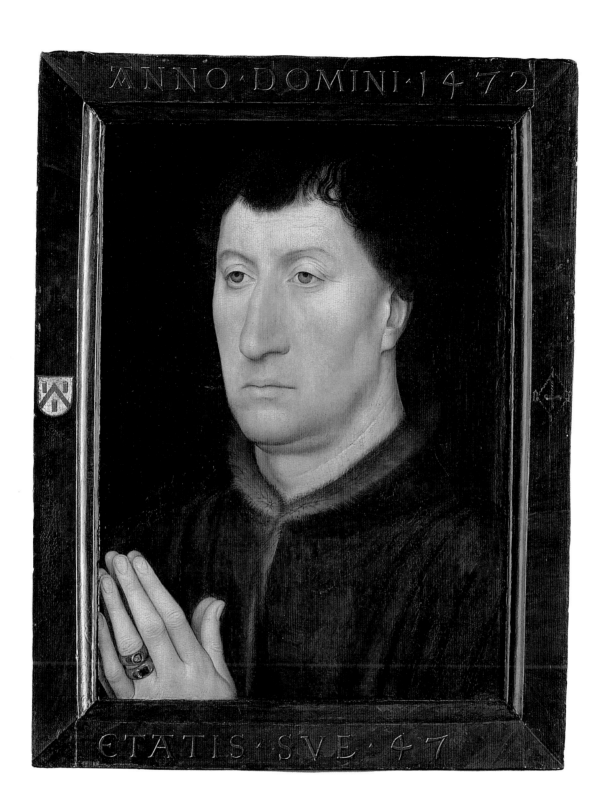

Domenico Ghirlandaio

ITALIAN (FLORENTINE), 1449–1494

Portrait of a Lady

c. 1485

Tempera and oil on panel

22¹⁄₁₆ × 14¹³⁄₁₆ in. (56.1 × 37.7 cm)

Unsigned

1955.938

Robert Sterling Clark acquired this sensitive Florentine portrait in 1913, when he was on a European buying trip with his brother Stephen and George Gray Barnard (1863–1938), a noted sculptor and collector.

As was common in the fifteenth century, Domenico Ghirlandaio ran a family workshop. It became one of the most active in Florence and employed two of his brothers, his son, and a brother-in-law. In this period of workshop collaborations the hand of a particular artist is often difficult to identify with certainty. While in the past this painting has been assigned to others, it is now accepted as a work by Domenico because of the high quality of the draftsmanship and the obvious technical competence.

The model has been tentatively identified as Giovanna degli Albizzi (1468–1488) on the basis of several profile portraits that show her with an almost identical hairstyle and, in one case, a similarly distinctive necklace with three pendant pearls. The orange blossom in her right hand, a traditional adornment of brides, suggests that the painting was a marriage portrait. If the sitter is Giovanna, the picture would have been painted shortly before her wedding in 1486 to Lorenzo Tournabuoni, son of the wealthy Florentine merchant Giovanni Tournabuoni.

The painting seems to reflect the influence of Flemish art—for example, in the placement of the subject behind a parapet and in the precise draftsmanship, especially the meticulous rendering of distant people and trees. The exacting technique and emphasis on linear motifs establish crisp patterns of flowing curves, noticeable in the strands of hair cascading down to frame the sitter's face, in the serpentine road and rivers of the landscape, and even in the sharp folds of the costume. A road at the right picks up the rhythm in the designs of the dress and connects them in a graceful curve. The faraway bridge and walled cityscape on the left appear in a similar location in several contemporary paintings by other masters.

Domenico's son Ridolfo also painted portraits, one of which, of an unknown man, is also in the Clark collection. JHB

FOR FURTHER READING

James H. Beck, *Italian Renaissance Painting* (New York: Harper and Row, 1981).

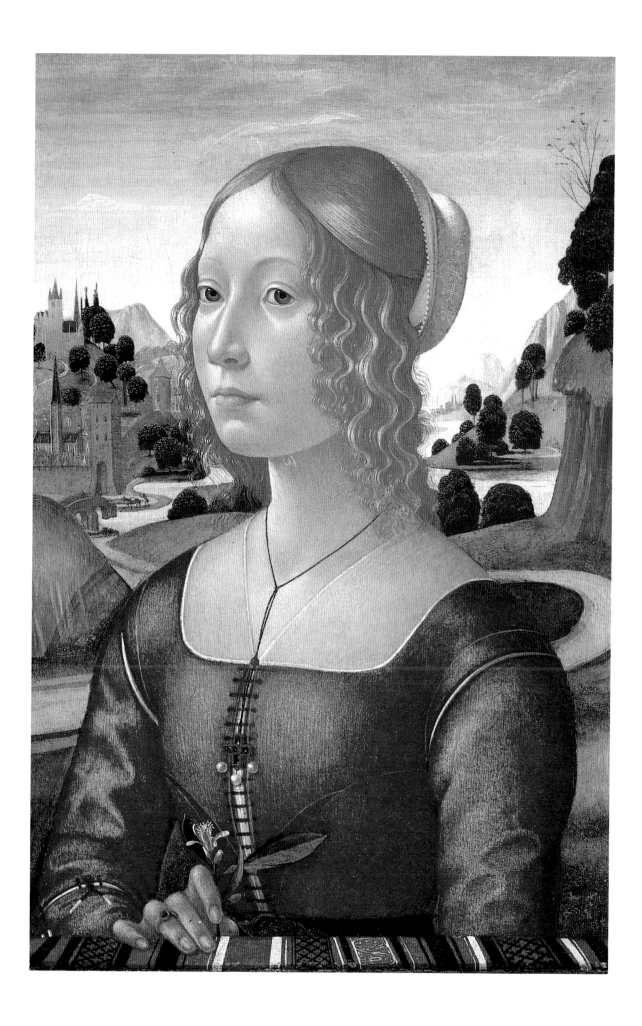

Joachim Wtewael

DUTCH, 1566–1638

The Wedding of Peleus and Thetis 1612

Oil on copper

14¼ × 16½ in. (36.5 × 42 cm)

Unsigned; dated lower right: 1612

1991.9

Joachim Wtewael is one of a group of mannerist artists active in Haarlem and Utrecht at the end of the sixteenth century and in the early years of the seventeenth century. Unlike Jacob van Ruisdael (see p. 30), who chose to interpret the Dutch countryside and its inhabitants in a naturalistic way, Wtewael and the other mannerists were interested in the human body, elegantly though artificially rendered—a taste refined by study in Italy. *The Wedding of Peleus and Thetis* is a celebration of the nude. It is an extremely complex arrangement of figures in exaggerated poses. The artist did not, however, deny the traditional Dutch penchant for naturalism, for he placed the scene in a lush and vividly detailed woodland setting. In this way, Wtewael bridged the styles of north and south in a single painting.

The narrative of the wedding of Peleus and Thetis is as complex as the painting's composition. The story was known to the Dutch through Catullus, a Roman poet of the first century B.C. It appears in his *Carmina 64* and is part of the prologue to the story of the Trojan War. Peleus, the king of the Myrmidons, fell in love with Thetis, the beautiful queen of the Nereids, who were sea nymphs. All the gods except Eris, the goddess of discord, were invited to the wedding. Many of them can be identified in the painting. At the left are Neptune with his trident in the lower corner and Apollo with his lyre in the upper corner. Venus and Mars embrace in the center, while Cupid stands beside her. At the far right Jupiter, wearing a crown, talks with Diana, who wears a crescent-moon diadem. Eris, in a rage at being excluded, hovers ominously, about to drop a golden apple into the crowd.

According to the legend, the apple was inscribed "For the Fairest," and Juno, Minerva, and Venus all claimed it. Jupiter, unwilling to become involved in deciding who was most beautiful, sent the three goddesses to find the shepherd Paris and ask him to choose among them (see also p. 104). This subsequent story, which culminated in Paris awarding the apple to Venus, can also be seen in the distant background of the painting, just to the right of center. All the goddesses had tried to bribe Paris, but Venus won by promising him the most beautiful woman in the world as his wife. Accordingly, after winning the golden apple, Venus helped Paris abduct Helen, the wife of King Menelaus of Sparta. Paris took her home to Troy, where Priam, his father, was king. Menelaus pursued them with a huge army of Greeks, and thus began the Trojan War.

The Wedding of Peleus and Thetis was one of Wtewael's favorite subjects, and he painted at least six versions. While the original story warned against pride and envy, Wtewael's vision of the wedding feast focused more on the evils of excess and immorality. Nonetheless, his bacchanal is seductive, and its appeal is increased by the painting's jewel-like surface and perfect condition. SK

FOR FURTHER READING

Anne W. Lowenthal, *Joachim Wtewael and Dutch Mannerism* (Doornspijk, the Netherlands: Davaco, 1986).

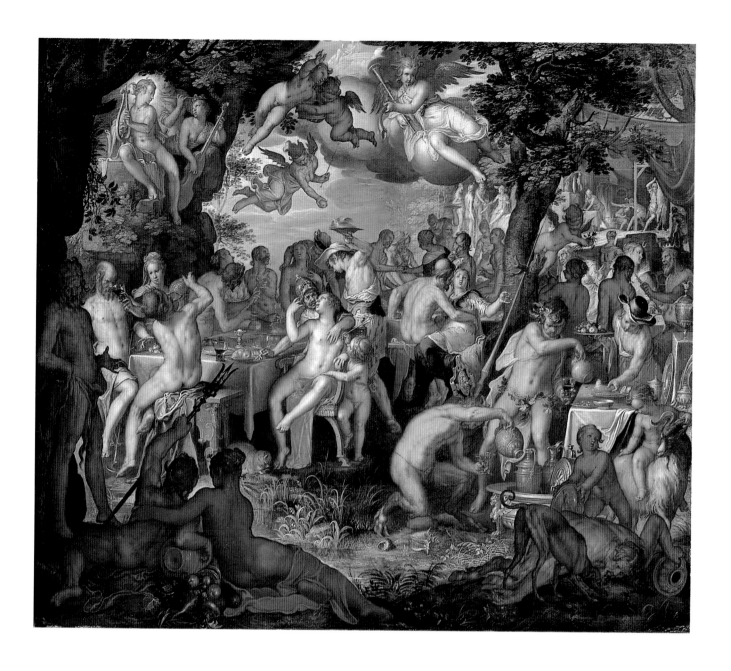

Claude Lorrain

FRENCH, 1604/5–1682

Landscape with the Voyage of Jacob 1677

Oil on canvas

28 × 37⁷⁄₁₆ in. (71.2 × 95.1 cm)

Signed, dated, and inscribed left center:
CLAUDIO IVF/ROMA 1677

1955.42

Claude Gellée, called Claude Lorrain, was perhaps the most famous landscape painter in Europe in the seventeenth century. Born in Chamagne in the French province of Lorraine, he traveled to Rome as an adolescent and became studio servant and assistant to the landscape painter Agostino Tassi (1566–1642). He also worked for a time in Naples with the German painter Goffredo Wals (c. 1595–1638). Following a brief job in Nancy in his native Lorraine, Claude returned to Rome about 1627 and remained there for virtually the rest of his long and productive life.

Most of Claude's landscapes are idyllic scenes of golden Italian sunshine, the rolling hills of the Roman Campagna, ancient ruins, and fantasy architecture. They are the settings for peasants, cowherds, and all manner of country life. But these magnificent canvases should not be mistaken for purely joyous landscapes, for included in every one is a biblical or mythological narrative to enhance the dignity and importance of the painting. In *Landscape with the Voyage of Jacob,* the story of Jacob's journey to Canaan with his flocks and herds (Genesis 33:12–18) has not been allowed to interrupt the bucolic charm and natural beauty that Claude was intent on rendering. The narrative is relegated to the right middle distance where the camels do not look too incongruous in the lush Italian countryside.

Claude Lorrain's paintings were in very high demand during nearly all of his career. By the end of his life, his patrons ranged from prelates to princes across Europe, including the pope and the king of Spain. It was probably due in part to his great popularity and the risk of forgery that, about 1636, Claude began keeping a record of his major works. Upon completion of a painting and before it was sent to the buyer, Claude drew a copy for the *Liber Veritatis* (The Book of Truth), which contains some 195 drawings. *Landscape with the Voyage of Jacob* is a late work, number 189. SK

FOR FURTHER READING

Marcel Röthlisberger, *Claude Lorrain: The Paintings* (New Haven: Yale University Press, 1961).

Claude to Corot: The Development of Landscape Painting in France, exhibition catalogue (New York: Colnaghi, 1990).

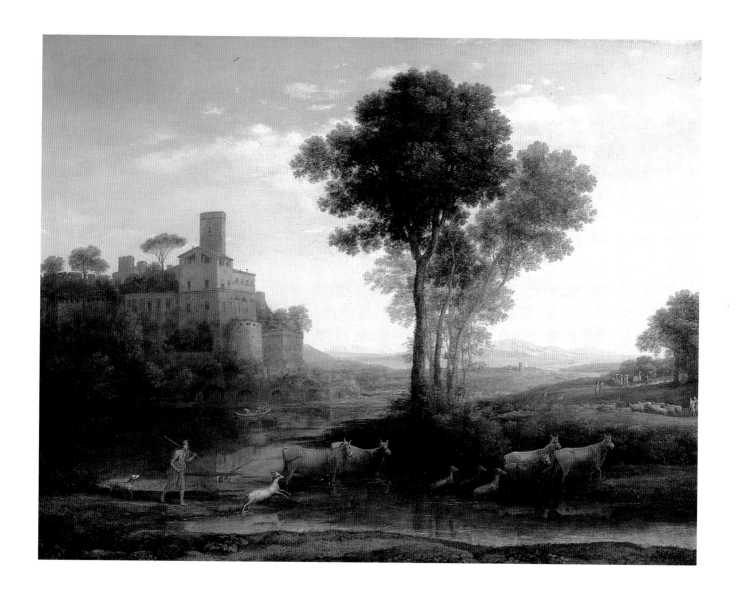

Adam Pynacker

DUTCH, C. 1620–1673

The Ferryboat c. 1657

Oil on canvas

25½ × 29¾ in. (64.8 × 75.7 cm)

Signed lower right: A PIJNACKER

1990.6

The birthplace of the modern landscape painting is considered by many to be seventeenth-century Holland. Without the restrictions or the commissions of the Catholic Church and without an oppressive monarchy, artists in the fledgling country were free to turn to subjects that earlier had been neglected. In part as a patriotic gesture, painters such as Jacob van Ruisdael (see p. 30) focused on the local landscape and climate. Others were seduced by the warmth and beauty of Italy, which, however, they interpreted in a thoroughly Dutch way. Adam Pynacker is one of these Italianate artists.

In his youth Pynacker appears to have had no training as an artist. It was his early profession as a merchant, working with his father, that took him to Italy, where he was inspired by the golden light that would later become such an important element in his paintings. Pynacker's work can be divided into three distinct periods: early work through about 1650, showing his attempts to define his own style; mature work into the mid-1650s with beautifully balanced compositions, innovative narrative, and dazzling displays of sunlight; late concentration on dramatic natural elements placed in the immediate foreground with a tendency toward the decorative. *The Ferryboat* is a fine example of the middle period. Pynacker's originality can be seen in the juxtaposition of idealized landscape in the classical spirit of Claude Lorrain (see p. 26) and contemporary, mundane narrative.

At first glance *The Ferryboat* is remarkable for masterful draftsmanship, brilliant color, and carefully balanced contrast in light and shadow. Upon closer scrutiny, however, it is the narrative that reveals the true genius of the artist. With great humor, Pynacker has painted a mishap in the loading of a ferryboat. Before the unamused eyes of a gentleman, perhaps the owner of the boat, a worker falls into the water after a splashing donkey. A dog barks and passengers laugh. This excitement is heightened by contrast with the serene still-life details of the goods piled on the boat. It is tempting to think that Pynacker, the merchant-turned-artist, would have been familiar with such a scene. SK

FOR FURTHER READING

Laurie Harwood, *Adam Pynacker* (Doornspijk, the Netherlands: Davaco, 1988).

A Golden Harvest: Paintings by Adam Pynacker, exhibition catalogue (Williamstown: Sterling and Francine Clark Art Institute, 1994).

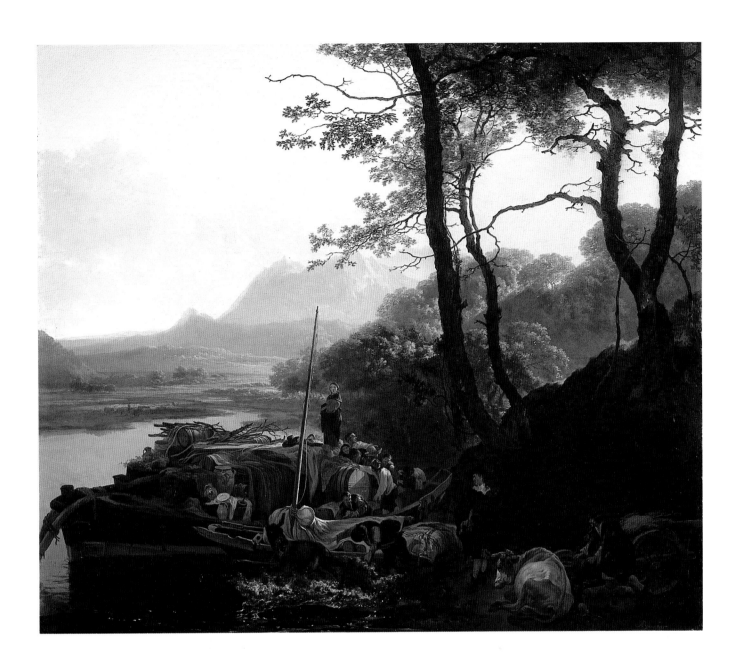

Jacob van Ruisdael

DUTCH, 1628/29–1682

Landscape with Bridge, Cattle, and Figures c. 1660

Oil on canvas

37⅝ × 51¹⁄₁₆ in. (95.6 × 129.7 cm)

Signed lower right: JVR

1955.29

L andscape painting in the Netherlands in the seventeenth century was, in many ways, unique. Instead of fleeing to distant or exotic lands, painters concentrated largely on capturing their immediate surroundings. They found beauty in dunes, rather than ancient ruins, and dignity in the work of peasants, rather than stories from the Bible or mythology. Often unidealized and unadorned but with some artistic license, the work of these artists provides an extraordinary record of the life, the people, and the countryside of the Netherlands in the baroque period.

This painting by Jacob van Ruisdael was carefully composed to achieve balance and beauty. The rocky and wooded outcrops have been treated like a series of planes receding into space and made interesting by great variety in height and texture and by a subtle rhythm of contrasting areas of light and shadow. The horizon line is at approximately one-third the height of the canvas, a convention based on the low horizon in the Netherlands, and much attention is given to the clouds that billow above.

The Dutch predilection for naturalism in seventeenth-century painting was often accompanied by a desire for instructive moral symbols. Many of Ruisdael's landscapes follow this convention. The juxtaposition of saplings with mature and dying trees, for example, is generally seen as representing the cycle of life, a caution that all mankind meets the same end. Likewise, the inclusion of a river or waterfall, both of which can be found in this landscape, may carry the meaning of mortality. Human life, like flowing water, goes past all obstacles to its inevitable end. SK

FOR FURTHER READING

Masters of 17th-Century Dutch Landscape Painting, exhibition catalogue (Boston: Museum of Fine Arts, 1987).

E. John Walford, *Jacob van Ruisdael and the Perception of Landscape* (New Haven: Yale University Press, 1991).

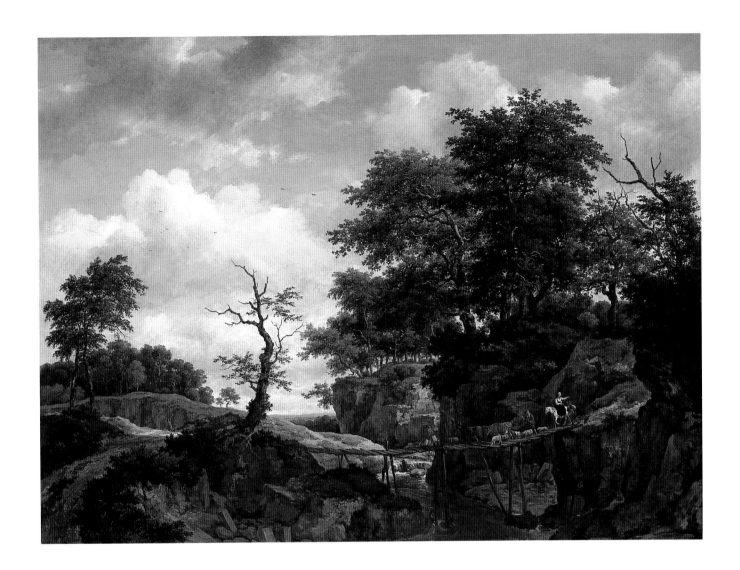

Giovanni Battista Tiepolo

ITALIAN (VENETIAN), 1696–1770

The Chariot of Aurora

c. 1734

Oil on canvas

19⅜ × 19⅛ in. (49.3 × 48.6 cm)

Unsigned

1955.87

The eighteenth-century Venetian artist Giovanni Battista Tiepolo enjoyed an international reputation; commissions for decorative projects came from both the church and private patrons as far away as Germany and Spain. These often monumental works were either frescoes or oil paintings, for he was equally adept in both media.

The relatively small size of this canvas and the fluid, rapidly applied brushstrokes are typical of Tiepolo's oil sketches, of which he produced hundreds. Some were preparatory sketches; others recorded completed commissions. Although this is a study for a large-scale painting, no such work has been identified. The design was apparently meant for a ceiling painting because the figures are foreshortened as if seen from below. Tiepolo was a master decorator of ceilings. Typically he created an expansive light-filled sky crowded with floating religious, mythological, or historical figures, depending on the commission. The winged figure in the upper left is Aurora, the goddess of dawn, rising into the night sky in her horse-drawn chariot. On the rocky outcrop below, a cherub awakens Aurora's brother, Helios, the sun god. The sky, still strewn with stars, is about to be transformed by the glorious oranges and yellows of the sunrise that lights one of three sunflowers with its first rays. Nearby, a bat, the final creature of the night, takes flight.

Tiepolo's Aurora is based on Cesare Ripa's *Iconologia,* a widely used reference book of classical and mythological personifications, published in 1611. Tiepolo often referred to it for descriptions of his subjects. The depiction of Aurora, for example, follows the *Iconologia* with her yellow dress, flesh-colored wings, the flaming torch in her left hand, and the flower petals that she sprinkles on the earth below. PRI

FOR FURTHER READING

Giambattista Tiepolo: Master of the Oil Sketch, exhibition catalogue (Fort Worth: Kimbell Art Museum in association with Electa/Abbeville, 1993).

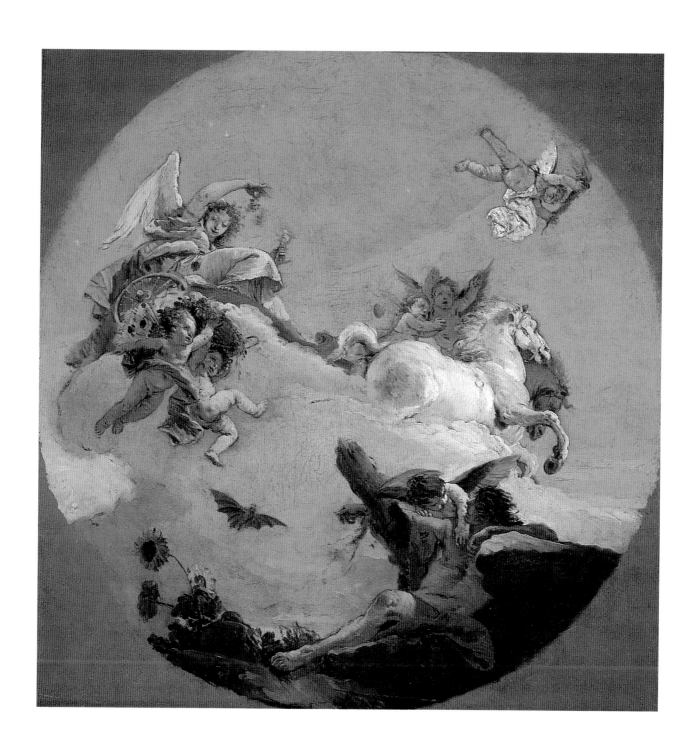

François Boucher

FRENCH, 1703–1770

Vulcan Presenting Arms to Venus for Aeneas 1756

Oil on canvas

16¹³/₁₆ × 17⅞ in. (41.2 × 45.3 cm)

Signed and dated lower right:
F. BOUCHER/1756

Purchased in memory of Talcott M. Banks, Institute Trustee 1950–77, President 1966–77

1983.29

This vivid and colorful little painting is related to a tapestry design many times its size, which was exhibited at the Paris Salon of 1757. The painting in the Clark collection was once owned by the marquis de Marigny, who commissioned François Boucher, Louis Michel Van Loo (1707–1771), Jean-Baptiste Pierre (1714–1789), and Joseph-Marie Vien (1716–1809) to produce a series of four paintings devoted to the loves of the gods as designs for Gobelin tapestries. At the posthumous sale of Marigny's collection in 1782, this sketch was described as full of spirit and fire, and it is, indeed, filled with restless movement and small explosions of color and brushwork. The composition, driven as it were by the wind, revolves around the central figure of Venus supported by a cloud. Her husband, Vulcan, is seated at the right, beside a heap of armor. He seems to be showing Venus the sword made for Aeneas, while at the right an attendant brings him the newly completed breastplate and two putti play with the plumed helmet. Above, in a firelit cave, two cyclopes work at an anvil.

The theme of Venus at Vulcan's forge was a favorite of Boucher, who painted it many times. This version shows the moment, in the eighth book of Virgil's *Aeneid,* when Venus collects the weapons that she has seduced Vulcan into making. Her chariot, visible amid the clouds at the lower left, waits to carry her away.

Boucher, an archetypal painter of rococo themes and a friend and protégé of Madame de Pompadour, made many tapestry designs. DSB

FOR FURTHER READING

François Boucher, exhibition catalogue (New York: The Metropolitan Museum of Art, 1986).

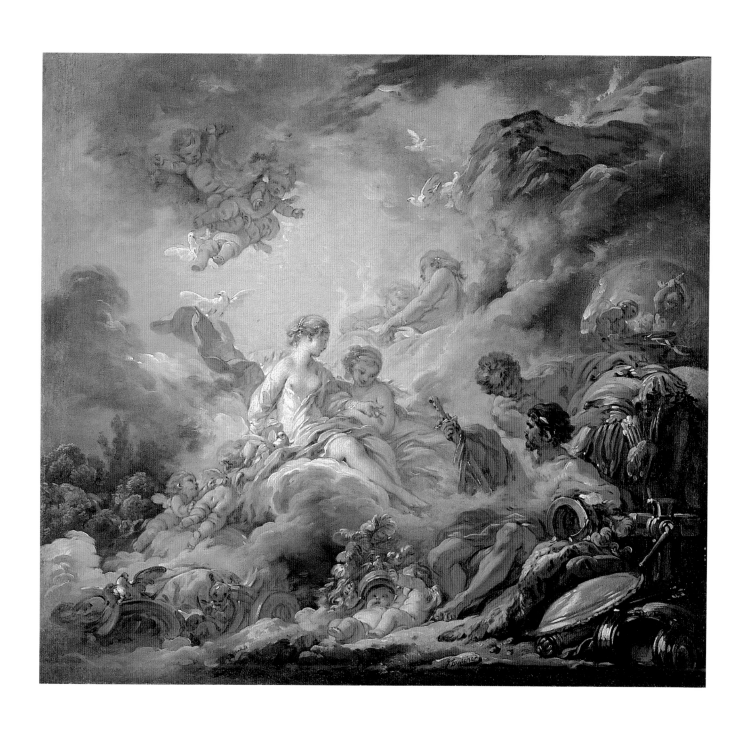

Thomas Gainsborough

BRITISH, 1727–1788

Miss Linley and Her Brother c. 1768

27½ × 24½ in. (69.8 × 62.3 cm)

Oil on canvas

Unsigned

1955.955

Although Thomas Gainsborough painted many landscapes, he spent most of his career as a portraitist. Praised for his ability to capture likenesses precisely and elegantly, Gainsborough was popular with fashionable ladies and gentlemen. He moved from Ipswich to Bath in 1759 and in a short time earned commissions from some of the city's most distinguished residents. Gainsborough surrounded himself with famous members of the music community in Bath and was a talented musician in his own right. He became friendly with Thomas Linley the Elder, a harpsichordist, singer, and composer. Gainsborough painted many portraits of the Linley family, including this one of the eldest daughter, Elizabeth (1754–1792), and her brother Thomas (1756–1778).

Their careers were assiduously promoted by their father, who as a teacher and performer recognized the extraordinary musical gifts of his children. Elizabeth began performing publicly in 1767 and won great praise for her beautiful singing voice and appearance. Thomas, who was taught to sing and play the piano and the violin, also demonstrated great talent.

In 1770, at the age of sixteen, Elizabeth became engaged to be married. The engagement was broken, however, and she fled to France with a friend of the family, Richard Brinsley Sheridan. The trip may have been an elopement, as the couple probably were married in France. Elizabeth's father forced them to return to England, where marriage between minors was considered invalid. Although both families were initially opposed to the union, the young lovers were legally wed in England in 1773. Sheridan, a playwright and politician, decided that it was improper for his wife to perform in public and limited her to intimate concerts in their home for members of the British upper class. Their marriage was not particularly happy. He had a series of widely known love affairs, and she eventually turned to Lord Edward Fitzgerald, by whom she had an illegitimate child. The dramatic events of Elizabeth's life were common knowledge and served as the source of contemporary plays, novels, and biographies.

The same year that he sat for this portrait, young Thomas Linley traveled to Italy to study with the renowned violinist Pietro Nardini. While there, Linley was befriended by the famous child prodigy Wolfgang Amadeus Mozart (both were fourteen years old at the time). In 1771 Linley returned to England, where he continued to play the violin and write sonatas. His life was tragically cut short when he drowned at the age of twenty-two.

Although Gainsborough often used outdoor scenes as backgrounds for his portraits, the sitters usually wore formal attire. In marked contrast are the rustic costumes of the young people in this double portrait. The informal clothes and the grotto in the background anticipate Gainsborough's "fancy pictures." These images of peasants in pastoral surroundings were painted mainly in the 1780s. PRI

FOR FURTHER READING

A Nest of Nightingales, exhibition catalogue (London: Dulwich Picture Gallery, 1988).

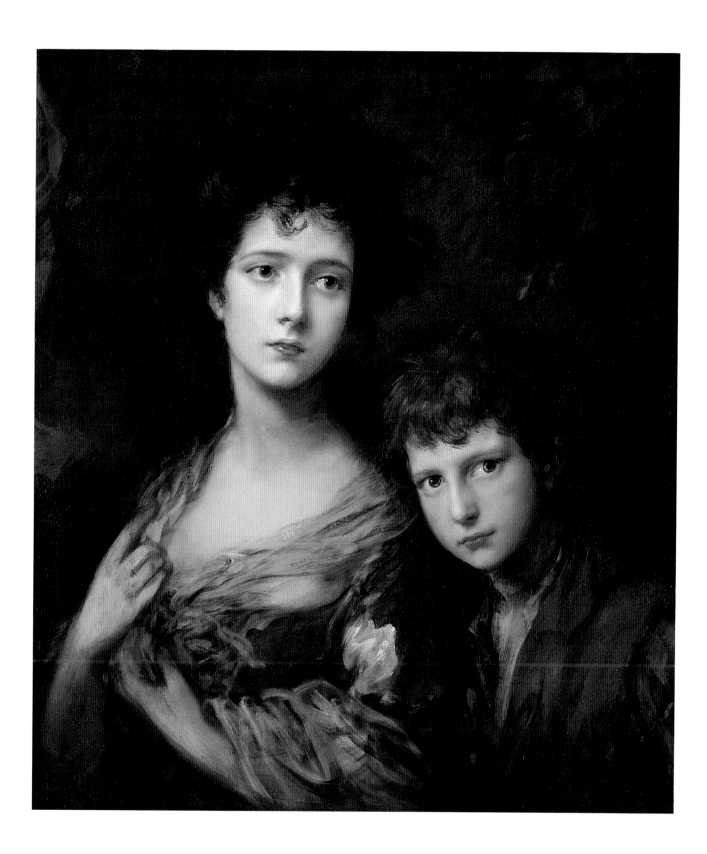

Jean-Honoré Fragonard

FRENCH, 1732–1806

The Warrior c. 1769

Oil on canvas

32¹⁄₁₆ × 25⅜ in. (81.5 × 64.5 cm)

Unsigned

1964.8

I n the late 1760s, Jean-Honoré Fragonard produced a series of four-teen fantasy portraits, one of which is *The Warrior*, identified by the large sword. All were painted rapidly with a spirited technique. In fact, it is recorded on the backs of two of them that each was completed in one hour. The slight foreshortening suggests that they may have been intended to hang over doors. Although some of the portraits have been tentatively identified, *The Warrior* has not. His intense gaze, the dramatic pose with his head turned sharply, and the hand in a fist have suggested to some that he was an actor.

The most impressive aspect of this painting is the dazzling brilliance of Fragonard's technique. Rich paint has been applied with speed and control: a dash of white here, a slash of yellow there—for example, the square patches that highlight the tip of the nose and the joints of the fingers. In the face, strong colors are placed side by side without transition. Small blue-gray dashes emphasize the forehead, the eye, and the mouth, just as red accentuates the nose, the cheek, and the chin.

Placed behind a parapet, the figure remains remote. His forceful physical presence is enhanced by the dramatic appearance of the elaborate seventeenth-century costume, with its large neck ruff, slashed sleeve, and black-and-red mantle rippling in what has been called a "heroic wind."

JHB

FOR FURTHER READING

Fragonard, exhibition catalogue (New York: The Metropolitan Museum of Art, 1988).

Dore Ashton, *Fragonard in the Universe of Painting* (Washington, D.C.: Smithsonian Institution Press, 1988).

Jean Montague Massengale, *Jean-Honoré Fragonard* (New York: Harry N. Abrams, 1993).

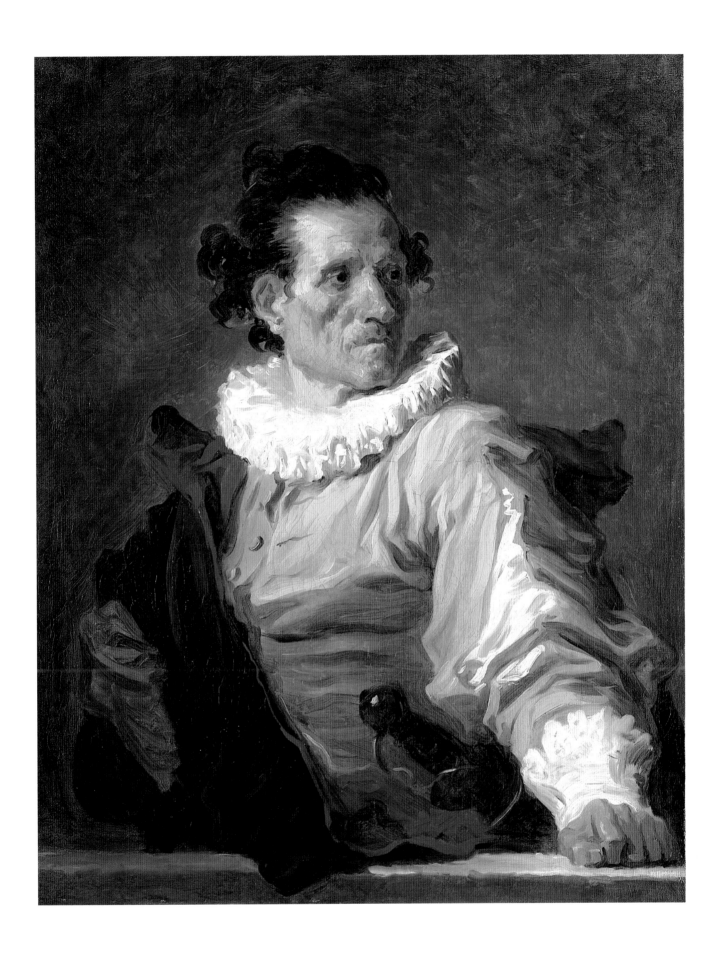

Francisco José de Goya
y Lucientes

SPANISH, 1746–1828

Asensio Juliá 1814

Oil on canvas

28¹³/₁₆ × 22¹¹/₁₆ in. (73.2 × 57.7 cm)

Signed, dated, and inscribed lower left:
pᴿ pᴿ GOYA. 1814.

1955.83

Francisco Goya was born in the town of Fuentetodos, near the city of Zaragoza, the capital of the northern Spanish province of Aragon. In 1760, at the age of fourteen, he entered the studio of the history painter José Luxán (1710–1785) in Madrid. A member of the Academia de Bellas Artes de San Fernando, Luxán was painter to the king and painting inspector for the Inquisition. In the four years spent with him, Goya learned by copying the work of the great masters. He was especially influenced by the works of the seventeenth-century masters Diego Velázquez (1599–1660) and Rembrandt van Rijn (see p. 158).

In 1763 and again in 1766, Goya tried unsuccessfully to be accepted into the Academia in Madrid. He worked at that time in the studio of the court painter Francisco Bayeu and his brother Ramón (1734–1795, 1746–1793, respectively). In 1770, fleeing from unrest in the Spanish capital, he went to Italy. It was there that Goya's work, heavily influenced by neoclassicism, received its first critical acclaim. Following his return to Zaragoza in 1771, Goya was given his first commission. It established his career, which eventually led to the position of painter to the king.

Although Goya achieved success as an artist, his personal life was troubled. All but one of his children died young. He was afflicted on several occasions with mysterious near-fatal illnesses, one of which left him totally deaf in 1792. And he was often embroiled in the political upheavals in Spain at the turn of the nineteenth century.

During the last thirty years of his career—especially during the second decade of the nineteenth century—Goya devoted much time to painting portraits of friends and colleagues. This is one of three that he painted of the artist Asensio Juliá (1760–1832) between the late 1790s and the early 1820s. Juliá collaborated with Goya on the fresco decoration of the church of San Antonio de la Florida in Madrid in 1798 and remained a committed follower for the rest of Goya's career. In this painting, the fifty-four-year-old Juliá wears the outfit of a bohemian artist: beaver top hat, overcoat, and high-collared shirt. He has been caught in a pause in writing or, more likely, drawing. The portrait is largely monochromatic, with little more color than the touch of red of the flower in the hatband and the deep blue of the vest. The contrast between the dark background and the highly lighted face and hand, together with the intensity of the sitter's expression, shows that, even as late as 1814, Goya was affected by the lessons learned from Velázquez and Rembrandt. SK

FOR FURTHER READING

Goya and the Spirit of Enlightenment, exhibition catalogue (Boston: Museum of Fine Arts, 1989).

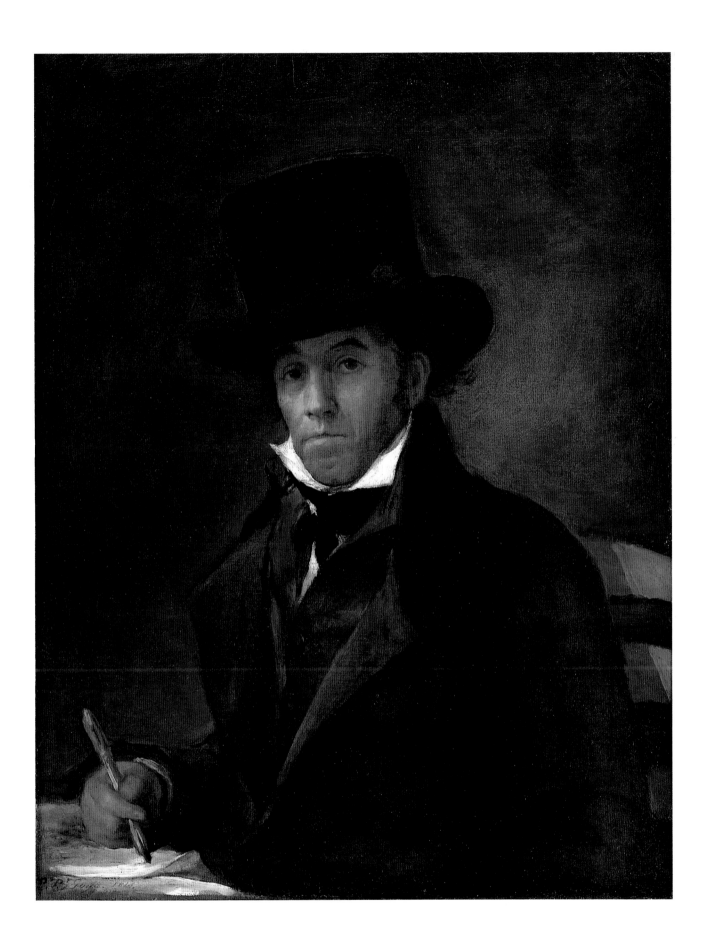

Joseph Mallord William
Turner

BRITISH, 1775–1851

Rockets and Blue Lights (Close at Hand) to Warn Steamboats of Shoal Water 1840

Oil on canvas
36¹⁄₁₆ × 48⅛ in. (91.8 × 122.2 cm)
Unsigned
1955.37

T he greatest influence on late-eighteenth-century English land-
scape painting was the seventeenth-century French painter
Claude Lorrain (see p. 26), whose work was very popular with
both artists and collectors. He was followed so rigidly by many
artists that others began to view his style as overly restrictive and conven-
tional. It was in this artistic climate that Joseph Mallord William Turner
received his early training.

A student at the Royal Academy when he was only fourteen years
old and elected to the academy at twenty-seven, Turner quickly became
quite successful, especially with his watercolors (see p. 164). In painting,
he at first followed the classical tradition of Claude and applied those
precepts to history painting. In the early 1820s, however, his work under-
went a change. History became a mere pretext for poetic explorations of
color, light, and atmosphere.

In this painting Turner captured the fury of a storm on the coast—
perhaps of the English Channel—and the drama of human attempts to
avoid disaster. Sea spray, mist, smoke, and clouds merge and swirl around
the focus of the painting, which seems to be the crash of surf on a pier
where rockets are being set off. The rockets, along with blue lights, signal
the danger of shallows on the approach to the pier and the entrance to the
harbor, which is visible to the left. In the middle ground on the shore, men
haul in a line from a foundering vessel, the mast of which rises just above
the breakers to the far right. In the foreground, a group of onlookers—some
with hand-held telescopes—observes the drama.

The contemporary response to paintings like this was almost entirely
negative. Turner's color, composition, subject matter, and technique were
condemned. Ironically, the works of about 1840 are the very ones that were
admired by later generations. Paintings such as *Rockets and Blue Lights* estab-
lished Turner as a precursor of the impressionists, whose main goal was to
capture the effects of light, color, and atmosphere. In fact, Claude Monet
(see pp. 86–92) and Camille Pissarro (see pp. 62–64), who were to become
leading impressionists, first met in London where they studied Turner's
work and recognized the common ground between their ideas and the
work of the earlier, English master. SK

FOR FURTHER READING
Evelyn Joll and Martin Butlin, *Catalogue of the Paintings of J. M. W. Turner*
(London: Yale University Press, 1977).
Andrew Wilton, *J. M. W. Turner* (Fribourg, Switzerland: Office du Livre, 1978).

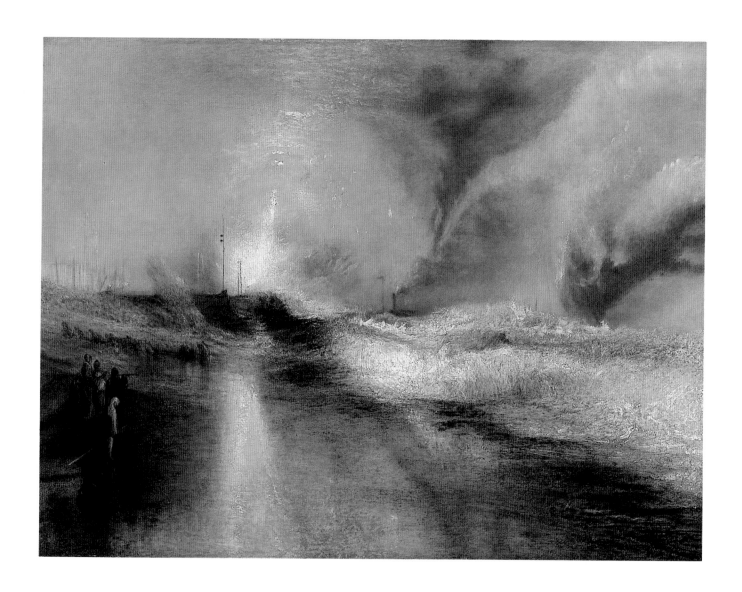

Pierre-Jean David, called David d'Angers

FRENCH, 1788–1856

Philopoemen 1837

Bronze

Height: 25¾ in. (65.4 cm)

Incised in rear on tree stump: DAVID D'ANGERS 1837

1993.24

David d'Angers was judged by many contemporary critics to be the greatest sculptor of the second quarter of the nineteenth century. As one of the most versatile sculptors of the Romantic period, he was the recognized leader in the revolt against the formal severity of academic neoclassicism.

David began modeling portraits during his three-year sojourn in Italy after winning the coveted Prix de Rome in 1811. Throughout much of his career, he concentrated on commemorating famous men and women who he felt had made significant or noble contributions to society through politics, science, or the arts. Most of his subjects shared his morals, political philosophy, and aesthetic convictions.

In 1832 David received a government commission for the statue of *Philopoemen of Megalopolis* (253–184 B.C.), General of the Achaeans. He chose to represent an episode from Plutarch's *Lives* in which the wounded hero pulled a javelin from his leg and fought on to win the battle of Sellasia (222 B.C.). Although Philopoemen was only about thirty years old at the time of this event, David portrayed him as a much older man to emphasize both the soldier's symbolic role as the last of the Greeks and, by extension, the demise of the Hellenic civilization.

The marble *Philopoemen*, which now belongs to the Louvre, stands slightly over nine feet tall. Originally installed in the Tuileries Garden, the piece—unlike many of David's works—was readily accessible to subsequent artistic generations. The statue was greatly admired by Auguste Rodin (1840–1917), who attempted, in his own work, to resolve similar aesthetic and intellectual issues.

Like many of David's large statues, the figure of *Philopoemen* was reduced and cast in bronze by the lost-wax method. Although it is not marked, this piece is of exceptional quality and may represent the workmanship of the expert founder Achille Collas, who is known to have cast several of David's works. JGL

FOR FURTHER READING

Jacques de Caso, *David d'Angers, Sculptural Communication in the Age of Romanticism,* trans. Dorothy Johnson and Jacques de Caso (Princeton: Princeton University Press, 1992).

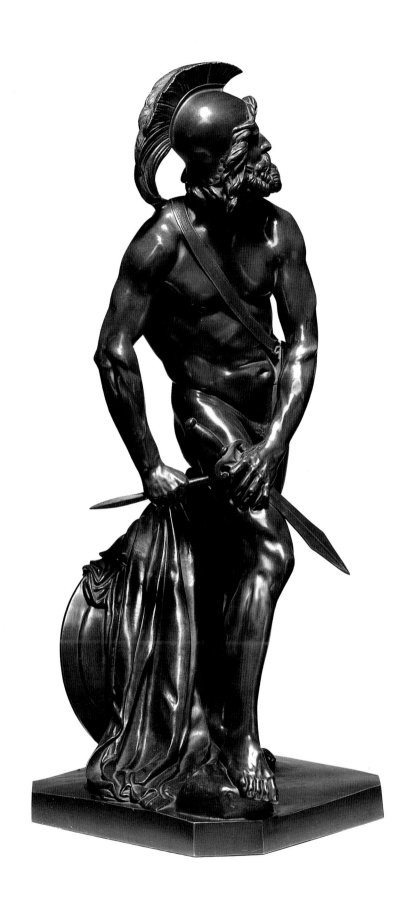

Ammi Phillips

AMERICAN, 1788–1865

Portrait of Harriet Campbell c. 1815

Oil on canvas

48½ × 25 in. (123.2 × 63.5 cm)

Unsigned

Gift of Oliver Eldridge in memory of Sarah Fairchild Anderson, teacher of art, North Adams Public Schools, daughter of Harriet Campbell

1991.8

L ittle is known about the early life of the itinerant portrait painter Ammi Phillips. The first reference to him is not until 1811, when the twenty-three-year-old Phillips was already a well-known limner in rural New England.

Five periods have been identified to assist in categorizing, defining, and dating Phillips's work: Border, Realistic, Kent, Sculptural, and Late styles. The *Portrait of Harriet Campbell* was painted during the Border period, so named because most of the portraits painted between 1812 and 1819 were of the residents of the small towns on the borders of New York, Massachusetts, and Connecticut. This portrait includes all the characteristics of the period, notably soft pastel colors; a light background; and the definition of form predominantly through strong contour lines. While much of the figure remains flat, Phillips did attempt to suggest modeling to round his figure.

Harriet Campbell was probably born on June 10, 1808, in Greenwich, New York, the daughter of John and Polly Walker Campbell. In 1836 she married Marinus Fairchild, a lawyer in Salem, New York. SK

FOR FURTHER READING

Barbara C. and Lawrence B. Holdridge and Mary Black, *Ammi Phillips: Portrait Painter, 1788–1865* (New York: Clarkson N. Potter, 1968).

Between the Rivers: Itinerant Painters from the Connecticut to the Hudson, exhibition catalogue (Williamstown: Sterling and Francine Clark Art Institute, 1990).

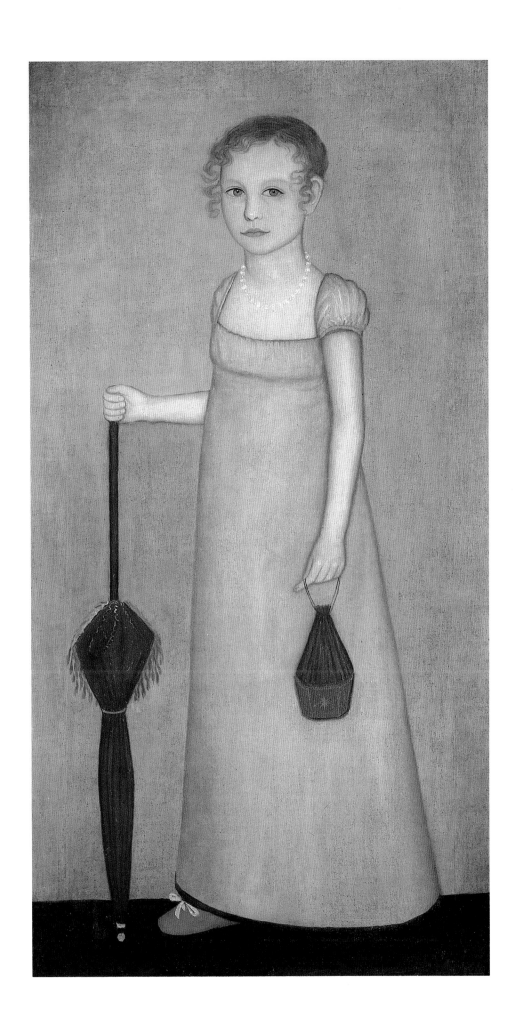

Théodore Géricault

FRENCH, 1791–1824

Trumpeter of the Hussars on Horseback

c. 1815–20

Oil on canvas

Original dimensions: 28⁵⁄₁₆ × 22³⁄₁₆ in. (72 × 57.2 cm); with posthumous additions: 37¹³⁄₁₆ × 28³⁄₈ in. (96.1 × 72.1 cm)

Unsigned

1955.959

Born in the midst of the French Revolution and reared in the Napoleonic era, Théodore Géricault often turned to military subjects during his brief lifetime. The painter was especially inspired at the beginning of his career by the glory of France and Napoleon. Commissions resulting from France's victories came to an end, however, with the defeat on the fields of Waterloo in 1815, and Géricault found himself no longer in the company of soldier-heroes but rather of beaten veterans. Géricault produced a small group of military scenes in this new social climate between 1815 and 1820.

The *Trumpeter of the Hussars on Horseback* is typical of his military canvases of the post-Napoleonic period. The powerful painting shows a lone equestrian figure against the neutral background of a heavy, cloudy sky. The low vantage point increases the effect—which is not the glorious monumentality of victory but rather the melancholy and nostalgic monumentality of defeat. SK

FOR FURTHER READING

Lorenz E. A. Eitner, *Géricault: His Life and Work* (London: Orbis Publishing, 1983).

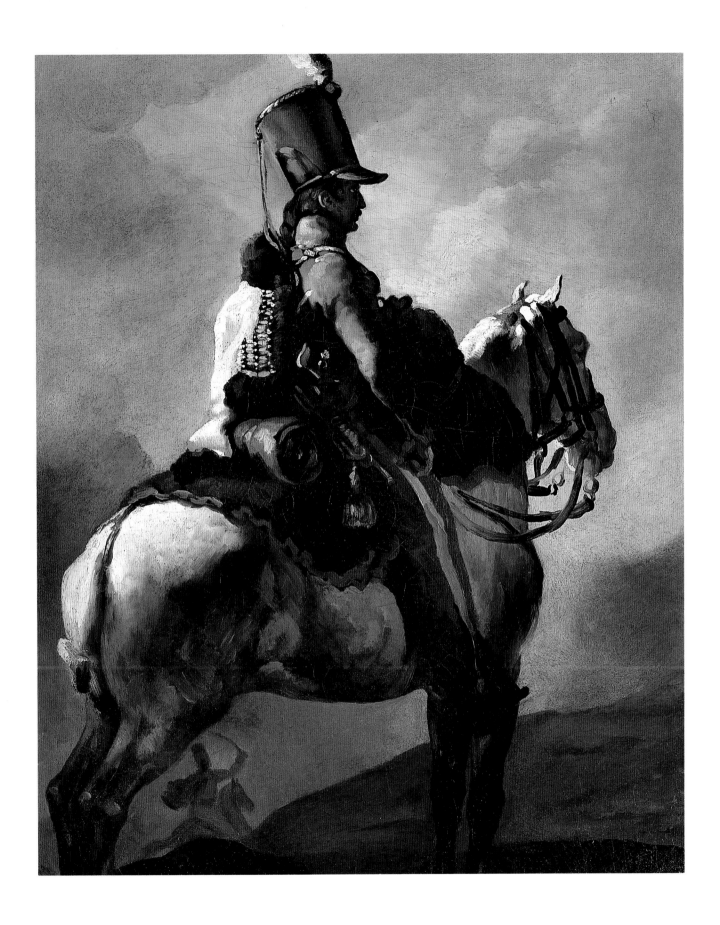

Camille Corot

FRENCH, 1796–1875

The Bathers of the Borromean Isles

c. 1865–70

Oil on canvas
31 × 22⅛ in. (78.7 × 56.2 cm)
Signed lower left: COROT
1955.537

This rather late painting sums up many of the characteristics that secured Camille Corot's place as arguably the most important landscape painter in France of the mid-nineteenth century. He bridged the gap between the neoclassical landscape painters of the early nineteenth century and the open-air painters of mid-century. Corot profoundly influenced two generations of artists, including painters of the Barbizon school and the impressionists.

Corot combined formal training in distinguished Paris studios with informal study outside the city. At Fontainebleau, he occupied himself with the French landscape, and later, in Italy, he discovered new subjects and different effects of light and atmosphere. Upon his return to France, he traveled often from his residences and studios in Paris and nearby Ville d'Avray to Fontainebleau and locations in Normandy and Burgundy. By the early 1830s, Corot had joined a group of artists working around Barbizon. It was there that he refined his approach to landscape and gained a reputation for informal scenes of the French countryside. Lyrical and charming, they were filled with beautifully diffused light and subtle variations of color. Free of serious narrative content, his canvases often focused on peasants, their labor, and their lives.

In 1843 Corot made his third and final trip to Italy. He filled himself with observations—of people and places, of atmosphere and light—that would provide him with ample subjects for the remainder of his very prolific career. *The Bathers of the Borromean Isles* is a souvenir of this last visit. Painted at least twenty years later, this view has all of the lyricism, charm, and subtlety of color that marked Corot's early work in Barbizon.

Ignoring the majestic vistas of Lake Maggiore in northern Italy, Corot chose instead to paint this modest and intimate detail showing the lake's Borromean Isles. Neither the narrative content nor the specific site is as important as the artist's celebration of nature and his virtuoso study of light—its play on leaves and branches, its reflection off the water, and its glow on the architecture in the background. SK

FOR FURTHER READING

Peter Galassi, *Corot in Italy: Open-Air Painting and the Classical Landscape Tradition* (New Haven: Yale University Press, 1991).

The Rise of Landscape Painting in France: Corot to Monet, exhibition catalogue (Manchester, N.H.: The Currier Gallery of Art, 1991).

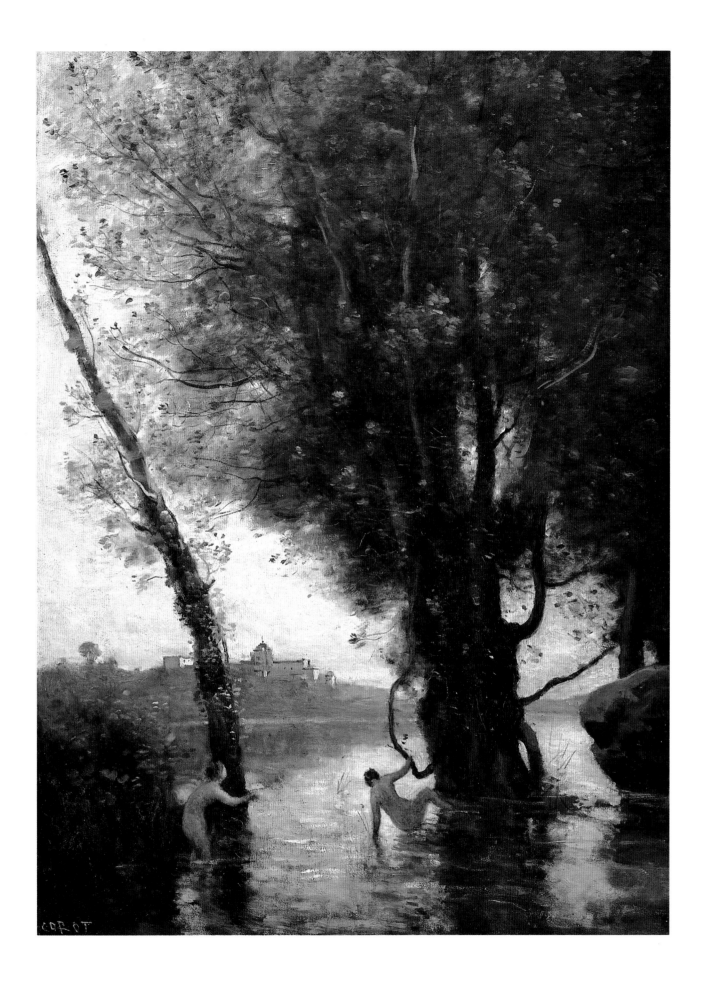

Honoré Daumier

FRENCH, 1808–1879

The Print Collectors

c. 1860–63

Oil on panel

12⁵/₁₆ × 15¹⁵/₁₆ in. (31.2 × 40.5 cm)

Signed lower right: H. DAUMIER

1955.696

Honoré Daumier was certainly one of the most original artists of the mid-nineteenth century. He is not known for great innovations in subject, style, or technique but rather for his highly personal depiction of the world around him. Daumier is recognized today, much as he was in his own time, as a skilled draftsman and witty cartoonist. His illustrations were standard fare for almost four decades in such nineteenth-century Paris periodicals as *Le Charivari*. The events, ideas, and people depicted by Daumier cut across all levels of French society, politics, economy, religion, and entertainment. The art world was not exempt from his attention, and Daumier produced memorable images of such public spectacles as the annual Paris Salons and the connoisseurs who flocked to them.

This painting of print collectors is very different, however, from Daumier's well-known prints of similar subjects. Here, the collectors are in a private gallery, the table covered with prints and albums, the walls heavy with paintings that, although unrecognizable, establish an air of credibility and connoisseurship. Daumier does not mock the men's intellect or lampoon their activity by caricaturing their faces. The collectors are presented as individuals. Daumier seems to respect them as people who are capable of sharing with artists an understanding of their creations.

The Print Collectors represents a turn inward by Daumier. Far from a brash public display, the image is intimate and contemplative. The artist has fully exploited his expressive brushwork to create a feeling of intensity and quiet joy. SK

FOR FURTHER READING

Daumier Drawings, exhibition catalogue (New York: The Metropolitan Museum of Art, 1992).

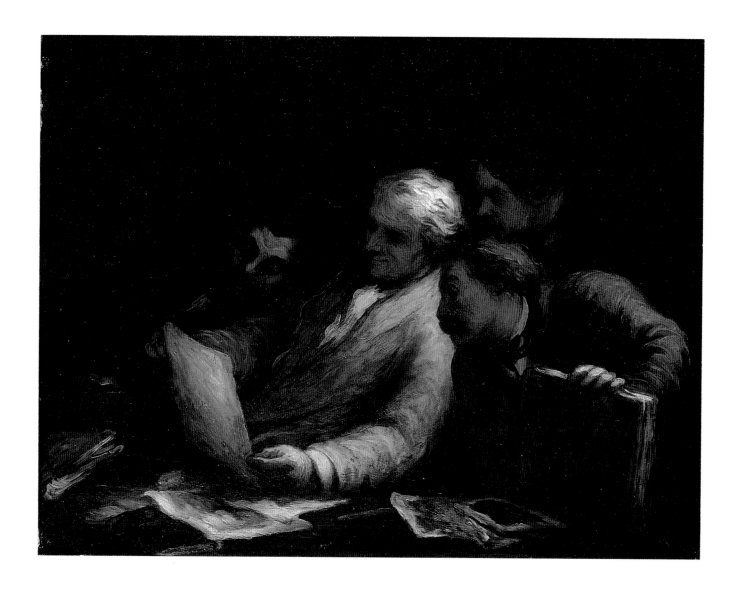

Jean-François Millet

FRENCH, 1814–1875

The Shepherdess: Plains of Barbizon

c. 1862

Oil on panel

14¹⁵⁄₁₆ × 10¾ in. (38 × 27.3 cm)

Signed lower right: J. F. MILLET.

1955.532

J ean-François Millet was born into a farming family in the small Norman town of Gruchy. Fortunately, his parents recognized his artistic talent, and, at the age of nineteen, he was sent to nearby Cherbourg for training. Within only four years, that city awarded him a scholarship to study art in Paris.

In 1849 Millet returned to the country, to the village of Barbizon, near the forest of Fontainebleau, where he remained for the rest of his life. Once outside Paris, he rejected the historical subjects that were favored at the time and concentrated on images of peasants, who depended on nature for their livelihood. These works initially met with a great deal of criticism because the subject matter was thought to be vulgar. By the late 1860s, however, paintings such as *The Shepherdess: Plains of Barbizon* were in demand.

Shepherdesses tending their flocks were among Millet's favorite images. Many Conté crayon and pastel drawings of the subject exist, in addition to numerous oil paintings. Here, the shepherdess stands with her back to the nearby sheep and concentrates on her knitting. There is monumentality in the erect pose and bulky form. Her features are not clearly defined, as she seems to represent a figure inextricably linked to the land rather than a particular person. The image is not sentimentalized with anecdotal detail, nor is the shepherdess presented as oppressed by her labor: she is simply doing her work.

Many people read religious or political messages into the paintings of Millet, but he consistently denied such interpretations. Nonetheless, the shepherdess is imbued with a sense of grandeur that links her to images of the heroic classical and biblical figures with which Millet was certainly familiar.

Robert Sterling and Francine Clark purchased three other images of young peasant women painted by Millet, as well as many works by his contemporaries in the Barbizon school. PRI

FOR FURTHER READING
Jean-François Millet, exhibition catalogue (Boston: Museum of Fine Arts, 1984).

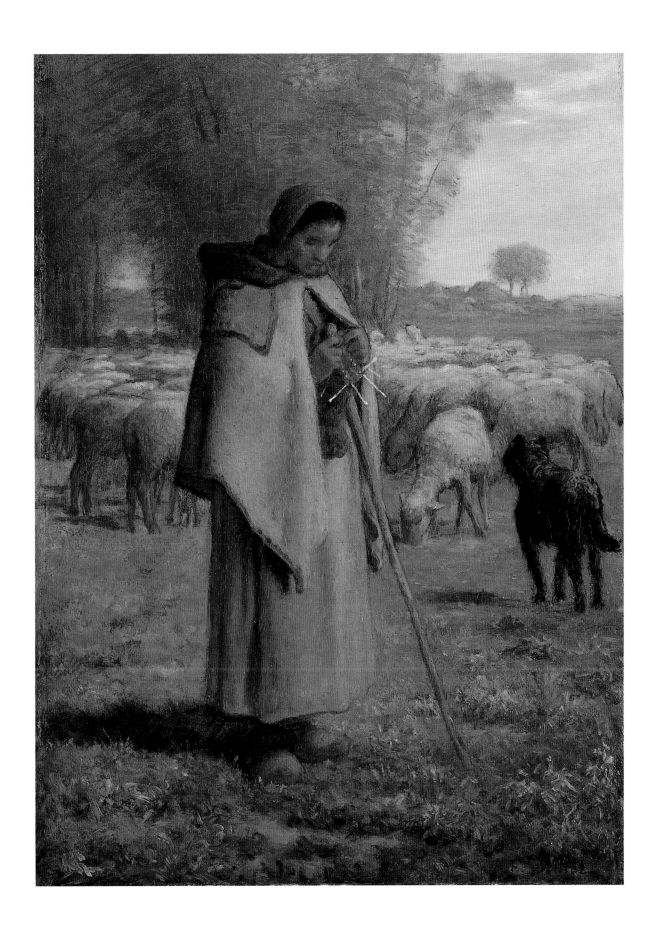

Alfred Stevens

BELGIAN, 1823–1906

The Four Seasons 1878

Winter

Oil on canvas

46⁹⁄₁₆ × 23⁵⁄₁₆ in. (118.3 × 59.3 cm)

Signed lower left: ALFRED STEVENS.

1955.867

Spring

Oil on canvas

46½ × 23⁵⁄₁₆ in. (118.2 × 59.3 cm)

Signed lower right: ALFRED STEVENS.

1955.868

Alfred Stevens was one of Robert Sterling Clark's favorite painters. Clark's diary in the late 1920s mentions his purchase of a Stevens sketch "for its fine paint" and in the 1930s compares an 1883 portrait, "very well drawn [with its] pastel coloring," to John Singer Sargent's wonderful *Smoke of Ambergris* (see p. 116). By 1940 Clark had bought ten paintings by the Belgian artist. The fact that he had a special gallery designed for the Four Seasons further emphasizes his affection for the beautiful, elegant women that are typical of Stevens's work.

Born in Brussels, Alfred Stevens grew up in an atmosphere saturated with art. His father was an avid collector of paintings by such artists as Eugène Delacroix (1798–1863), and his maternal grandfather was the proprietor of the Café de l'Amitié, a Brussels establishment where artists gathered. Stevens's early art education in Brussels and Paris was conservative and gave him a firm foundation in the academic approach to painting, but his subject matter and technique quickly departed from what he had been taught. He admired Jean-François Millet and Camille Corot and became a great friend of Edouard Manet (see pp. 54, 50, and 66, respectively). Stevens was accepted into the group of artists who frequented the Café Guerbois in Paris and who soon became known as the impressionists. While he did not adopt all their ideas, he did share their interest in the truthful and detached depiction of contemporary Parisian life.

Stevens was one of the first painters to be attracted to the art of Japan, which he collected with great enthusiasm. By the 1860s he was incorpo-

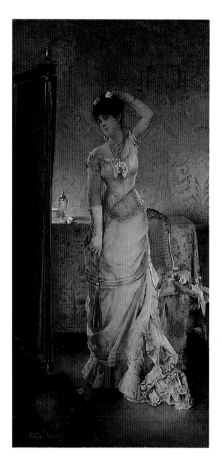 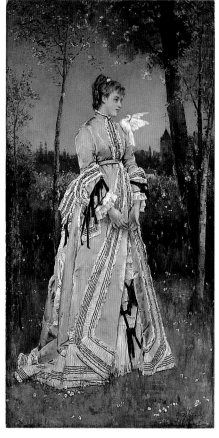

Summer

Oil on canvas
46⁹⁄₁₆ × 23⁵⁄₁₆ in. (118.3 × 59.3 cm)
Signed lower left: ALFRED STEVENS.
1955.869

Fall

Oil on canvas
46⁹⁄₁₆ × 23⁵⁄₁₆ in. (118.3 × 59.3 cm)
Signed lower left: ALFRED STEVENS.
1955.870

rating Japanese elements of design into his compositions. This influence is evident in the Four Seasons. It shows in the complex spatial arrangement of the interiors in *Summer* and *Winter* and also in the models, who appear to be suspended in front of highly decorative backdrops in *Spring* and *Fall.* These women look like French counterparts of the courtesans in the Japanese color woodblock prints that were by then flooding into the West.

Stevens's mastery of color—subtle and rich with discordant notes—earned him praise from artists and critics and helped guarantee his popularity. It was not the standard iconography of the seasons that attracted him to this series. He was interested instead in depicting introspective and elegant women. Each season is recognizable by color rather than by traditional seasonal attributes: *Spring* is lush with blues and greens, decorated with a twinkle of blossoms; *Summer* is bright with salmon and coral; *Fall* is a somber symphony of browns; *Winter* is icy white, warmed with a subtle glow like the embers of a fire or the weak late-afternoon sun.

The Four Seasons in the Clark collection is a slightly later version of a series commissioned by King Leopold of Belgium about 1869 and completed in 1876. SK

FOR FURTHER READING

Alfred Stevens, *Impressions on Painting,* trans. Charlotte Adams (New York: George J. Coombes, 1886).

Alfred Stevens, exhibition catalogue (Ann Arbor: University of Michigan Museum of Art, 1977).

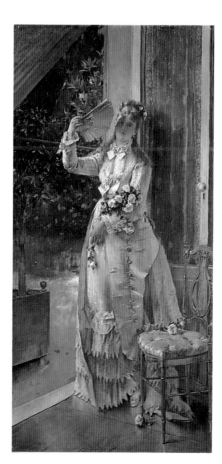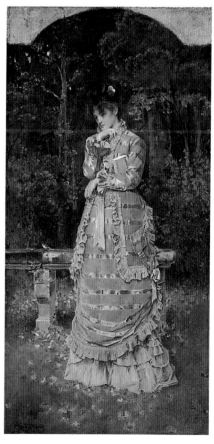

Jean-Léon Gérôme

FRENCH, 1824–1904

The Snake Charmer

c. 1870

Oil on canvas

33 × 48¹⁄₁₆ in. (83.8 × 122.1 cm)

Signed below center, left edge:
J. L GEROME.

1955.51

Robert Sterling Clark liked a broad range of art. He wrote in his diary on March 26, 1942, that he liked "all kinds of art, if it is good of its kind." While many of his contemporaries collected paintings predominantly from one group or the other, Clark purchased pictures by both nineteenth-century French academic artists and the impressionists.

This academic masterpiece was in his parents' collection while Clark was growing up; it left the family's possession sometime after his father died in 1896. When it came back on the market in 1942, Clark was pleased to be able to purchase this familiar painting. He wrote in his diary at that time: "There was the painting as fine as I remembered—academic, yes, tight, yes, but what drawing and mastery of the art."

The Snake Charmer focuses on a naked boy handling a python. An old man plays a fipple flute as part of the performance. Watching intently is a group of mercenaries differentiated by the distinctive costumes of their tribes, by ornaments, and by weapons. Gérôme's precise draftsmanship is demonstrated in all the details, from the individual expressions of the onlookers to the inscriptions from the Koran on the wall. His work was often compared to photographs. In fact he was also an accomplished photographer who took many pictures that later provided models for his paintings.

Gérôme composed this scene very carefully. The spectators are placed in the left half of the painting, their presence emphasized by the light reflected from the wall of tiles. The snake's head and its open basket mark the center, and the right half contains only the two performers against a shadowed background. The intense gaze of the onlookers and the fact that the boy is naked and embraced by the large reptile give the scene a distinctly sexual connotation.

Such an exotic and erotic scene was very popular in its day. Paintings like this placed him among the orientalists, artists who drew inspiration from non-Western subjects, especially the Islamic Near East and North Africa. Between 1854 and his death in 1904, Gérôme made at least seven trips to Egypt and Turkey. He returned with many photographs and oriental props—armor, costumes, tiles, rugs, weapons, and headdresses—that he later used in his paintings. Gérôme's version of orientalism was clearly idealized, carefully crafted, and ultimately to be interpreted through European eyes. JHB

FOR FURTHER READING

Gerald M. Ackerman, *The Life and Work of Jean-Léon Gérôme* (New York: Sotheby's Publications, 1986).

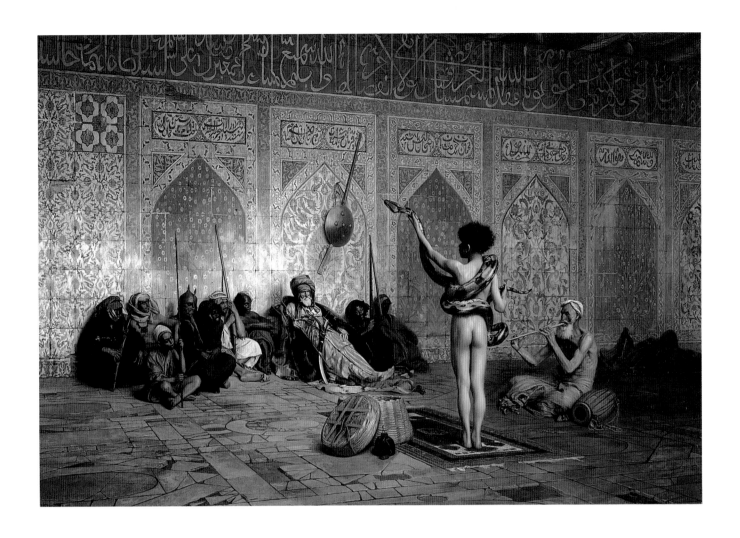

William Bouguereau

FRENCH, 1825–1905

Nymphs and Satyr

1873

Oil on canvas

102⅜ × 70⅞ in. (260 × 180 cm)

Signed and dated lower left:
W-BOUGUEREAU-1873

1955.658

ouguereau's *Nymphs*—to use its popular nickname—is a splendid example of the academic art that dominated the Paris Salon in the 1860s and 1870s. A favorite of Robert Sterling Clark, this painting was by far the largest that he bought. First exhibited at the Salon in 1873, it was promptly purchased by John Wolfe, a leading New York collector of academic pictures. In 1882 the painting was acquired by the notorious Edward Stokes, one of the owners of New York's Hoffman House Hotel, where it hung opposite the bar. The *Nymphs* became a popular landmark, much toasted by the regulars, and an inspiration for cigar-box labels, plates, urns, and even bathroom tiles. After Stokes's death in 1901, the picture was banished to storage. There it was discovered in the 1930s by Robert Sterling Clark (an admirer of the painting from its Hoffman House days). After acquiring the picture in 1943, Clark decided to launch it once again in New York society, this time to raise money for the Free French Relief Committee. The painting was shown in solitary splendor at the Durand-Ruel Galleries in New York where, as one reporter put it, "Nymphs, Satyr Rally to Fighting French."

The subject of the painting is taken from a text by the first-century Latin poet Statius, who described the frustration of Pan, a nonswimmer, when one of the nymphs he was chasing took refuge in a lake. In this picture, the well-deserved revenge of the nymphs for the satyr's continued lecherous advances seems to be an invention of the artist. *Nymphs and Satyr* was one of William Bouguereau's most successful paintings. Its composition was carefully worked out in a number of sketches in which the movements of the figures were intermeshed rather like the wheels of a great watch. DSB

FOR FURTHER READING
William Bouguereau, exhibition catalogue (Montreal: Montreal Museum of Fine Arts, 1984).

Biography of Bouguereau's Nymphs and Satyr, exhibition catalogue (Williamstown: Sterling and Francine Clark Art Institute, 1985).

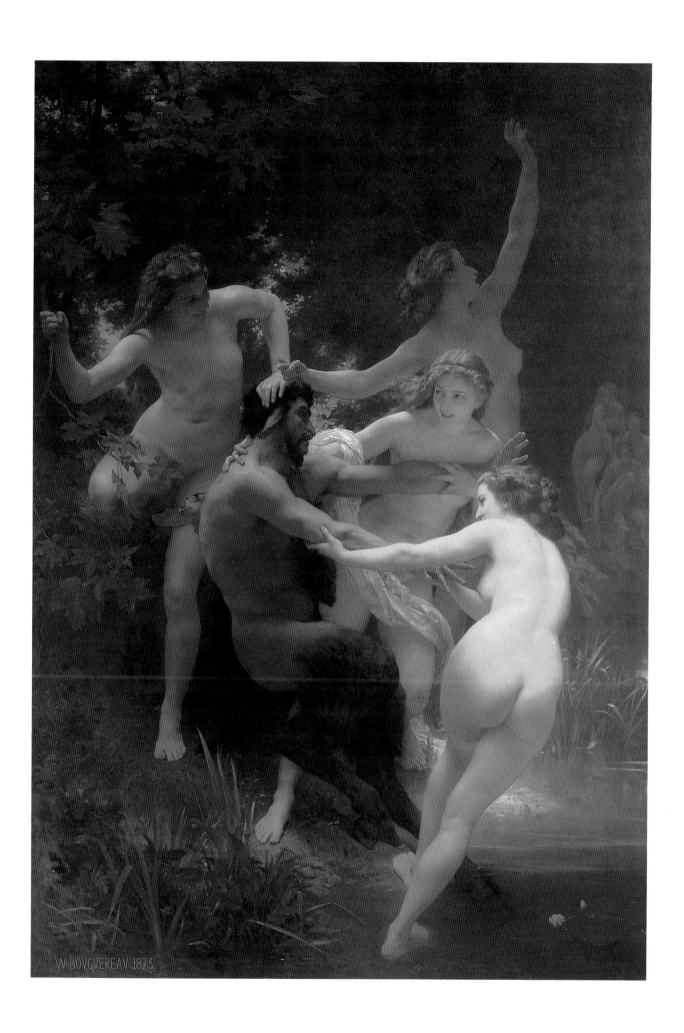

W·BOVGVEREAV·1873

Camille Pissarro

FRENCH, 1830–1903

The River Oise near Pontoise 1873

Oil on canvas

17¹³/₁₆ × 21⅝ in. (45.3 × 55 cm)

Signed and dated lower right:
C. PISSARRO. 1873

1955.554

Born on the Caribbean island of Saint Thomas, Camille Pissarro was introduced to open-air painting by the Danish artist Fritz Melbye (1826–1896) on a trip to Venezuela. After Pissarro had moved to France in 1855, this interest was furthered by his study of the work of Camille Corot (see p. 50), Charles Daubigny (1817–1878), and Gustave Courbet (1819–1877). In 1870, during the Franco-Prussian War, Pissarro's home was sacked and his early work destroyed. He fled to London, where he met another refugee French artist, Claude Monet (see pp. 86–92). Enjoying each other's company and sharing views on painting, they were soon working together and exploring the work of British artists, especially that of J. M. W. Turner (see pp. 42 and 164). They both returned home in 1871. Back in Paris, Pissarro joined ranks with Monet and the other artists who would become the impressionists, and it was with them that his interest in landscape painting matured.

During his eighteen months in England, Pissarro had assimilated Monet's ideas and vision. By 1873, when *The River Oise near Pontoise* was painted, Pissarro was already using unprimed canvas, applying the impressionist technique of broken brushwork, and avoiding black and dark earth tones. For a subject, he chose the tranquil and idyllic landscape near his home in Pontoise.

Like Monet, Pissarro had an unbiased, detached, and unsentimental approach to landscape painting. The factory of the sugar processors Chalon et Compagnie, on the south bank of the Oise across from Pontoise, is a primary element of the composition. Factories and other industrial subjects were most often associated with urban modernization, but by the 1870s they were springing up in the countryside as well. To Pissarro, they were apparently not at all sinister but simply part of the contemporary French landscape. The smokestacks of this factory stand like poplars, and the smoke does not belch forth but rather seems to drift out and merge with the clouds. The geometry of the buildings parallels the arrangement of the bushes and trees. SK

FOR FURTHER READING

Robert Herbert, *Impressionism: Art, Leisure, and Parisian Society* (New Haven: Yale University Press, 1988).

Richard A. Brettell, *Pissarro and Pontoise: The Painter in a Landscape* (New Haven: Yale University Press, 1990).

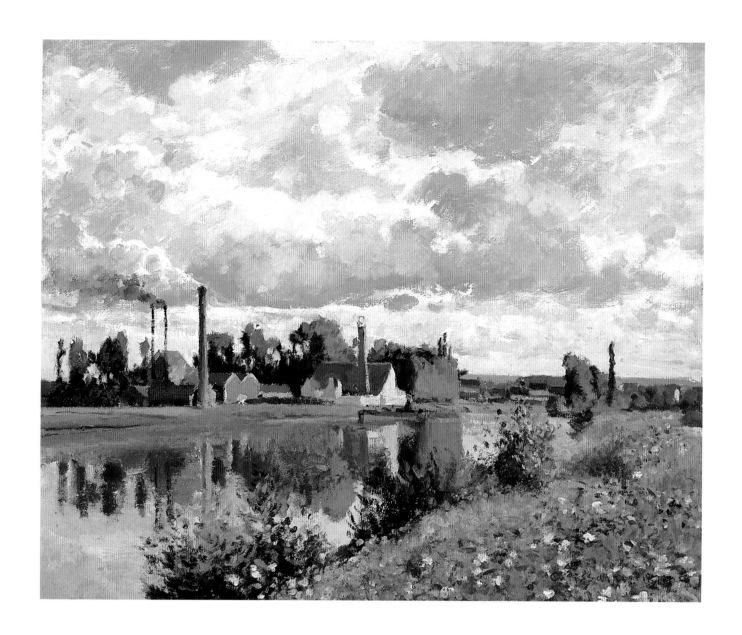

Camille Pissarro

FRENCH, 1830–1903

Port of Rouen: Unloading Wood 1898

Oil on canvas

28¾ × 36¼ in. (73 × 92.1 cm)

Signed and dated lower left: C. PISSARRO. 98

Purchased in honor of John E. Sawyer, Institute Trustee 1962–89

1989.3

P*ort of Rouen* belongs to a series of industrialized marine subjects that Camille Pissarro painted in that city in 1896 and 1898. The subjects of factories, cargo steamers, and docks are often repeated. Many of the paintings show bustling scenes of loading and unloading, observed at various times of day and under different weather conditions. Here richly applied pigment catches the movement of the clouds, river, and smoke. Pissarro seems to have been fascinated also by the angular complexities of the composition and the varieties of shapes within it. Particularly effective are the dominance of the steamer in the foreground and the way its mast and funnel lock together the four horizontal bands of dock, river, factories, and sky. In a letter to his son Lucien, written March 7, 1896, Camille Pissarro compared Rouen to Venice and declared, "I wanted to paint the animation of that beehive: Rouen and its quays."

Pissarro was one of Robert Sterling Clark's favorite artists, and between 1933 and 1950 Clark bought seven of his paintings. Five date from the 1870s. Thus, when the *Port of Rouen: Unloading Wood* entered the collection in 1989, it joined a significant body of work. It makes a particularly interesting comparison in subject matter and style with the more rural *River Oise near Pontoise* (see p. 62) with its factories, which Pissarro painted twenty-five years earlier. DSB

FOR FURTHER READING

Robert Herbert, *Impressionism: Art, Leisure, and Parisian Society* (New Haven: Yale University Press, 1988).

Richard A. Brettell, *Pissarro and Pontoise: The Painter in a Landscape* (New Haven: Yale University Press, 1990).

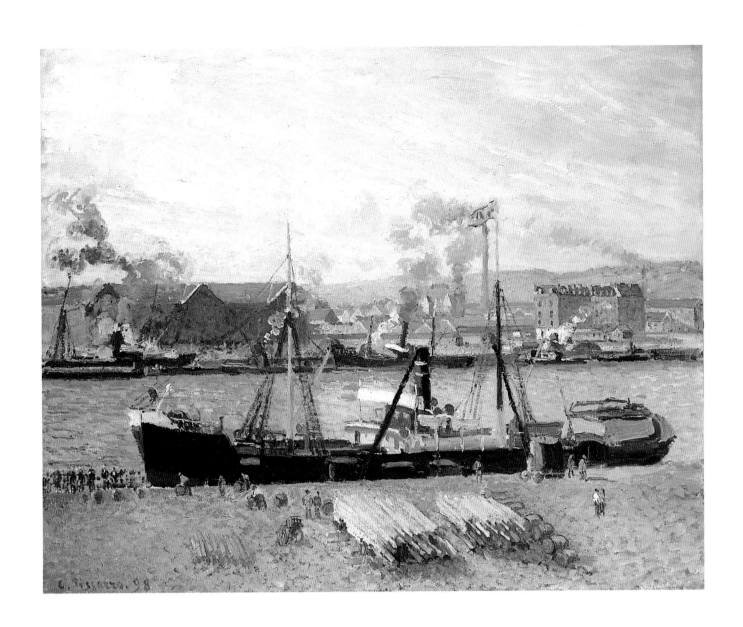

Edouard Manet

FRENCH, 1832–1883

Manet's Family at Home in Arcachon 1871

Oil on canvas

15½ × 21⅛ in. (39.4 × 53.7 cm)

Signed lower right: MANET

1955.552

Edouard Manet was one of the artists who, in the late 1860s and early 1870s, influenced and encouraged the circle of young painters who were to become the impressionists. Older than Claude Monet (see pp. 86–92), Alfred Sisley (1839–1899), and Pierre-Auguste Renoir (see pp. 96–104), Manet was already established as a prominent painter of modern life in Paris when these younger men began exploring the elements they would synthesize into a new way of painting.

During the 1870 siege of Paris in the Franco-Prussian War, Manet sent his family to safety in Orolon-Sainte-Marie in the Pyrenees while he enlisted in the National Guard to defend the capital. At the conclusion of the war, Manet joined his family, but unrest in Paris during the Commune kept them from returning home. They went from Orolon to Bordeaux and then rented a villa in Arcachon, overlooking the Bay of Biscay. This canvas, painted in the drawing room of that temporary home, shows Manet's wife and her son, Léon Leenhoff, in a moment of reverie.

Intimate to the point of being downright casual, this type of painting certainly had an impact on the impressionists. Mme Manet has momentarily stopped her activity—apparently writing—and stares out at the sea. Leenhoff, a book on his knee, seems hardly to notice even the cigarette he smokes. While the painting can be interpreted as an instance of ennui or perhaps a longing to return home after many months of displacement, it should also be viewed as an opportunity for Manet to capture an evanescent moment. SK

FOR FURTHER READING

Manet, 1832–1883, exhibition catalogue (New York: The Metropolitan Museum of Art, 1983).

Splendid Legacy: The Havemeyer Collection, exhibition catalogue (New York: The Metropolitan Museum of Art, 1993).

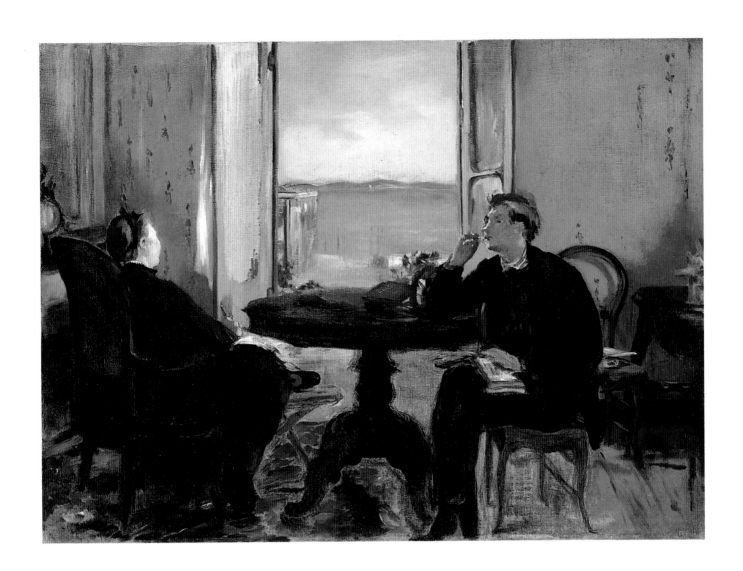

Hilaire Germain Edgar Degas

FRENCH, 1834–1917

Self-Portrait c. 1857

Oil on paper mounted on canvas
10¼ × 7½ in. (26 × 19 cm)
Unsigned
1955.544

Edgar Degas was the eldest of five children of a prosperous Parisian banker and his American-born wife. According to his father's wishes, Degas set out to become a lawyer but abandoned his legal studies in 1855 to pursue training as an artist. In 1856 he traveled to Italy, where he devoted the next three years to studying Old Master paintings and perfecting his etching technique.

This small but impressive self-portrait—one of Degas's earliest known works—was done in Italy when he was about twenty-three years old. Throughout the 1850s and 1860s, Degas painted several self-portraits and then abruptly stopped. Thirty years later, he returned to this subject and, using photography, produced another series of penetrating and sensitive self-portraits.

Degas presents himself here as an introspective young man. The eyes that peer from beneath his hat brim are heavy-lidded and somewhat melancholy. Shadow lightly veils his face like a protective device. The careful painting of the face contrasts with the sketchy handling of the clothes—a painter's costume rather than the garb of a gentleman. A monochromatic palette, broken only by the splash of salmon color of the cravat, reinforces the sober mood of the picture. Furthermore, the portrait confronts the viewer at close range within a tightly cropped format. This is a perceptive work—its subject withdrawn and aloof, the treatment challenging and bold.

The dark palette, somber visage, and confrontational pose resemble works by Rembrandt van Rijn (see p. 158), whom Degas particularly admired. The painting is also similar to the well-known portraits by Jan Vermeer (1632–1675) in the oblique angle of the sitter's glance, the aloof expression, the soft planes of the face, and the clarity of line and detail. Like Vermeer, Degas sought to achieve extreme realism.

Even at this early point in his career, the elements of Degas's mature style are apparent. Throughout his life, his portraits remained somber in tone, carefully focused, and psychologically probing. JGL

FOR FURTHER READING

Denys Sutton, *Edgar Degas, Life and Work* (New York: Rizzoli International Publications, 1986).

Degas in the Clark Collection, exhibition catalogue (Williamstown: Sterling and Francine Clark Art Institute, 1987).

Degas, exhibition catalogue (New York: The Metropolitan Museum of Art, 1988).

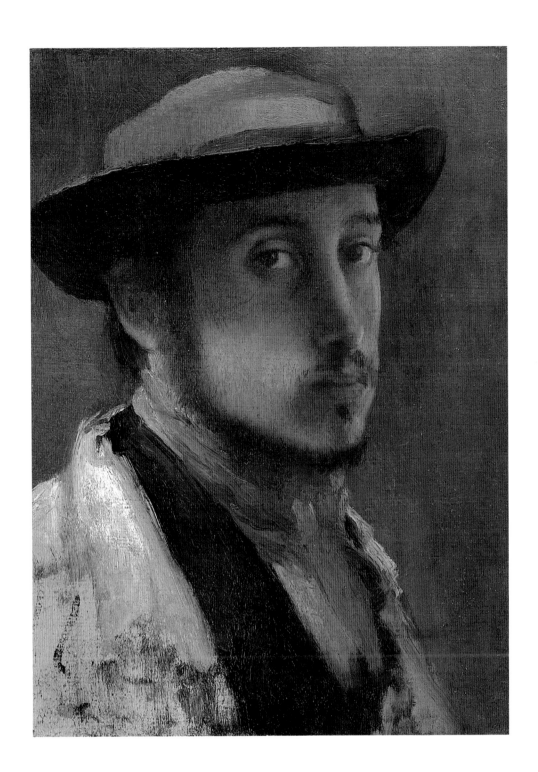

Hilaire Germain Edgar Degas

FRENCH, 1834–1917

The Dancing Lesson

c. 1880

Oil on canvas

15½ × 34¹³⁄₁₆ in. (39.4 × 88.4 cm)

Signed upper right: DEGAS

1955.562

Although Edgar Degas associated with the impressionists, he did not consider himself to be one of them. Through his distinctly modern subjects, he challenged traditional rules about composition, color, and ideals of human beauty. He did not, however, attempt—as the impressionists did—to capture spontaneous naturalism in his pictures. He remained essentially a classical artist, using line as his primary tool and depending on his superb draftsmanship to create sculpturesque forms.

Degas was a frequent visitor to the Paris Opéra. In the 1870s he began observing the corps de ballet backstage, where he made hundreds of sketches of dancers tying their shoes, resting or waiting in the wings to perform, practicing in the rehearsal halls, and arranging their costumes and hair. Later, in his studio, he reworked these images repeatedly and combined elements from drawings done at different times to create his vital glimpses of the world of dance. At least half of his mature work was devoted to it—about 1,500 paintings, prints, pastels, and drawings.

The Dancing Lesson is probably the earliest of several paintings that reflect Degas's interest in the formal relationships of figures to each other and to the space they inhabit. All show the kind of space that Degas liked to create in his ballet paintings: an elongated room in which he placed several dancers and, occasionally, musical instruments. In *The Dancing Lesson,* the diagonal composition, the large proportion of empty space, and the asymmetrical concentration of the largest figures in the lower right corner suggest the influence of Japanese prints, especially those of Katsushika Hokusai (1760–1849). The dramatic reduction in size of the farthest dancers conveys the huge size of the rehearsal hall. This effect is enhanced by the sophisticated use of light—the foreground in shadow and daylight silhouetting one of the distant figures and picking out details of the others, such as the lemon-colored sash of the central dancer. JGL

FOR FURTHER READING

Denys Sutton, *Edgar Degas, Life and Work* (New York: Rizzoli International Publications, 1986).

Degas in the Clark Collection, exhibition catalogue (Williamstown: Sterling and Francine Clark Art Institute, 1987).

Degas, exhibition catalogue (New York: The Metropolitan Museum of Art, 1988).

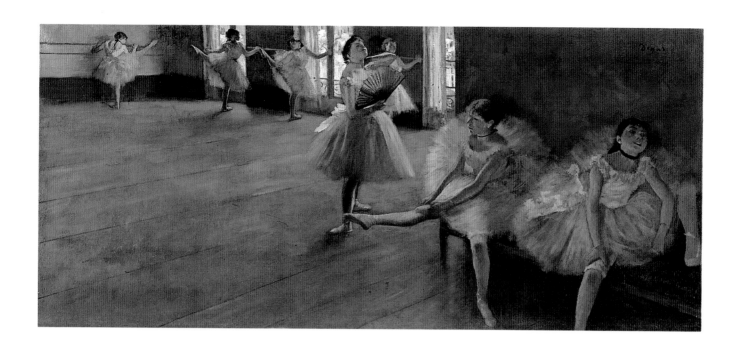

Hilaire Germain Edgar Degas

FRENCH, 1834–1917

The Entrance of the Masked Dancers c. 1884

Pastel on paper

19⁵⁄₁₆ × 25½ in. (49 × 64.7 cm)

Signed lower left: DEGAS

1955.559

Edgar Degas rarely portrayed recognizable theatrical productions. Most of his ballet scenes were composed of diverse elements extracted and combined from a multitude of unrelated sketches made in the rehearsal rooms and stages of the Paris Opéra. Nevertheless, the subject of *The Entrance of the Masked Dancers* is believed to be from Mozart's opera *Don Giovanni*.

Degas was an innovative artist whose choice of pastel was particularly appropriate for his many pictures of ballet dancers. The medium allowed him to create impressive juxtapositions of solid figures and more ethereal forms—bold contours in sharply focused foregrounds against softer backgrounds. In this picture the ambiguous perspective draws the viewer into the scene. The transition from the viewer's space into the picture plane is unclear: the two girls in the foreground seem about to emerge from the drawing. Standing in the wings with their backs to the masked dancers, they appear withdrawn and self-absorbed, psychologically isolated from the viewer and from each other.

Barely noticeable across the stage is an *abonné,* one of the subscribers to the Paris Opéra, who had freedom of access backstage. These stiff observers in stylish black evening attire appear in many of Degas's ballet pictures. Passive, watchful, somewhat sinister, and powerful, they are skillfully contrasted with the mobile young dancers and their colorful costumes.

Although Degas seems sympathetic toward the young women of the ballet, he and the viewers of this painting are like *abonnés.* This point of view is parallel to that of the man on the opposite side of the stage, who watches from behind a flat and receives a private and perhaps invasive view of the dancers' world. Degas is interested primarily in composition and does not make overt moral judgment. Nevertheless, his expert juxtapositions of form and color reinforce allusions to the complex and often unsavory social issues that surrounded the world of the theater. JGL

FOR FURTHER READING

Degas: The Dancers, exhibition catalogue (Washington, D.C.: National Gallery of Art, 1984).

Degas in the Clark Collection, exhibition catalogue (Williamstown: Sterling and Francine Clark Art Institute, 1987).

Jean Sutherland Boggs and Anne Maheux, *Degas Pastels* (New York: George Braziller, 1992).

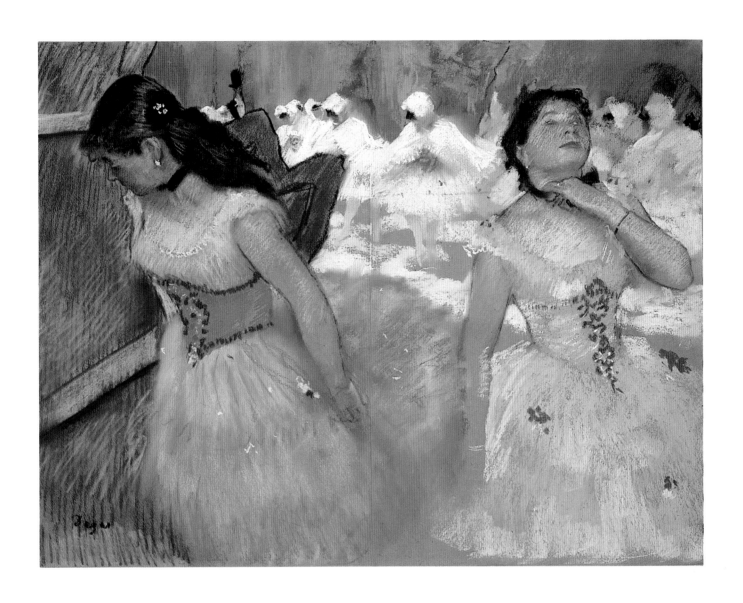

Hilaire Germain Edgar Degas

FRENCH, 1834–1917

Little Dancer of Fourteen Years

Modeled 1880–81; cast 1919–21

Bronze
Height: 39 in. (99.1 cm)

Incised on wooden base: DEGAS; and on metal shield in base, founder's mark: CIRE PERDUE [lost wax], A. A. HEBRARD-D

1955.45

The *Little Dancer of Fourteen Years* was the only sculpture that Edgar Degas exhibited to the public in his lifetime. The model, Marie van Goethem, was a Belgian student at the Children's Ballet School of the Paris Opéra who turned fourteen in 1878. She was known for her thick black hair, worn not in the traditional dancer's topknot but tied with a ribbon and hanging down her back.

The original figure was modeled in wax and placed on a polished wood pedestal designed to look like a dance floor. Standing in fourth position, she wore a white gauze skirt, satin slippers, a linen bodice, and a satin hair ribbon. The slippers and bodice were covered with a thin layer of wax. The long black hair was real—obtained from a Parisian puppet-maker—and the skin was tinted to look like flesh.

Degas promised the *Little Dancer of Fourteen Years* to the fifth impressionist exhibition, in 1880, but the statue was not finished in time and the show opened with only the empty glass case in place. This aroused the curiosity of the public and critics alike. Reaction was mixed when the *Little Dancer* was finally shown the following year. The public found it unsettling, perhaps too truthful. Many people avoided it altogether. Both critics and artists recognized its importance, but their praise was guarded, and Degas's aesthetics and subject matter were widely condemned. Degas did nothing more in this vein. The *Little Dancer* remained unique. It ultimately came to be regarded as the first piece of modern sculpture.

What made the statue modern was Degas's abrupt break with most of the traditional rules of figural sculpture. The unheroic subject matter—an awkward adolescent—the precise description of gesture, expression, contemporary costume, and posture, together with the technical novelty of the materials and methods, were radical departures. Degas did not idealize his dancer as an elegant creature in effortless movement but revealed instead the emotional and physical stress of maintaining a difficult pose.

Four years after Degas's death in 1917, the *Little Dancer* and over seventy of his other sculptures were cast in bronze. It is not known exactly how many bronzes were made, but, because the other figures were issued in sets of twenty-two, it seems likely that a similar number of *Little Dancers* were cast. Of all the pieces, the *Little Dancer* was the one most adversely affected by the translation from wax to bronze. The translucent quality of the surface was lost, as was the individual texture of the hair, slippers, and bodice, which became consistent with the rest of the figure. JGL

FOR FURTHER READING

Charles W. Millard, *The Sculpture of Edgar Degas* (Princeton: Princeton University Press, 1976).

Degas in the Clark Collection, exhibition catalogue (Williamstown: Sterling and Francine Clark Art Institute, 1987).

Degas, exhibition catalogue (New York: The Metropolitan Museum of Art, 1988).

John Rewald, *Degas's Complete Sculpture* (San Francisco: Alan Wofsy Fine Arts, 1990).

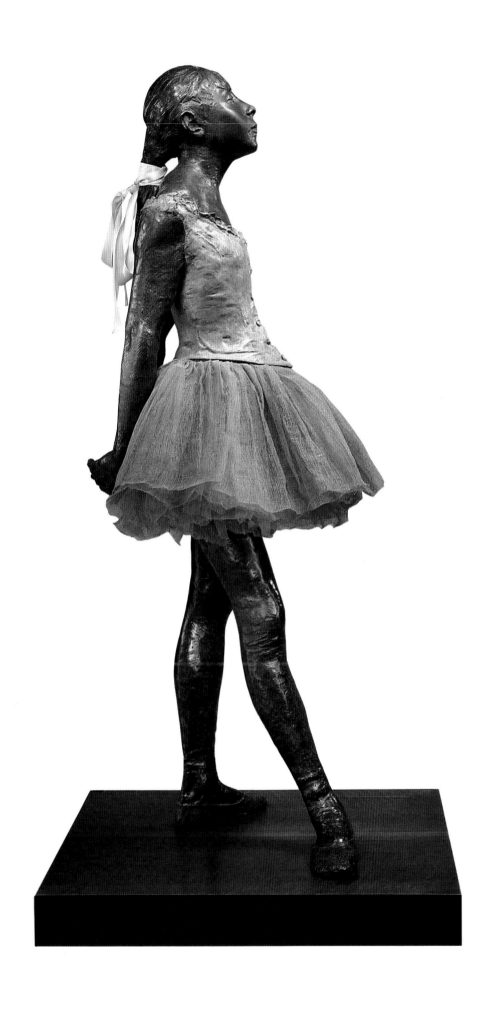

Lawrence Alma-Tadema

BRITISH, 1836–1912

The Women of Amphissa 1887

Oil on canvas

48 × 72 in. (121.9 × 182.9 cm)

Signed and inscribed lower right, in tambourine: L ALMA-TADEMA OP. CCLXXVIII

1978.12

Born in the Netherlands, Sir Lawrence Alma-Tadema became a British citizen in 1873 and was knighted by Queen Victoria in 1899. A remarkably skilled draftsman and colorist, he won favor for his highly detailed depictions of ancient Greek and Roman daily life. Alma-Tadema peopled these domestic scenes with typical English men and women, who seemed to him to be the modern heirs of the classical tradition. His portrayal of this link between his contemporaries and the ancients, whom they admired, made Alma-Tadema one of the most popular artists of the late Victorian era in Britain.

The relatively obscure story of the Women of Phocis, which inspired this painting, was recorded by the first-century Greek writer Plutarch in his *Moralia*. The painting shows a group of bacchantes from Phocis awakening after a night of celebrating the rites of Bacchus, the god of wine. These women are identified by their cloaks of leopard skin, the ivy wreaths in their hair, and several tambourines—all attributes of Bacchus. They find themselves in the marketplace of Amphissa, a city at war with Phocis. Fearing that soldiers might harm the bacchantes, the women of Amphissa have been standing guard while they slept and are offering food and wine before escorting them safely out of town.

Some critics considered the painting to have powerful emotional appeal. Others thought drama and sentiment were lacking. While the poses and facial expressions of the figures do not convey great emotion, the notion of charity is made apparent by the grateful look in the eyes of the two bacchantes at the left.

The composition includes over thirty women, but Alma-Tadema, who frequently used family and friends as models, has called attention to one: placed in the center and surrounded by figures in contrasting light-colored garments, the fair-haired woman dressed in brown is probably his wife, Laura.

The elaborate architectural setting is imaginary. Although many of the details are copied from antique examples, the artist has juxtaposed them in a manner that is not archaeologically accurate. Throughout his career, he was willing to subordinate historical accuracy to design.

Alma-Tadema received countless awards during his lifetime. One of the most significant was the Gold Medal of Honor given to *The Women of Amphissa* at the Universal Exposition in Paris in 1889. PRI

FOR FURTHER READING

Empires Restored, Elysium Revisited: The Art of Sir Lawrence Alma-Tadema, exhibition catalogue (Williamstown: Sterling and Francine Clark Art Institute, 1991).

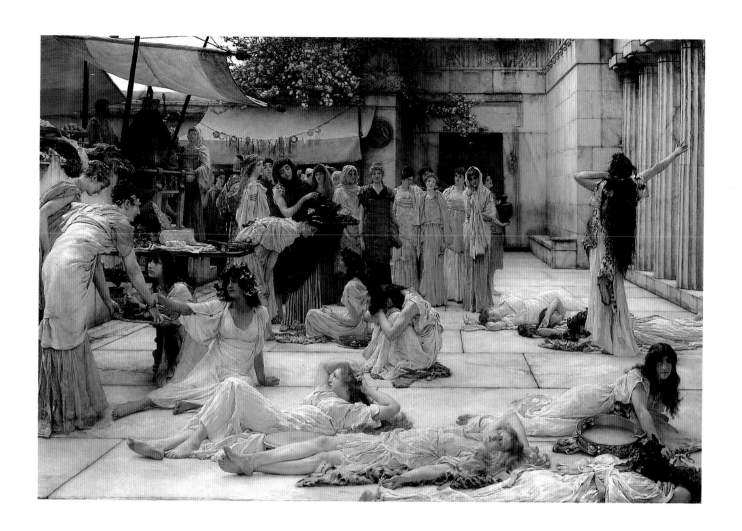

Winslow Homer

AMERICAN, 1836–1910

Two Guides c. 1875

Oil on canvas

24¼ × 38¼ in. (61.6 × 97.2 cm)

Signed and dated lower left: WINSLOW HOMER/187[?]

1955.3

It was most likely during Winslow Homer's 1874 autumn visit to the Adirondacks that he developed the idea for this painting of two recognizable mountain guides from Keene Valley, New York, posing in front of Beaver Mountain. Orson "Old Mountain" Phelps, the shorter figure wearing a typical Adirondack pack-basket, was a guide, philosopher, and local celebrity. "His tawny hair was long and tangled, matted now many years past the possibility of being entered by a comb," wrote Charles Dudley Warner in the *Atlantic Monthly* in 1878. "His clothes seem to have been put on him once and for all, like the bark of a tree, a long time ago." Phelps is pointing out something in the distance to the younger man, Charles Monroe Holt. In the 1890s several critics suggested that this painting could be interpreted as an older, wiser man passing on his knowledge to the next generation.

The guides carry axes and stand before freshly cut trees. Accentuated by warm light from the right, the two men serve as vertical elements to anchor the composition. Colorful wildflowers and ferns across the front of the painting add a lively staccato beat. Chocolate-gray mists float over the valley in lines that echo the general profile of Beaver Mountain and the clouds above.

This picture received little notice when it was shown at the National Academy of Design's annual exhibition in New York in 1878. By the 1890s tastes had changed, and Homer enjoyed more popularity. In that decade, *Two Guides* was exhibited no fewer than six times and received many favorable critical comments. The painting covers themes that Homer considered throughout his life: man and nature, the environment, the outdoors, and the suggestion of a story in process or an event unresolved. JHB

FOR FURTHER READING

Lloyd Goodrich, *Winslow Homer* (New York: Macmillan and Company, 1944).

Winslow Homer in the Clark Collection, exhibition catalogue (Williamstown: Sterling and Francine Clark Art Institute, 1986).

Margaret C. Conrads, *American Paintings and Sculpture at the Sterling and Francine Clark Art Institute* (New York: Hudson Hills Press, 1990).

Nicolai Cikovsky, Jr., *Winslow Homer* (New York: Harry N. Abrams, 1990).

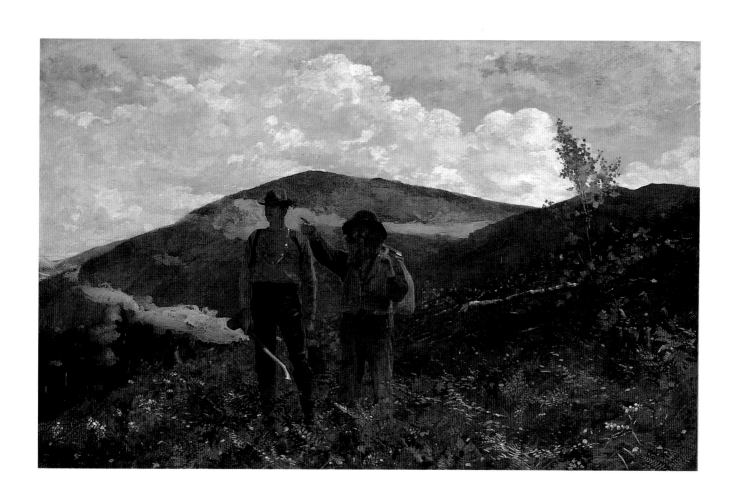

Winslow Homer

AMERICAN, 1836–1910

Undertow 1886

Oil on canvas

29¹³/₁₆ × 47⅝ in. (75.7 × 121 cm)

Signed and dated lower right: WINSLOW HOMER/1886

1955.4

By 1883 Winslow Homer had become a year-round resident of Prout's Neck, Maine, where for the next three decades he produced many of the greatest masterpieces of his career. In the mid-1880s the struggle of humankind against the awesome power of the sea dominated Homer's work, including *Undertow,* the last major oil painting of that decade.

The scene was described in the catalogue of the 1911 Homer memorial exhibition at the Metropolitan Museum of Art in New York: "Two exhausted women, clinging to each other, are being drawn toward shore by two men. The man at right . . . lifts one of the women by her blue bathing suit; at the left a man . . . is struggling against the current, his right hand raised to shield his eyes from the glare and the left one dragging a rope, which is fastened around the waist of a woman whose face is upturned." The highly dramatic composition came from Homer's imagination, the result of many studies; but the subject was based on a specific incident, a rescue that Homer witnessed in Atlantic City, New Jersey. Women were not routinely taught to swim until the turn of the century, and the tragedy of near or actual drowning was all too common.

Undertow can be seen as the culmination of Homer's attention to the human figure, for his subsequent oil paintings turned increasingly to pure landscape (see p. 82). The figures in this painting are monumental and sculptural. They are related in spirit to the Hellenistic Greek sculpture that he would have seen at the British Museum during his visit to England in 1881 and 1882. Homer supposedly studied the effects of wet drapery by drenching his clothed models in order to render the anatomical forms accurately. Reviewing a show at the National Academy of Design in New York, the *Critic,* April 9, 1887, praised *Undertow* and commented that Homer's "thorough understanding of the human figure and his brilliant draughtsmanship were never better shown than in this powerful group." SK

FOR FURTHER READING

Lloyd Goodrich, *Winslow Homer* (New York: Macmillan and Company, 1944).

Winslow Homer in the Clark Collection, exhibition catalogue (Williamstown: Sterling and Francine Clark Art Institute, 1986).

Margaret C. Conrads, *American Paintings and Sculpture at the Sterling and Francine Clark Art Institute* (New York: Hudson Hills Press, 1990).

Nicolai Cikovsky, Jr., *Winslow Homer* (New York: Harry N. Abrams, 1990).

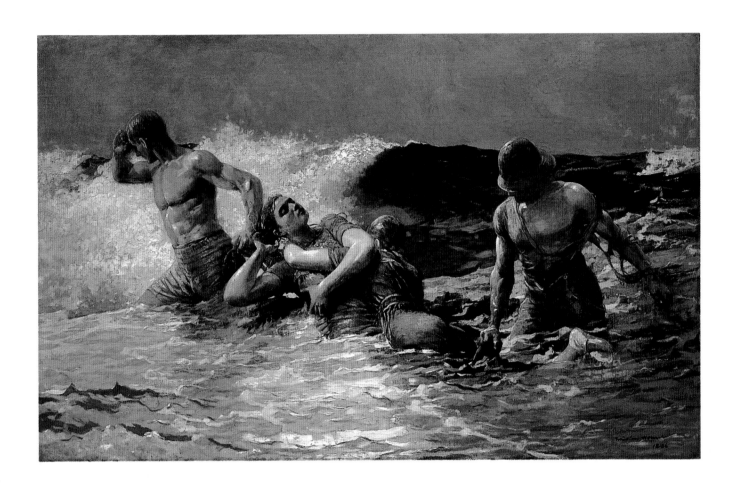

Winslow Homer

AMERICAN, 1836–1910

Eastern Point 1900

Oil on canvas

30¼ × 48½ in. (76.8 × 123.2 cm)

Signed and dated lower right: WINSLOW
HOMER/OCT. 14 1900

1955.6

By 1895 Winslow Homer had spent more than ten years at Prout's Neck, outside of Portland, Maine, where the simplicity of his lifestyle and celebration of his surroundings produced many of the greatest works of his career. It was in this joyful spirit that Homer painted *Eastern Point* and *West Point, Prout's Neck.* On January 4, 1901, he wrote to the collector Thomas B. Clarke that both paintings were "the best that I have painted" and that same year, to Knoedler's, his dealer, that *Eastern Point* was "too good not to be sold."

When Homer executed these two seascapes in 1900, he had been living with the sea for nearly twenty years, studying and painting it in all of its moods. As a result, he was able to grasp his subject and paint it boldly. The leaden sky contrasts with the surge of the waves and the energy of the spray. In the foreground, Homer built up layers of paint to describe both visually and physically the varied surfaces of the rocks.

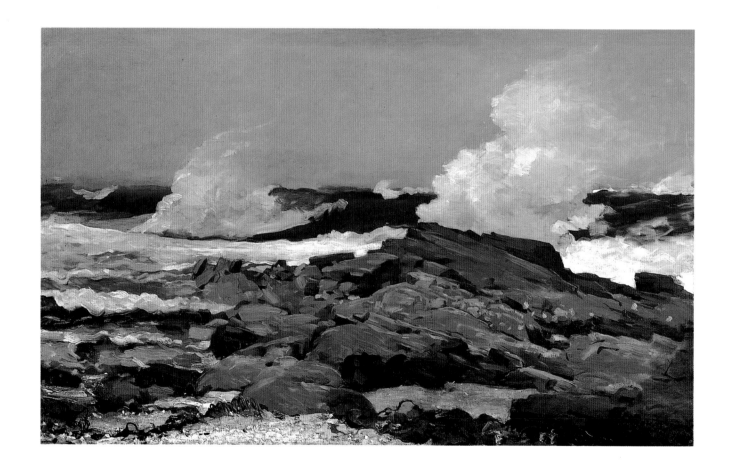

West Point, Prout's Neck 1900

Oil on canvas

30¹/₁₆ × 48¹/₈ in. (76.4 × 122.2 cm)

Signed and dated lower right: HOMER 1900

1955.7

West Point, Prout's Neck makes an appropriate companion to *Eastern Point.* In addition to boulders and plumes of spray, this canvas shows a brilliant sunset—Homer's last. The painting is not a statement of spontaneity and bravura, however, but rather the conclusion of careful observation. As Homer wrote to Knoedler's on April 16, 1901, it was "painted fifteen minutes after sunset, not one minute before, as up to that minute the clouds over the sun would have their edges lighted with a brilliant glow of color, but now the sun has got beyond their immediate range and they are in shadow. You can see that it took many careful hours of observation to get this, with a high sea and the tide just right." SK

FOR FURTHER READING

Lloyd Goodrich, *Winslow Homer* (New York: Macmillan and Company, 1944).

Winslow Homer in the Clark Collection, exhibition catalogue (Williamstown: Sterling and Francine Clark Art Institute, 1986).

Margaret C. Conrads, *American Paintings and Sculpture at the Sterling and Francine Clark Art Institute* (New York: Hudson Hills Press, 1990).

Winslow Homer in the 1890s: Prout's Neck Observed, exhibition catalogue (New York: Hudson Hills Press, 1990).

Nicolai Cikovsky, Jr., *Winslow Homer* (New York: Harry N. Abrams, 1990).

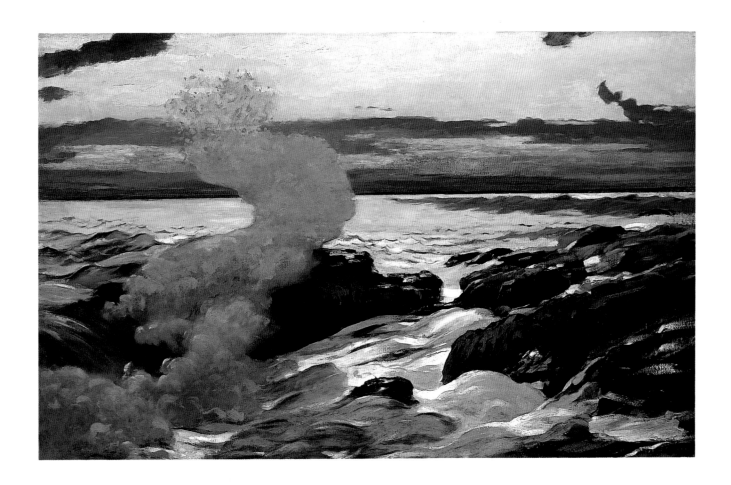

James Jacques Joseph Tissot

FRENCH, 1836–1902

Chrysanthemums

c. 1874–75

Oil on canvas

46⅝ × 30¹⁄₁₆ in. (118.4 × 76.4 cm)

Signed bottom, left of center: J.J.TISSOT

Purchased in honor of David S. Brooke, Institute Director 1977–94

1994.2

By the time James Tissot arrived in London from Paris in 1871—immediately following the fall of the Commune—he was already a successful and much-sought-after painter in the French capital. A bit of a hybrid, Tissot was academically trained but active in avant-garde circles as well. He was a strong presence in the arts establishment of Paris, his work having been accepted for the Salon of 1859 and having been purchased by the French government as early as 1861. In contrast, he was one of the first painters to appreciate and collect Japanese art and to incorporate lessons learned from it into his work.

In London, Tissot seems to have been a bit of a novelty, and success came to him rather quickly. *Chrysanthemums,* for example, appears to have been purchased off his easel. When his work was included in the 1877 Grosvenor Gallery exhibition, a show to which Tissot sent his finest works available at the time, this painting was lent by a private collector rather than by the artist himself.

This is one of the most beautiful and haunting of Tissot's early London works. The subject—an unidentified woman who modeled for Tissot before he fell under the spell of Kathleen Newton, his mistress and favorite model—is interrupted in the conservatory. Her concentration is seemingly broken by the intrusion of the viewer. The painting has no overt narrative; Tissot seems preoccupied with psychology, and the mood is brooding and introspective, with a hint of melancholy. The chrysanthemums, harbinger of autumn as well as popular cemetery flowers, along with the black ribbon on the woman's hat, lend a feeling of mourning which has, in fact, been suggested as the meaning of this painting.

Chrysanthemums is a beautiful example of the multi-faceted influences on Tissot's work. While the painting bears many of the hallmarks of Tissot's academic training—the strong reliance on draftsmanship and an attempt to create the illusion of plausible space, for example—the incorporation of elements derived from Japanese art and photography is much in evidence. The elegant woman in beautiful surroundings and a dynamically cropped composition show Tissot's debt to the Japanese color woodblock prints he collected. The painting has the immediacy and informality of a snapshot, and many of the passages seem to be studies in depth of field, particularly the flowers behind the woman and her face, which seems almost blurred as she is caught in the action of looking up. Tissot's work was so dominated by new influences and elements, in fact, that, when the independent artists in Paris—those who were to become known as the impressionists—organized their first exhibition, they invited Tissot to participate, an invitation he declined. SK

FOR FURTHER READING
James Jacques Joseph Tissot, 1836–1902: A Retrospective Exhibition, exhibition catalogue (Providence, R.I.: Rhode Island School of Design, Museum of Art, 1968).

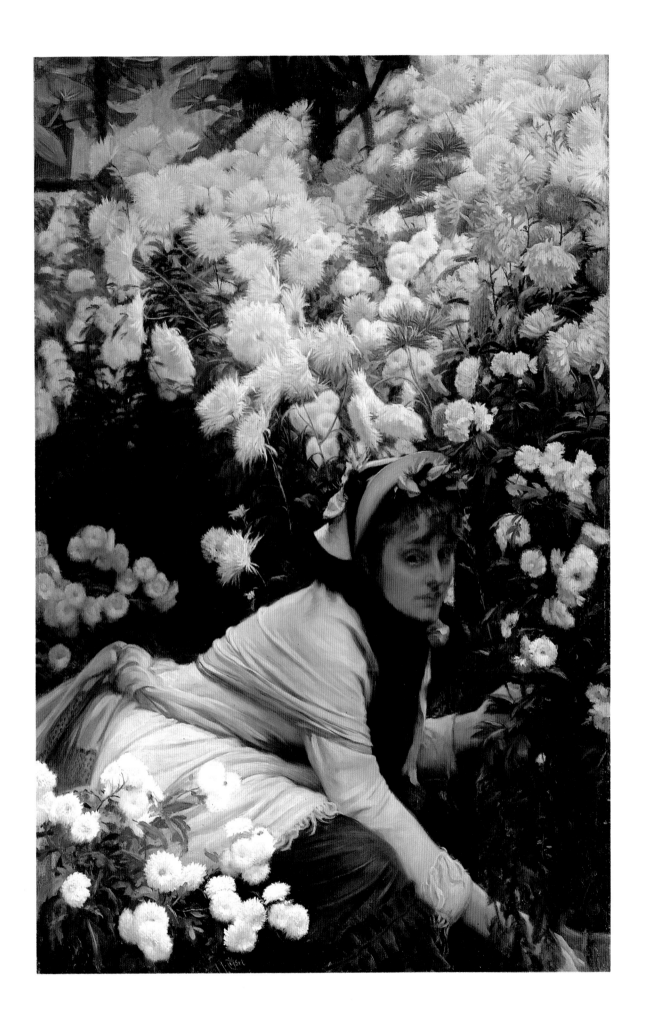

Claude Monet

FRENCH, 1840–1926

Seascape: Storm 1866

Oil on canvas

19³/₁₆ × 25½ in. (48.7 × 64.7 cm)

Signed lower right: CLAUDE MONET

1955.561

I n 1874 when Claude Monet exhibited a painting called *Impression: Sunrise*, it and the paintings of the other avant-garde artists in the show were derided by a journalist who coined the term *impressionism*. Thus, a new way of painting was made public. It was not new for the artists, however. Monet's style, for example, had developed after almost a decade of exploration and experimentation, and he was greatly influenced by the generation of painters immediately preceding him.

Born in Paris and reared in Normandy in the port city of Le Havre, Monet had begun painting by the age of fourteen. His first master was Eugène Boudin (1824–1898), an artist and art-supplies dealer who also displayed contemporary paintings, drawings, and watercolors in his shop. Boudin and Monet would spend hours painting outdoors, usually on the coast. This developed in Monet a love for the landscape and a keen sense of atmosphere and light.

After serving in the military, Monet went to Paris and, at his parents' suggestion, sought formal art training. He entered the studio of Charles Gleyre (1806–1874) where, although he learned little, he made the acquaintance of Pierre-Auguste Renoir (see pp. 96–104), Alfred Sisley (1839–1899), and Frédéric Bazille (1841–1870); it was only 1862, and the core of the impressionist group was being formed.

During the mid-1860s, Monet focused largely on seascapes. In *Seascape: Storm*, painted in 1866, many of the characteristics of impressionism are present. Based on the artist's own observation of a coming storm, the painting relies on color and brushwork to describe the light and atmosphere. The paint, not yet in the vibrant dabs of full-blown impressionism, is applied broadly and freely to capture the raking light and the rising wind.

SK

FOR FURTHER READING

Charles Stuckey, ed., *Monet: A Retrospective* (New York: Hugh Lauter Levin, 1985).

Robert Herbert, *Impressionism: Art, Leisure, and Parisian Society* (New Haven: Yale University Press, 1988).

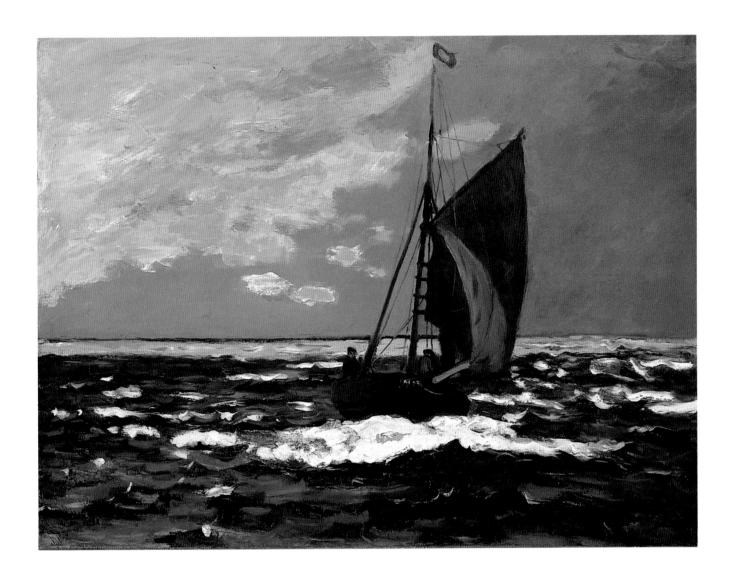

Claude Monet

FRENCH, 1840–1926

The Duck Pond 1874

Oil on canvas

28⅞ × 23¹¹⁄₁₆ in. (73.3 × 60.2 cm)

Signed and dated lower left: CLAUDE MONET 74

1955.529

The 1870s were a time of struggle for Claude Monet, who waged a war for acceptance with critics, collectors, the public, and other artists. Understandably, such academics as Jean-Léon Gérôme and William Bouguereau (see pp. 58 and 60, respectively) felt threatened by him, but it was ironic that Edouard Manet (see p. 66) should be hostile, as he later assimilated many of Monet's ideas. In the early 1870s all the elements that characterize impressionism came together and can be seen in a painting such as this.

The Duck Pond is a dazzling vision of a sunny autumn day. Painting outdoors, Monet apparently selected as a subject an intimate corner of his own property in Argenteuil, on the Seine outside Paris. The work is not sentimental in any respect, however, and even the figures, probably the artist's wife and son, are as detached from the painter as the ducks swimming in the foreground.

The painting is all about light and atmosphere: the clarity of the deep blue sky contrasting with the brilliance of the sunshine on the yellow and orange leaves, which are reflected in the rippling pond. Monet recorded his observations through color: bright touches of pure color, placed side by side with no attempt to mix or blend them, are as vibrant as the leaves themselves. The water—the perfect vehicle for the impressionist painter—reflects its surroundings, moves with the effect of rippling light, and as a result dissolves contours and softens transitions. SK

FOR FURTHER READING

Paul Hayes Tucker, *Monet and Argenteuil* (New Haven: Yale University Press, 1982).

Charles Stuckey, ed., *Monet: A Retrospective* (New York: Hugh Lauter Levin, 1985).

Robert Herbert, *Impressionism: Art, Leisure, and Parisian Society* (New Haven: Yale University Press, 1988).

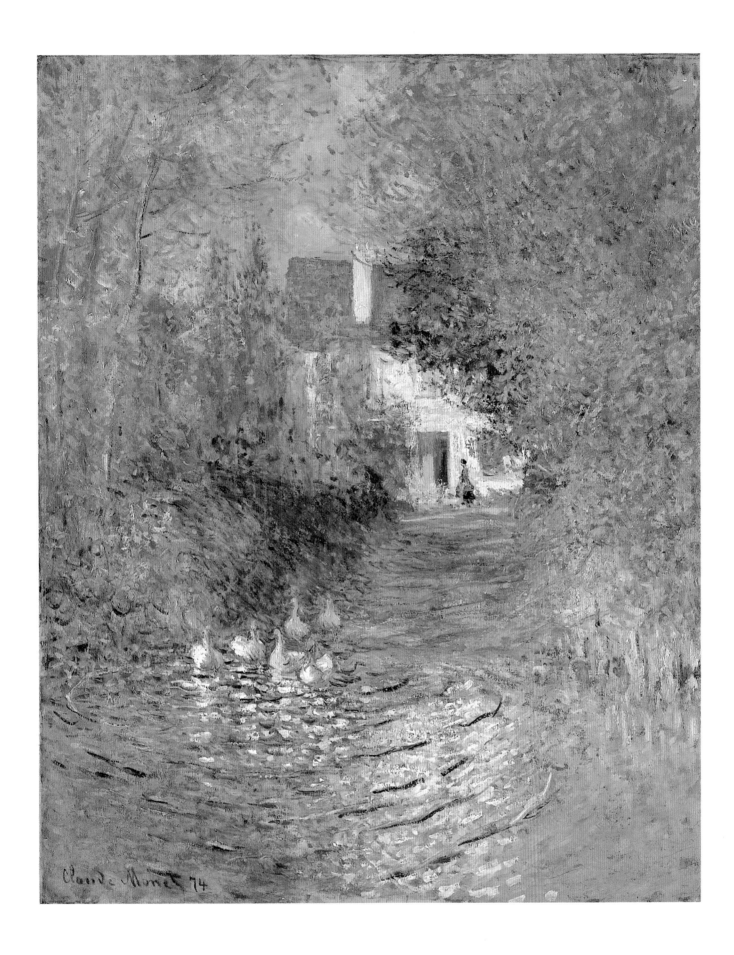

Claude Monet

FRENCH, 1840–1926

The Cliffs at Etretat

1885

Oil on canvas

25⁹⁄₁₆ × 31¹⁵⁄₁₆ in. (64.9 × 81.1 cm)

Signed and dated lower right: CLAUDE MONET 85

1955.528

B y the 1880s Claude Monet had begun to enjoy a certain level of acceptance and success. Previously, his subjects had been predominantly in the greater Paris area—the city itself, Vétheuil, and Argenteuil. By 1882, however, he had turned his attention to Normandy and the shores of the English Channel. At first, he worked in Pourville and Varengeville. In 1883 he settled in Giverny, the town that was to become synonymous with his name and work.

In Normandy the cliffs of Etretat were one of Monet's favorite subjects. They were particularly popular with artists in the nineteenth century and had inspired such painters as Gustave Courbet (1819–1877), Camille Corot (see p. 50), Johan Jongkind (1819–1891), and Monet's first teacher, Eugène Boudin (1824–1898). At this eroded spot where the very contours of the earth dissolved into water, the strata of millennia were visible.

In this version of *The Cliffs at Etretat,* Monet selected an intimate view of the interior of the Needle and the Cliffs of Aval. Ignoring the dramatic potential of a grand panorama and such genre elements as washerwomen or beached fishing boats, the artist focused on the cliffs themselves in the limpid coastal light and the glistening sea. Whereas the reflective qualities of water had long been a favorite element in Monet's work, the cliffs at Etretat offered him an opportunity to explore the characteristics of stone. It was the layers of rock that attracted Monet, and he described them beautifully with the free brushwork of the mature impressionist. SK

FOR FURTHER READING

Charles Stuckey, ed., *Monet: A Retrospective* (New York: Hugh Lauter Levin, 1985).

Robert Herbert, *Impressionism: Art, Leisure, and Parisian Society* (New Haven: Yale University Press, 1988).

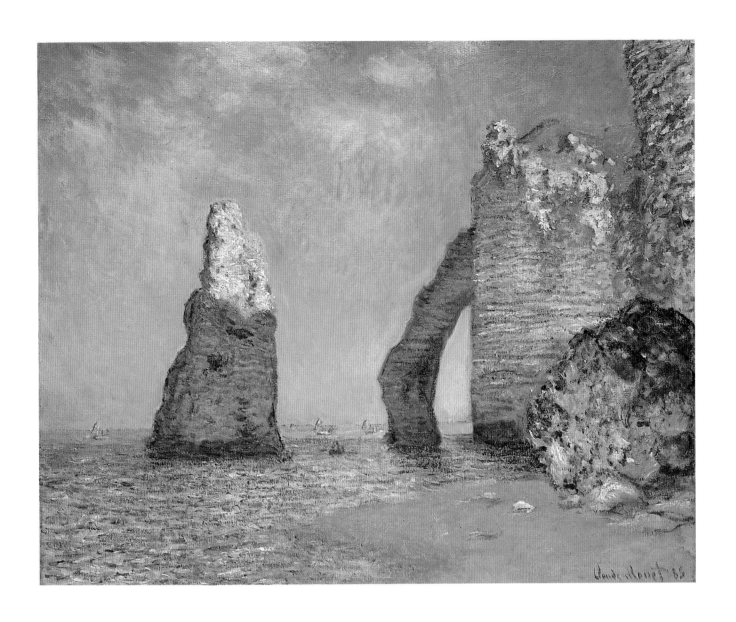

Claude Monet

FRENCH, 1840–1926

Rouen Cathedral, Façade 1894

Oil on canvas

41¹³⁄₁₆ × 29 in. (106.3 × 73.7 cm)

Signed and dated lower right: CLAUDE MONET 94

Purchased in memory of Anne Strang Baxter

1967.1

Throughout his career, Claude Monet was guided by his gift for observation, which enabled him to capture fleeting moments in the world around him. About the end of the 1880s and into the 1890s, other members of the impressionist circle began to go their separate ways. Camille Pissarro (see pp. 62–64), for example, in his drive to explore what was new, exchanged the transitory effects of impressionism for the structure of the neo-impressionism, or pointillism, of Georges Seurat (1859–1891). Pierre-Auguste Renoir (see pp. 96–102), by the mid-1880s, had turned away from the informality of impressionism and embraced the discipline of the Old Masters. Although Monet's brushstrokes, colors, and subjects varied, his drive to refine his own power of perception—his dedication to impressionism—never flagged.

It was in the 1890s that Claude Monet painted all of the magnificent series paintings for which he is so famous. The motifs ranged from the poplars along the banks of the Epte River to the grain stacks that surrounded his beloved home in Giverny. The most spectacular series is the one devoted to the west façade of the cathedral of Notre-Dame in Rouen. The version in the Clark collection is a virtuoso statement in paint about the bright orange and gold of sunlight reflecting from the limestone of the sculpture-filled west front. Monet painted directly on unprimed, white canvas to increase the brilliance of the colors and built up layer upon layer of paint until the surface seems nearly as sculptural as the cathedral itself.

Monet would often work on many canvases in a single day, moving from one to the next as the light and atmosphere changed around him. Therefore, the paintings in each series are best understood as a group. While *Rouen Cathedral, Façade* is a stunning example of Monet's painting of the 1890s, a complete and wonderful work in itself, it is only one of almost thirty versions of the same subject. Only when seen as a group do Monet's cathedrals give full evidence of the master impressionist's working process, his drive, and his vision. SK

FOR FURTHER READING

Charles Stuckey, ed., *Monet: A Retrospective* (New York: Hugh Lauter Levin, 1985).

Robert Herbert, *Impressionism: Art, Leisure, and Parisian Society* (New Haven: Yale University Press, 1988).

Monet in the '90s: The Series Paintings, exhibition catalogue (Boston: Museum of Fine Arts, 1989).

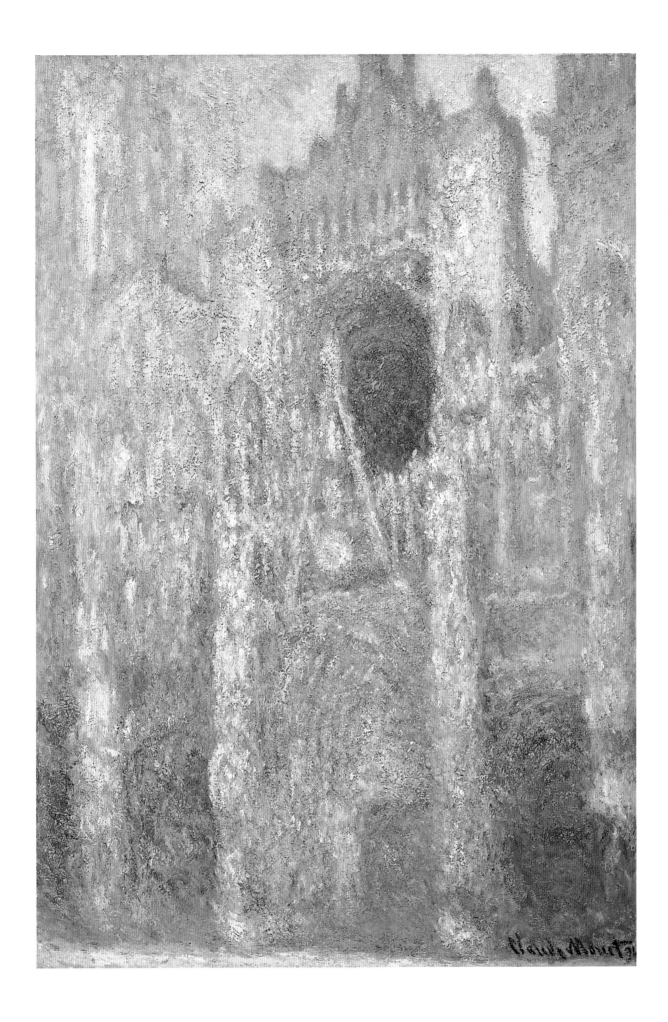

Berthe Morisot

FRENCH, 1841–1895

The Bath c. 1885–86

Oil on canvas

35⅞ × 28⁷⁄₁₆ in. (91.1 × 72.3 cm)

Signed lower right: BERTHE MORISOT/ BERTHE MORISOT

1955.926

Berthe Morisot was born in Bourges and moved with her family to Paris when she was eleven years old. Shortly after their arrival in the capital, she and her two sisters began taking drawing lessons. The girls were the great-granddaughters of the famous eighteenth-century court painter Jean-Honoré Fragonard (see p. 38). From 1856 to 1859, Morisot studied with Joseph Guichard (1806–1880), whose teaching method required the copying of paintings in the Louvre. While copying the work of the Old Masters, Morisot met many contemporary painters, including Edouard Manet (see p. 66), her future brother-in-law. She became friends with Félix Bracquemond (1833–1914) and Henri Fantin-Latour (1836–1904) and was especially influenced by the work of Camille Corot (see p. 50), who introduced her to painting out-of-doors. By the late 1860s Morisot was a frequent guest of the Manets. She posed for Edouard and studied his work and, in 1874, married his younger brother Eugène.

Like so many of the impressionists, Morisot was heavily dependent on the works of older or more influential artists. From the late 1860s until the 1880s, her paintings had many characteristics in common with Edouard Manet's. After his death in 1883, Morisot was increasingly influenced by Pierre-Auguste Renoir (see pp. 96–104), an artist recognized for his lavish and sensitive images of women. It was he who eventually had the greatest effect on her art.

Unlike Morisot's paintings of stylish women at the theater or out for the evening, all of which serve as portraits as much as images of femininity, *The Bath* is a simple genre scene. Also known by its descriptive title, *A Girl Arranging Her Hair,* it depicts the kind of preparation that was required to achieve the fashionable appearance of most of her sitters. SK

FOR FURTHER READING

Berthe Morisot, Impressionist, exhibition catalogue (New York: Hudson Hills Press, 1987).

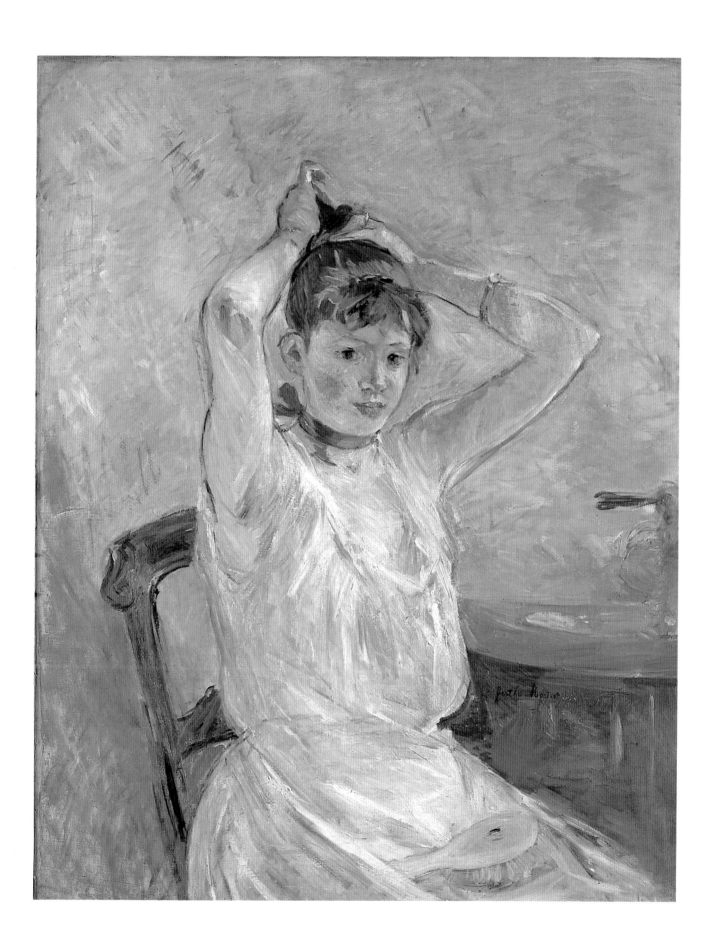

Pierre-Auguste Renoir

FRENCH, 1841–1919

At the Concert 1880

Oil on canvas

39¹⁄₁₆ × 31¾ in. (99.2 × 80.6 cm)

Signed and dated upper left: RENOIR. 80.;
signed center left: RENOIR.

1955.594

Of all the impressionists, Pierre-Auguste Renoir seems to have had the easiest time with critics and collectors. By the end of the 1870s, he was enjoying favorable reviews and accepting important portrait commissions. Despite its title, this painting is not an anonymous scene of a woman and a young girl at the theater. It is a portrait of the wife and daughter of the French undersecretary of fine arts Edmond Turquet. The patronage of such rich and powerful families guaranteed Renoir's career and reputation. Ironically, this portrait—along with other works by impressionists shown in an 1880 exhibition at the Durand-Ruel Galleries in Paris—earned the praise of Louis Leroy, the critic who, only six years earlier, had denounced their first exhibition and sarcastically labeled the movement *impressionism*.

At the Concert demonstrates Renoir's power in the late 1870s and early 1880s to create refined images of beautiful women in elegant surroundings. He lavished attention on depicting rich materials and surfaces, and his mastery of color asserted itself to the fullest at this time. Compositions were also carefully refined, as evidenced here by the scraping out and overpainting of a male figure in the right background, surely a portrait of the undersecretary himself. By the early 1880s Renoir had taken impressionism to what, for him, amounted to its logical conclusion. SK

FOR FURTHER READING

Barbara Ehrlich White, *Renoir: His Life, Art, and Letters* (New York: Harry N. Abrams, 1984).

Renoir, exhibition catalogue (Boston: Museum of Fine Arts, 1985).

Robert Herbert, *Impressionism: Art, Leisure, and Parisian Society* (New Haven: Yale University Press, 1988).

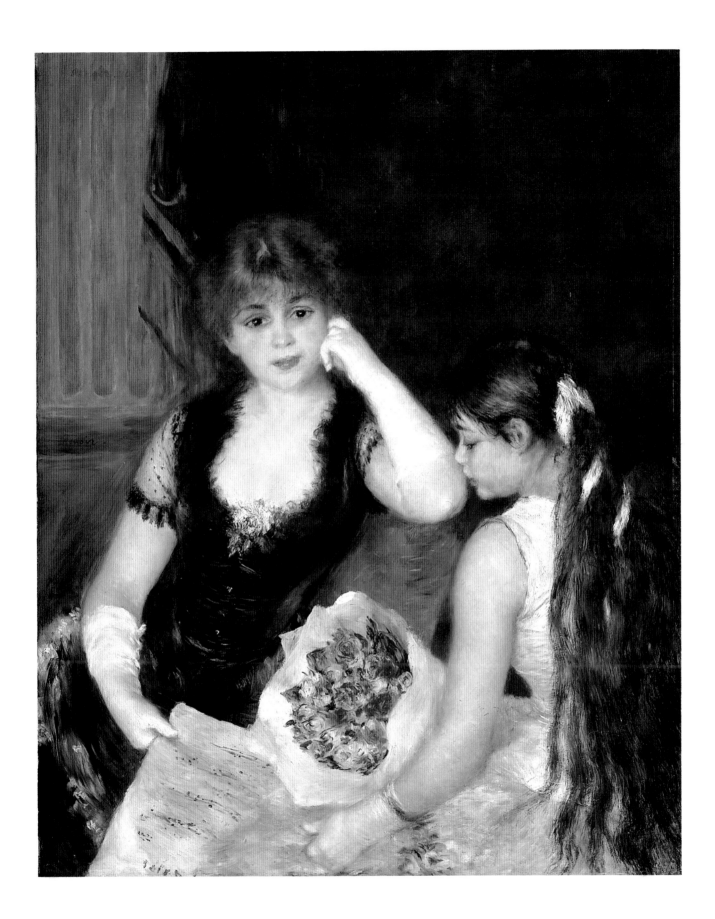

Pierre-Auguste Renoir

FRENCH, 1841–1919

Blonde Bather 1881

Oil on canvas

32³⁄₁₆ × 25⅞ in. (81.8 × 65.7 cm)

Signed, dated, and inscribed upper right: À MONSIEUR H. VEVER/RENOIR 81 [partially overpainted]/RENOIR.81.

1955.609

Pierre-Auguste Renoir traveled to Italy in 1881. While visiting Rome and Naples, he was particularly struck by the frescoes of the great Renaissance master Raphael in the Vatican and by the simplicity and grandeur of the ancient frescoes at Pompeii. Renoir was already dissatisfied with the impressionists' method of capturing the ephemeral effects of light and atmosphere. In Italy he began to move toward a more precise definition of form. *Blonde Bather,* painted in Naples, exemplifies this change.

In his struggle to produce a work of art that was classical in nature, Renoir placed the greatest emphasis on the human form. The bather's body creates a pyramid shape, favored by artists such as Raphael for its balance and stability. Renoir continued to use the thick, visible brushstrokes of impressionism, but rather than dissolving the figure into patches of pure light and color, he manipulated the paint to produce a solid form.

The model for this painting is believed to have been Aline Charigot, who became Renoir's wife in 1890, nine years after *Blonde Bather* was painted. Interestingly, she appears to be wearing a wedding ring in this painting. Many of the models in Renoir's paintings of the 1880s wear similar rings, perhaps in deference to conservative patrons who may have considered it improper for unmarried women to pose nude. PRI

FOR FURTHER READING

Renoir, exhibition catalogue (Boston: Museum of Fine Arts, 1985).

Robert Herbert, *Impressionism: Art, Leisure, and Parisian Society* (New Haven: Yale University Press, 1988).

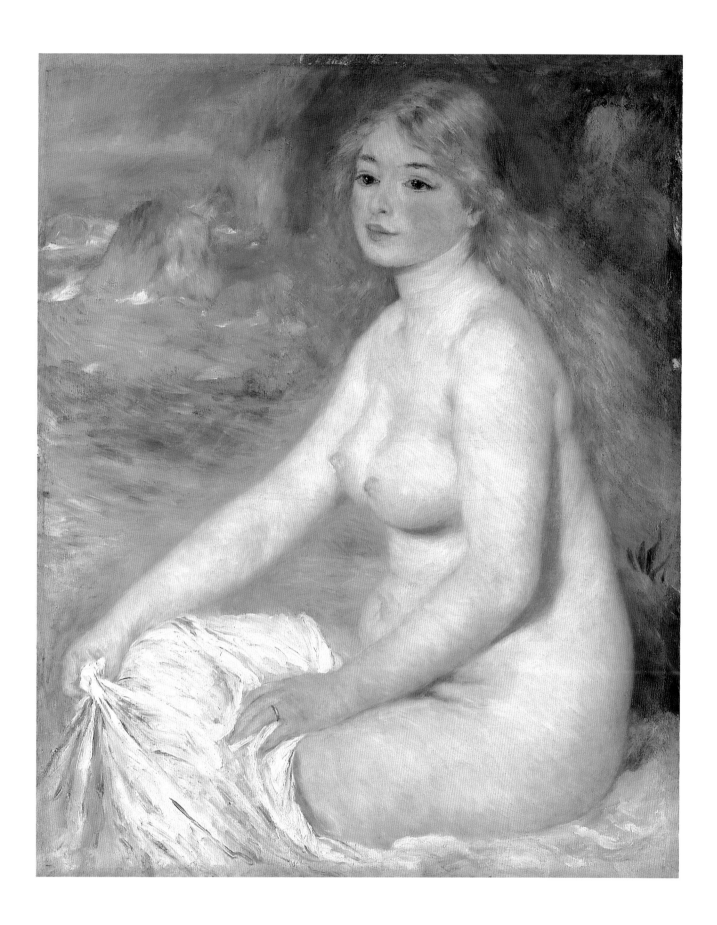

Pierre-Auguste Renoir

FRENCH, 1841–1919

The Onions 1881

Oil on canvas

15⅜ × 23⅞ in. (39.1 × 60.6 cm)

Signed and dated lower left: RENOIR. NAPLES. 81.

1955.588

A s the inscription indicates, this canvas was painted during Pierre-Auguste Renoir's 1881 trip to Italy, a journey that was to have an important influence on his artistic development. Robert Sterling Clark collected three other paintings by Renoir done during the same trip, including *Blonde Bather* (see p. 98).

The Onions reportedly was one of Clark's favorites. No doubt the lively composition, the free technique, and the warm, high-keyed colors appealed to him. Renoir arranged the onions and garlic in a composition that celebrates the rhythm of their curves and the sinuous border of the cloth on which they sit. The relationship of the various elements is carefully developed: a single onion on the left tilts toward the group, two others echo its position, and two lean in the same direction as the garlic in the center. The result is a finely tuned visual dance.

Renoir employed vigorous patterns of loose brushstrokes to define the forms of the vegetables and emphasize the texture of their thin, flaky skins. A contrasting rhythm of parallel diagonal strokes was used in the blue-green background. Light reflected from the papery skins imparts vivid color accents to the lavender, pink, orange, and mustard hues of the vegetables. All the details of this joyous still life demonstrate Renoir's love for humble beauty, vibrant color, and lush, rounded forms. JHB

FOR FURTHER READING

Renoir, exhibition catalogue (Boston: Museum of Fine Arts, 1985).

Robert Herbert, *Impressionism: Art, Leisure, and Parisian Society* (New Haven: Yale University Press, 1988).

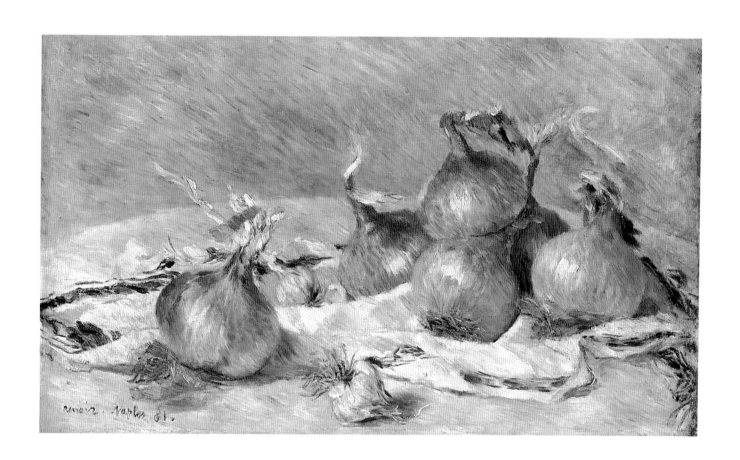

Pierre-Auguste Renoir

FRENCH, 1841–1919

A Girl with a Fan

c. 1881

Oil on canvas

25⁹⁄₁₆ × 21¼ in. (65 × 54 cm)

Signed lower left: RENOIR.

1955.595

T hroughout his long and productive career, Pierre-Auguste Renoir experimented with many different subjects in his paintings. While he was able to change easily from landscape to still life, genre to portrait, he is certainly best known for his depictions of women. And it is this subject that dominates the Renoir paintings collected by Robert Sterling and Francine Clark. *A Girl with a Fan* sums up the qualities that earned Renoir success in France during his lifetime and an enduring place in the heart of the public ever since: the charm and accessiblity of the subject; the beauty and sensuality of the sitter; the refinement of color; and the energetic and sparkling appearance of the paint itself.

The most immediately engaging aspect of this painting is perhaps the Japanese fan held by the sitter—the actress Jeanne Samary, one of Renoir's favorite models in the late 1870s. The inclusion of Japanese objects in paintings, as well as the use by the impressionists of compositional conventions learned from Japanese art, was common by this time. While Renoir denied the impact of Japanese art on his work, he was certainly indebted to the art of the East, as can be seen in the spatial ambiguity and compression that he created in this painting. For example, his model is obviously seated (the back of a chair is barely visible at her lower back), yet she seems to occupy almost the same plane as the flowers that dominate the upper left side of the painting. Their tight placement in front of a boldly striped wall also complicates the composition and challenges the viewer to define the space.

Renoir was the least intellectual of the impressionists. His overriding concern was to create images of beauty, rather than those charged with meaning. With many of his images of women, however, Renoir was interested in capturing feminine beauty on the cusp of womanhood with its incipient sexuality and allure. The informality of the straw hat and the young woman's seemingly clumsy grasp on the fan give her an almost adolescent charm, but the red lips and her blush—the same color as the flowers—convey mature sensuality. SK

FOR FURTHER READING

Barbara Ehrlich White, *Renoir: His Life, Art, and Letters* (New York: Harry N. Abrams, 1984).

Renoir, exhibition catalogue (Boston: Museum of Fine Arts, 1985).

Robert Herbert, *Impressionism: Art, Leisure, and Parisian Society* (New Haven: Yale University Press, 1988).

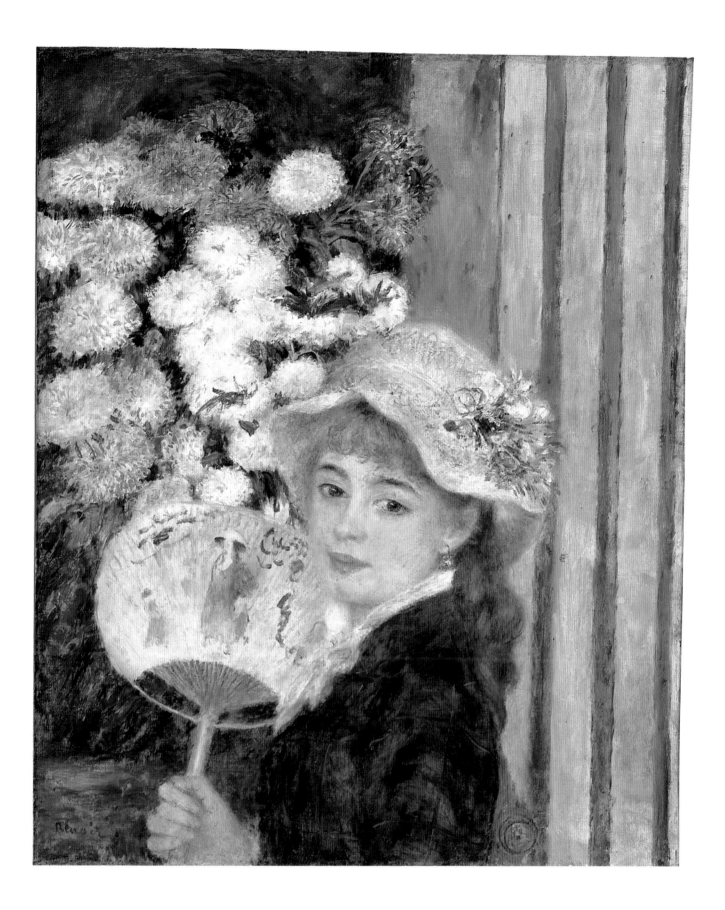

Pierre-Auguste Renoir

FRENCH, 1841–1919

Venus Victorious 1914

Bronze

Height: 71¾ in. (182.2 cm)

Inscribed top left rear of base: RENOIR/1914; top right rear of base: DEUXIEME EPREUVE/1E ETAT [Second proof/1st state]

1970.11

Pierre-Auguste Renoir's sculpture *Venus Victorious* represents the classical goddess of love holding a golden apple, the prize awarded to her for her beauty. The title refers to the mythical contest in which Paris, a shepherd and the son of King Priam of Troy, was appointed by Jupiter to select the most beautiful of the goddesses Venus, Minerva, and Juno (see also p. 24). Paris chose Venus because she promised him the love of Helen, the wife of King Menelaus of Sparta. The subsequent abduction of Helen by Paris triggered the Trojan War.

The Judgment of Paris was a subject that occupied Renoir toward the end of his career. He used it in several paintings and a bronze relief. His interest in this story may reflect his concerns about the contemporary political situation. At the time he began to work on the *Venus Victorious,* World War I was imminent.

Venus Victorious is Renoir's most important sculpture—the one to which he devoted the most time and effort and his most precisely finished work. It embodies the classical conception of female form that he had been developing in his paintings since 1890. In 1913 he began a clay statue of Venus twenty-four inches high. It attracted the attention of his dealer, Ambroise Vollard, who commissioned the monumental version, *Venus Victorious.* Aware that Renoir's arthritic hands were too rigid to hold tools, Vollard suggested that he hire as his studio assistant the young sculptor Richard Guino (1890–1973), who had studied with Aristide Maillol (1861–1944). Renoir and Guino developed an unusually effective collaboration in which the assistant substituted for the master's hands—modeling and casting pieces according to Renoir's careful directions, which were often delivered with the help of a long pointer. The clay model for *Venus Victorious* was fashioned in the cellar of Les Collettes, Renoir's home in Cagnes, with the aid of his drawings, the small clay figure, and a live model. After the large clay model was cast in plaster, the detailed finishing was completed in the garden. Renoir's conception of the monument included a large pedestal decorated with a bas-relief of the Judgment of Paris, measuring thirty by thirty-six inches and modeled by Guino after a painting by Renoir. This ensemble was to have been installed in a garden temple dedicated to the theme of love. Although the relief panel was made, Renoir's plans for the temple were never completed.

Renoir was dissatisfied with the first version of *Venus Victorious* and subsequently had the proportions reworked. The location of the preliminary cast is not known; the sculpture in the Clark collection is the only extant version of the first state of the finished sculpture. Inscribed in French "Second proof/1st state," it was cast by Richard Guino and shown in Paris at the Triennial Exhibition in the spring of 1916, the first public exhibition of Renoir's sculpture. JGL

FOR FURTHER READING

Paul Haesaerts, *Renoir Sculptor* (New York: Reynal and Hitchcock, 1947).

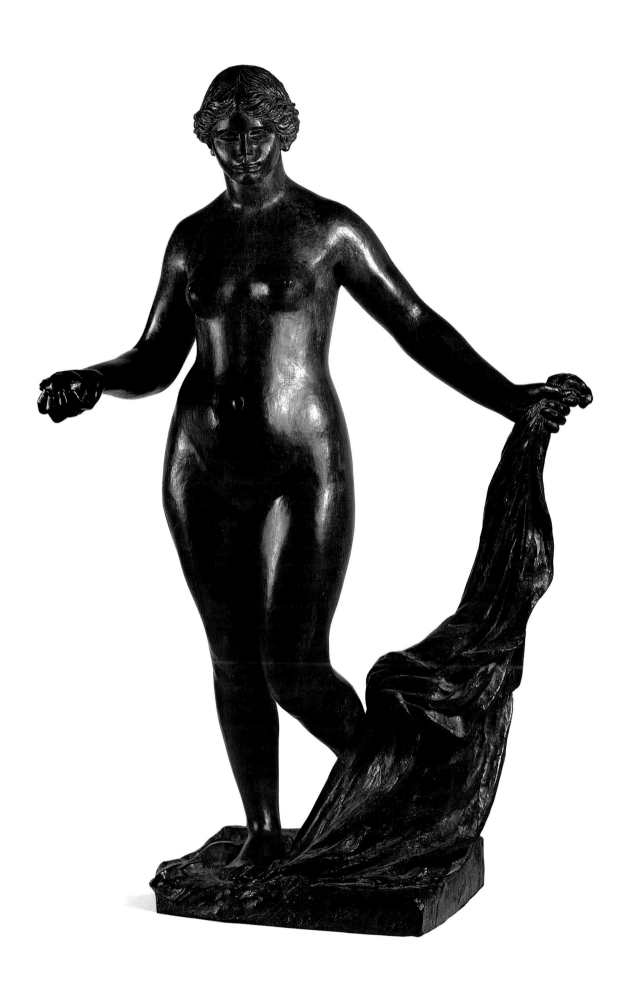

Mary Stevenson Cassatt

AMERICAN, 1844–1926

Offering the Panal to the Bullfighter 1873

Oil on canvas

39⅝ × 33½ in. (100.6 × 85.1 cm)

Signed, dated, and inscribed lower right:
MARY S. CASSATT./SEVILLE./1873.

1955.1

Mary Cassatt was born in Allegheny City, Pennsylvania, now part of Pittsburgh. Her taste for European life and art was cultivated from an early age; when she was seven her family went to Europe for a five-year stay. She received her formal art training at the Pennsylvania Academy of the Fine Arts in Philadelphia from 1861 to 1865. Following this, like many American artists after the Civil War, she went to Paris, where she studied with Jean-Léon Gérôme (see p. 58). During the late 1860s, Cassatt traveled extensively in Europe. She returned to the United States in 1870 during the Franco-Prussian War but went back to Europe in 1872 and after 1873 resided in or near Paris for the rest of her life.

Like many English-speaking people in the nineteenth century, Mary Cassatt was drawn to Spain. "I have been abandoning myself to despair and homesickness," she wrote to her friend Emily Sartain after postponing an 1871 trip, "for I really feel as if it was intended I should be a Spaniard and quite a mistake I was born in America." Cassatt finally made a trip to Spain in late 1872 and spent most of the five months in Seville. During this time, she painted four large canvases, including *Offering the Panal to the Bullfighter,* in which a bullfighter is given *panal*—Spanish for honeycomb or sponge sugar, dipped in water to provide energy and quench thirst.

The painting shows Cassatt's assimilation of various lessons learned in her student years in Philadelphia and Paris. Like her teacher Gérôme, she sought new subjects and exotic models in Spain. Inspired by another French contemporary, Edouard Manet (see p. 66), Cassatt applied paint in a relatively heavy, free, and brushy manner. Her composition and palette, however, drew on her knowledge of Old Master painting, particularly canvases by the seventeenth-century Spaniard Diego Velázquez.

Cassatt first exhibited this painting in 1873 at the Paris Salon as *Offrant le panal au torero.* Its American debut was that same year at the Cincinnati Industrial Fair. It was shown the following year in New York with the English title. The painting seems to have been overlooked by the critics, perhaps because the composition is weak in some areas, such as the woman's foreshortened arm, or because Cassatt was young, unknown, and female. SK

FOR FURTHER READING
Nancy Mowll Mathews, *Mary Cassatt* (New York: Harry N. Abrams, 1987).

Margaret C. Conrads, *American Paintings and Sculpture at the Sterling and Francine Clark Art Institute* (New York: Hudson Hills Press, 1990).

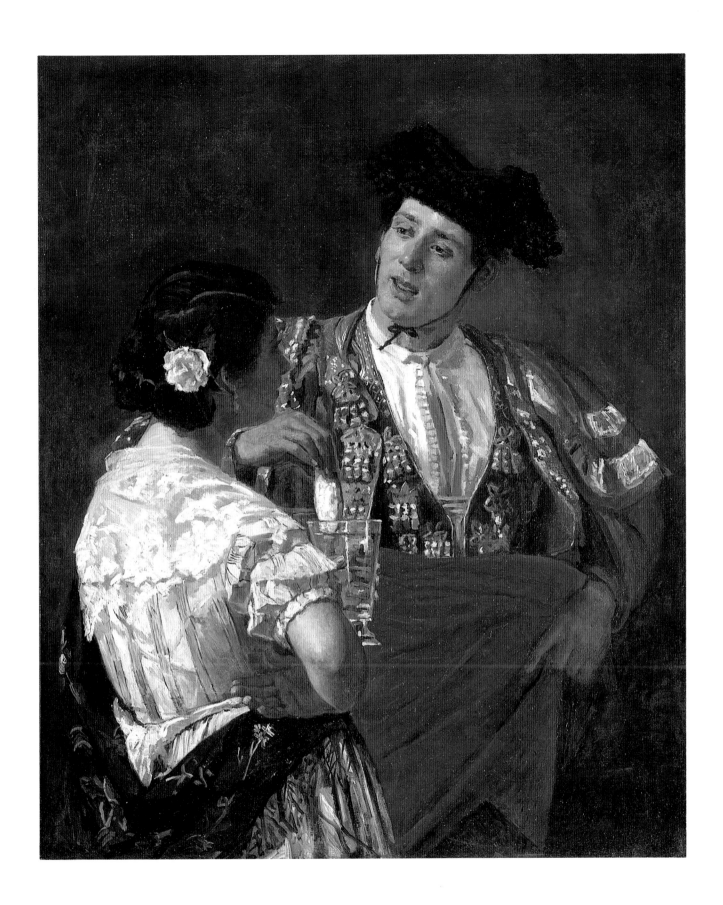

Mary Stevenson Cassatt

AMERICAN, 1844–1926

Woman with Baby

c. 1902

Pastel on paper

28⅜ × 20⅞ in. (72.1 × 53 cm)

Unsigned

1968.301

Mary Cassatt's favorite subjects were women with children, often depicted in pastel, as here. Never a mother herself, she managed to convey the nuances of feeling between mother and child, a theme she explored extensively from about 1888 to the end of her life. Although the implied relationship in *Woman with Baby* is that of mother and daughter, the models were not related. The woman has been identified as Cassatt's favorite model at this time, Reine LeFebvre, a local girl whom she employed as a cook.

The composition indicates a strong bond between the two figures even though they do not look at each other; with both hands the child embraces the woman, who, in turn, supports her with her upper arm, enfolding her in the orange kimono. Many similar scenes have suggested that Cassatt was inspired indirectly by the theme of the Madonna and Child.

Woman with Baby vibrates with brilliant colors—orange, blue, green, and red. Cassatt's skillful and bold use of pastels can be seen in the application and blending of these colors, particularly in the sensitivity and softness of the faces; the manipulation of the pinks, whites, and blues of the child's body; and the vigorous treatment of the kimono and the flat colors of the background. The kimono itself, the strong patterns, and the bold colors reflect Cassatt's admiration for Japanese art.

Mary Cassatt knew many of the impressionists and exhibited with them. She introduced their work to her wealthy American friends, especially Louisine and Horace Havemeyer. Because of Cassatt's wise advice, many important works by the impressionists are now in the United States.

JHB

FOR FURTHER READING

Nancy Mowll Mathews, *Mary Cassatt* (New York: Harry N. Abrams, 1987).

Margaret C. Conrads, *American Paintings and Sculpture at the Sterling and Francine Clark Art Institute* (New York: Hudson Hills Press, 1990).

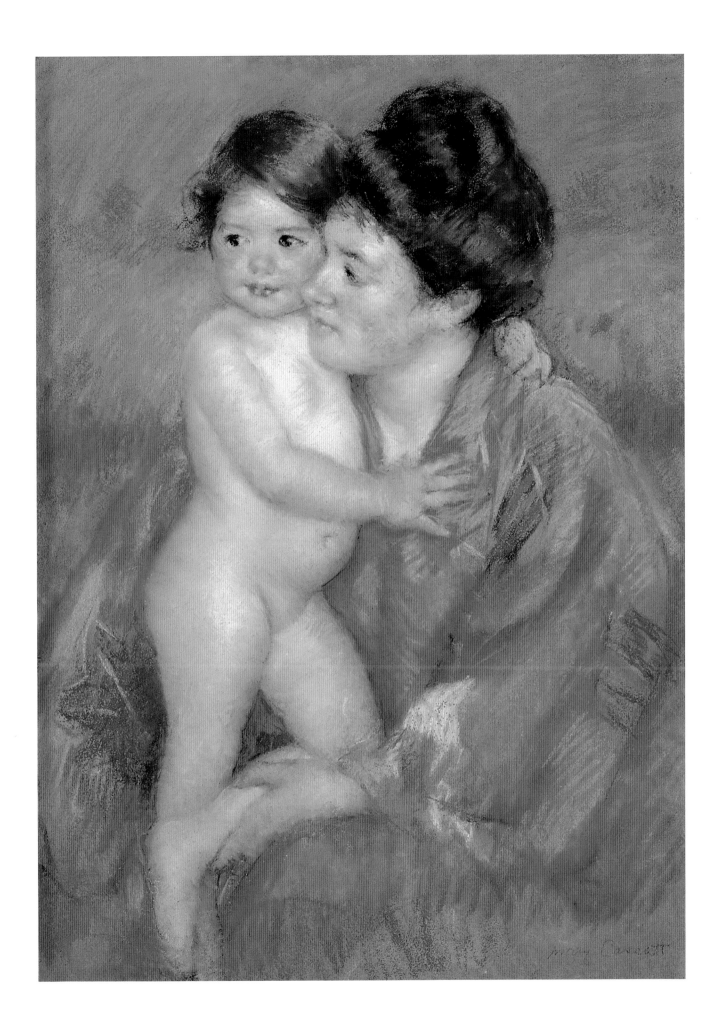

Paul Gauguin

FRENCH, 1848–1903

Young Christian Girl

1894

Oil on canvas

25¹¹/₁₆ × 18⅜ in. (65.2 × 46.7 cm)

Signed and dated lower right:
P. GAUGUIN 94

Purchased in honor of Harding F. Bancroft, Institute Trustee 1970–87; President 1977–87

1986.22

In late 1893 Paul Gauguin returned to Paris from Tahiti, where he had spent the previous two years. His time was largely divided between raising money to return to the South Pacific and writing and illustrating his monumental book *Noa Noa*. Gauguin, therefore, executed relatively few canvases in that or the following year. *Young Christian Girl* was painted in the autumn of 1894 when Gauguin was visiting Pont-Aven in Brittany for the last time. The brilliant red and orange foliage of the poplars in the background is characteristic of Pont-Aven in October.

Young Christian Girl shows the strong influence of Gauguin's stay in Tahiti. The flattened forms and ambiguous space, both drawn from his study of primitive art, are distinctly non-Western. The Breton girl is painted with the same strength and intensity as the very finest of the artist's earlier Tahitian subjects. The girl's hair is not tied back but rather is long and flowing, as seen on Gauguin's Tahitian models. And she seems to be wearing a Tahitian missionary dress, such as Annah the Javanese, Gauguin's young mistress, would have worn.

The painting also has strong bonds with historical European art. Early in 1894 Gauguin visited Belgium, where he had the opportunity to study works by Flemish masters of the fifteenth century in Brussels and Bruges. Perhaps this painting incorporates his response to the Renaissance panels he had seen, for *Young Christian Girl* has the same devotional impact as the many paintings of Hans Memling that he so admired (see, for example, p. 20).

If the influences on Gauguin when he painted this canvas seem clear, the exact meaning of the painting is not. While the town houses of Pont-Aven, its hills, and its poplars are immediately recognizable, they serve as no more than a backdrop. They are separated from the model by large forms resembling angel's wings, which may be another allusion to fifteenth-century painting. It seems best to accept this problematic painting as a portrait of virginal innocence and as Gauguin's own conflation of Europe and Tahiti, their religions, their people, and their traditions. SK

FOR FURTHER READING

Charles Stuckey and Maria Prather, *Gauguin: A Retrospective* (New York: Hugh Lauter Levin, 1987).

The Art of Paul Gauguin, exhibition catalogue (Washington, D.C.: National Gallery of Art, 1988).

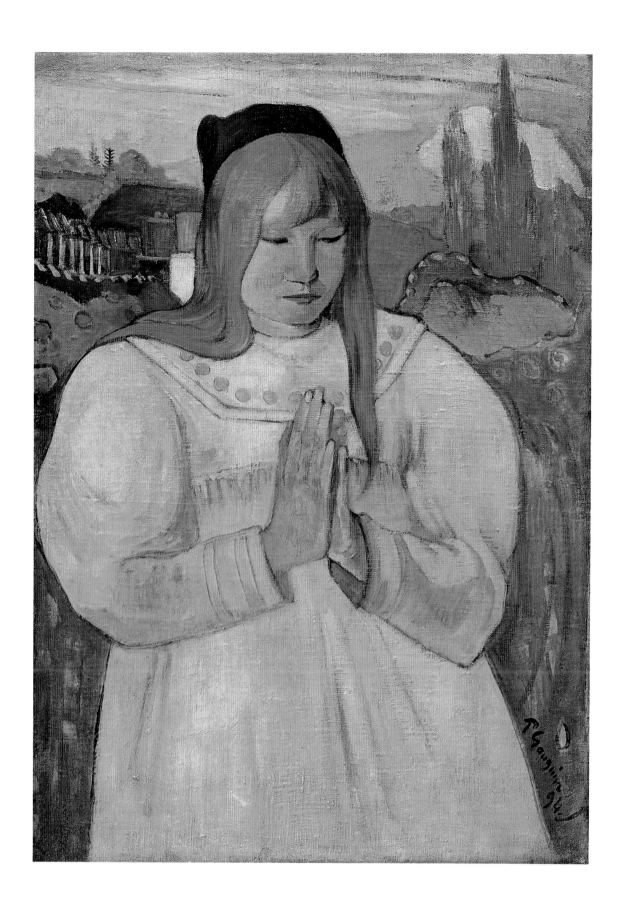

Vincent van Gogh

DUTCH, 1853–1890

Terrace in the Luxembourg Garden

1886

Oil on canvas

10⅝ × 18⅛ in. (27.1 × 46.1 cm)

Unsigned

1955.889

V incent van Gogh first encountered French impressionism when he moved to Paris in 1886. The brilliant hues of this style of painting had an immediate and lasting effect on him. He abandoned the gray tones of his earlier works, which reflected the prevailing palette of nineteenth-century Dutch painting, in favor of more vibrant colors.

During that year, van Gogh painted mostly bouquets of flowers, which lent themselves to his experiments with complementary colors. He also painted a few landscapes, such as *Terrace in the Luxembourg Garden* (formerly identified as *Terrace at the Tuileries*). This painting could easily be mistaken for the work of an impressionist. It is a scene of modern life, undoubtedly painted outdoors with the palette and brushwork typical of impressionism. Van Gogh did not associate with any of the impressionists at the time, however. He was simply responding to the colors he had seen in their works.

Van Gogh owned a print by Auguste Lançon (1836–1887) that showed a number of people amid the tall trees of the Luxembourg Garden. That image may have inspired the Clark painting, in which the people enjoying the pathways and benches of this public spot seem dwarfed by the trees and their abundant foliage. Van Gogh worked out the composition in at least two sketches: one a drawing of the garden and the other an elaboration of a similar view illustrated on a restaurant menu. Unlike later works in which van Gogh consciously distorted perspective, this painting shows a logical recession of space.

Terrace in the Luxembourg Garden and van Gogh's other paintings of Paris in 1886 bridge his early endeavors and the post-impressionist paintings for which he is now best known. Works in van Gogh's later, highly expressive style are recognizable by their increasingly intense color and agitated brushwork. PRI

FOR FURTHER READING
Van Gogh à Paris, exhibition catalogue (Paris: Editions de la Réunion des musées nationaux, 1988).

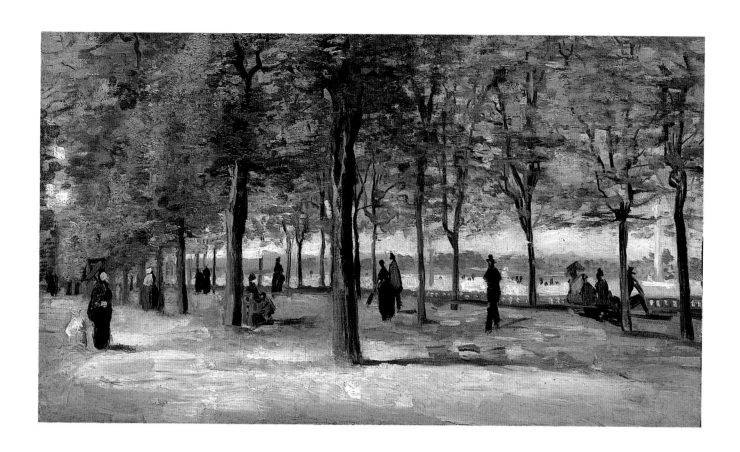

John Singer Sargent

AMERICAN, 1856–1925

Portrait of Carolus-Duran 1879

Oil on canvas

46 × 37¹³⁄₁₆ in. (116.8 × 96 cm)

Signed, dated, and inscribed upper right: À MON CHER MAÎTRE M. CAROLUS-DURAN, SON ÉLÈVE AFFECTIONNÉ [to my dear master Monsieur Carolus-Duran, his devoted student]/JOHN S. SARGENT. 1879

1955.14

John Singer Sargent was born in 1856 in Florence, where his family remained until 1874. Following a childhood interest in drawing, he began his formal art education in Rome in 1869 and continued in Florence at the Accademia di Belle Arti from 1873 to 1874. In May of that year, Sargent's family moved to Paris so that he could receive advanced training. He was quickly accepted into the studio of Carolus-Duran (born Charles-Emile-Auguste Durant, 1838–1917) and soon became one of the master's star pupils.

Sargent was drawn to the studio of Carolus-Duran by its pleasant atmosphere, its international nature with many foreign students, its flexibility when compared with the Ecole des Beaux-Arts, and especially Carolus-Duran's success and popularity. Trained at the Académie Suisse, Carolus-Duran had also studied in Italy and Spain. A portrait of his wife, admitted to the Paris Salon of 1869, launched his career as one of the preeminent portraitists of Paris. He opened his studio in 1873, and, while his career declined through the 1880s, his importance in the art world increased. In 1889 he was a founding member of the Société Nationale des Beaux-Arts and its president in 1898. He was named a chevalier of the French Legion of Honor in 1872 and was made a grand officer in 1900. In 1905 he became director of the French Academy in Rome.

In his studio Carolus-Duran did not follow the curriculum of the Ecole des Beaux-Arts, which stressed drawing as the foundation of good art. He taught that painting was of supreme importance. The *Portrait of Carolus-Duran* sums up all that Sargent learned from him: the informality of the portrait; the combination of elegance and realism; the contrast between the highlighted face and hands and the thinly painted dark background, and their contrast as well with the freely painted torso. These elements all combine to make this youthful work a masterful balance between psychological depth and bravura technique. The lessons that Sargent had learned and combined so successfully at the age of twenty-three, based on direct observation and the economical use of paint, would serve him throughout his career. SK

FOR FURTHER READING

Stanley Olson, *John Singer Sargent: His Portrait* (London: Macmillan, 1986).

John Singer Sargent, exhibition catalogue (New York: Whitney Museum of American Art, 1986).

Margaret C. Conrads, *American Paintings and Sculpture at the Sterling and Francine Clark Art Institute* (New York: Hudson Hills Press, 1990).

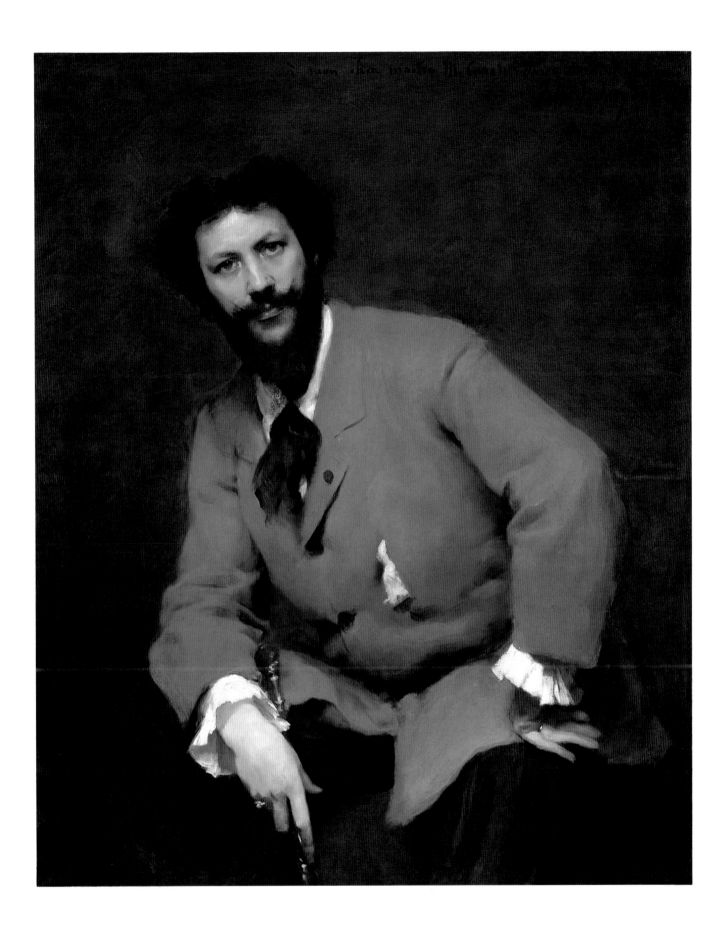

John Singer Sargent

AMERICAN, 1856–1925

Smoke of Ambergris

1880

Oil on canvas

54¾ × 35¹¹/₁₆ in. (139.1 × 90.6 cm)

Signed and inscribed lower right: JOHN S. SARGENT TANGER; **pentimento of signature and inscription lower center:** JOHN S. SARGENT TANGER.

1955.15

Smoke of Ambergris was the product of John Singer Sargent's trip to North Africa in the winter of 1879–80. One of two paintings that he sent to the Paris Salon of 1880, it is his own interpretation of orientalism, a common theme at that time in which artists sought out exotic subjects. The painting depicts a heavily draped woman inhaling the smoke of ambergris—a resinous substance found in tropical seawater and believed to come from whales. It was thought in the Near East to be an aphrodisiac, as well as a safeguard from evil spirits. The model, of whom Sargent made several sketches, probably lived in cosmopolitan Tangier. In a society that forced women to be intensely private, working as a model would have relegated her to its outer fringes. Her robes and mantle are of a type worn by both men and women throughout North Africa, but the details of the costume and setting come from different regions and social classes. The painting is a mélange of Moroccan objects and customs that Sargent encountered in Tangier and Tétouan. Therefore, the scene must be viewed as an imaginary one.

The masterfully seductive use of color in *Smoke of Ambergris* probably attracted the greatest praise. In an article on Sargent in *Harper's New Monthly Magazine,* October 1887, Henry James wrote, "I know not who this stately Mohammedan may be, nor in what mysterious domestic or religious rite she may be engaged; but in her plastered arcade, which shines in the Eastern light, she is beautiful and memorable. The picture is exquisite, a radiant effect of white upon white, of similar but discriminated tones." On June 9, 1880, an unidentified critic in the *Interchange* referred to Sargent's *Smoke of Ambergris* as, quite simply, "a perfect piece of painting." SK

FOR FURTHER READING

Stanley Olson, *John Singer Sargent: His Portrait* (London: Macmillan, 1986).

John Singer Sargent, exhibition catalogue (New York: Whitney Museum of American Art, 1986).

Margaret C. Conrads, *American Paintings and Sculpture at the Sterling and Francine Clark Art Institute* (New York: Hudson Hills Press, 1990).

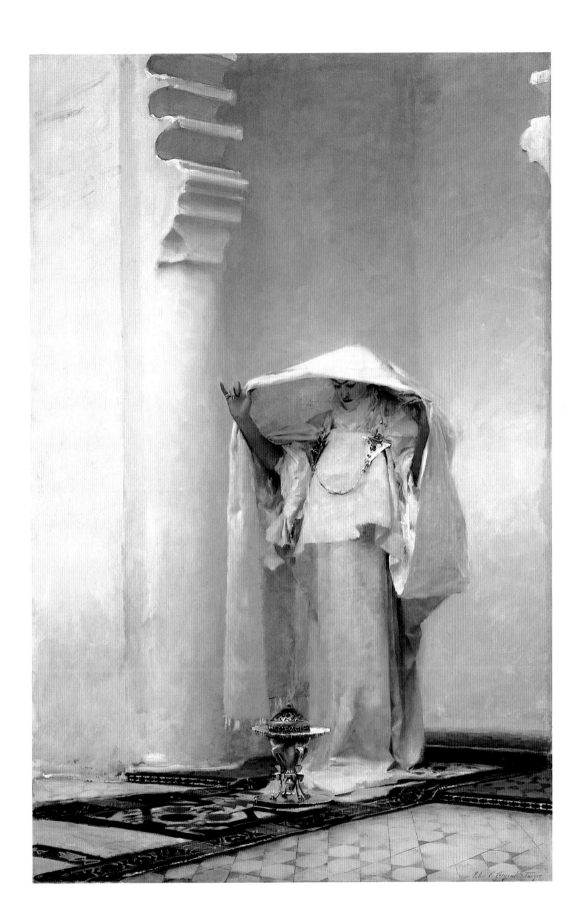

John Singer Sargent

AMERICAN, 1856–1925

A Street in Venice

1880 or 1882

Oil on canvas

29⁹⁄₁₆ × 20⅝ in. (75.1 × 52.4 cm)

Signed and inscribed lower right: JOHN S. SARGENT/VENISE

1955.575

V enice was a popular destination for artists of all nationalities in the late nineteenth century because of its picturesque canals and grand architecture, the colorful crowds, and the special quality of its light—limpid and sparkling. John Singer Sargent made two trips to the once-powerful city at the head of the Adriatic Sea, in 1880 and 1882. Rejecting the traditional views, he chose his subjects from the lower classes seen in the alleyways that criss-cross the city and depicted them in mundane tasks or, as in this case, in ambiguous relationships.

The setting for this painting was probably somewhere behind the Church of Santi Apostoli not far from the famous Ca' d'Oro. Sargent manipulated the scene to emphasize its ambiguity and tension. The murky shadows, the high walls that seem to be closing in, the dramatic perspective lines leading to the narrow slit of sunlight in the distance, all contribute to the mystery and menace of the scene. The palette is nearly monochromatic, barely heightened by the splash of coral color on the woman's dress. Above all, this encounter outside a wine shop has an almost uncomfortable air of immediacy in the agitated stance of the man and the direct gaze of the woman.

In this painting, Sargent owes a debt to both old and new sources of inspiration. Like many of his contemporaries, including Mary Cassatt (see p. 106), he admired the seventeenth-century Spanish master Diego Velázquez. Sargent incorporated into his work lessons learned from the earlier painter, particularly the organization of complex spaces and the use of rich, dark colors. But it was on photography—the souvenir photographs available throughout Venice by the 1880s—that Sargent based much of the composition of *A Street in Venice.* The painting seems almost like a snapshot in the frozen action, the distorted perspective, and the slight blurring of focus in the distance. SK

FOR FURTHER READING

Stanley Olson, *John Singer Sargent: His Portrait* (London: Macmillan, 1986).

John Singer Sargent, exhibition catalogue (New York: Whitney Museum of American Art, 1986).

Margaret C. Conrads, *American Paintings and Sculpture at the Sterling and Francine Clark Art Institute* (New York: Hudson Hills Press, 1990).

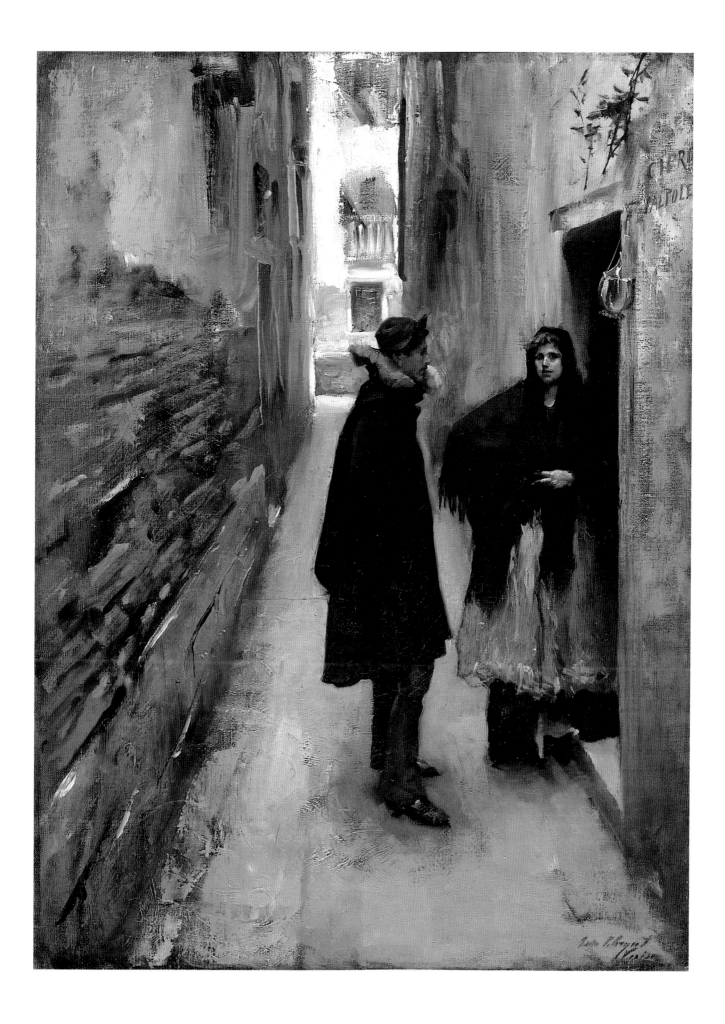

Frederic Remington

AMERICAN, 1861–1909

Dismounted: The Fourth Trooper Moving the Led Horses

1890

Oil on canvas

34¹⁄₁₆ × 48¹⁵⁄₁₆ in. (86.5 × 124.3 cm)

Signed and dated lower left: FREDERIC REMINGTON./1890

1955.11

F rederic Remington traveled west—to the Montana Territory—in 1881, when he was nineteen years old. It was the first of many trips, for he devoted the next twenty-eight years to documenting the disappearing lifestyle of the American frontier. His popular magazine illustrations and paintings determined the public vision of the Wild West. With romantic realism, he depicted cowboys, Native Americans, hunters, and soldiers. Contrary to contemporary popular belief, however, Remington did not see action with the military, nor did he work as a cowboy.

Dismounted: The Fourth Trooper Moving the Led Horses refers to the cavalry's method of getting its horses efficiently off the battlefield. The soldiers would count off in fours, and every fourth trooper would lead his horse and the other three to safety. Like all Remington's paintings of the 1890s, this scene was composed in the studio from sketches and photographs made in the field. It is an excellent example of Remington's early style. The horizontal format and low point of view intensify the action so that the four horses in the foreground appear to be galloping right out of the picture. Because none of the hooves touches the ground, the animals appear to fly through the dusty air. The horses are carefully individualized, each one different in color and posture, whereas the troopers all have identical features. Remington prided himself on his knowledge of horses and his ability to render them in his work, where they played a central role. Critics praised his skill in portraying equine anatomy and locomotion and depicting the idiosyncrasies of various breeds.

In 1892, two years after it was painted, *Dismounted* was reproduced as an illustration for E. S. Godfrey's article "Custer's Last Battle" in *Century Illustrated Magazine.* Consequently, the scene was believed to represent the battle of the Little Bighorn. This is unlikely, however, because Remington's site is nonspecific and the military accoutrements are not accurate for General Custer's final battle, which took place fourteen years before this painting was done. Sabers, prominent in Remington's painting, were not used at the Little Bighorn because it was feared that their rattling would alert the enemy. JGL

FOR FURTHER READING

Harold McCracken, *The Frederic Remington Book* (Garden City, N.Y.: Doubleday and Company, 1966).

Peter H. Hassrick, *Frederic Remington Paintings, Drawings, and Sculpture in the Amon Carter Museum and the Sid W. Richardson Collections* (New York: Harry N. Abrams, 1973).

Frederic Remington: The Masterworks, exhibition catalogue (Saint Louis: The Saint Louis Art Museum, 1988).

Margaret C. Conrads, *American Paintings and Sculpture at the Sterling and Francine Clark Art Institute* (New York: Hudson Hills Press, 1990).

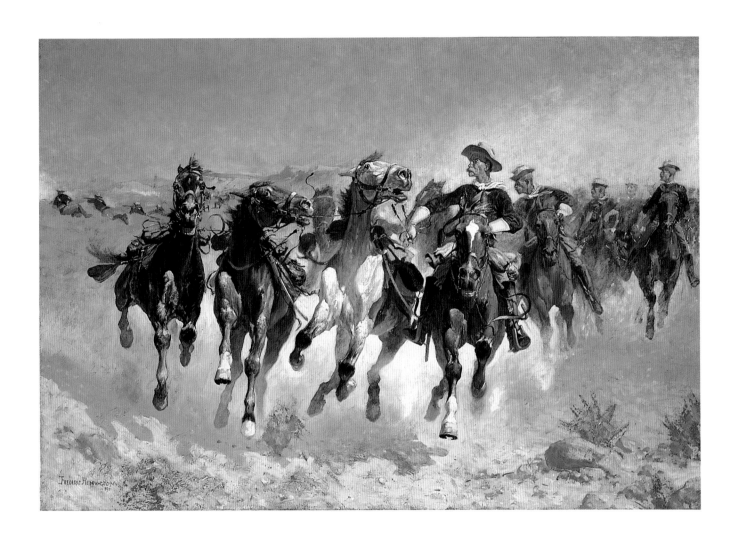

Frederic Remington

AMERICAN, 1861–1909

The Wounded Bunkie

1896

Bronze

Height: 24½ in. (62.2 cm)

Signed on base: Frederic Remington [series mark D incised above F]; incised on base: COPYRIGHTED BY/FREDERIC REMINGTON 1896/D; CAST BY THE HENRY-BONNARD BRONZE CO. N.Y. 1896

1955.13

Frederic Remington, born in upstate New York and educated at Yale University, was almost singlehandedly responsible for creating the view of the American West that was accepted by the public in the late nineteenth century. After his first trip west in 1881, he depicted primarily scenes of cowboys, Indians, and cavalrymen in his paintings and sculpture. These subjects appealed to both the growing fascination with frontier life and the desire for American themes.

The Wounded Bunkie, which became extremely popular, was Remington's second attempt at modeling. Typical of his work, it focuses on a moment of drama and danger. Two mounted cavalrymen are galloping away from a battle. One has been shot; the other attempts to support him until they reach safety. The word *bunkie* was cavalry slang for "bunk mate," which denoted a particularly close comradeship in which men felt responsible for one another. Cavalrymen often braved great danger to save a bunkie's life.

An edition of fourteen statues in bronze of *The Wounded Bunkie* was sand-cast by the Henry Bonnard Bronze Company in New York. The sequence was identified by letters instead of the usual numbers. Thus, the sculpture in the Clark collection, which was the fourth one made, bears the letter D. Small objects, such as guns, stirrups, and canteens, were cast separately and attached. The sculpture was praised for the naturalistic modeling of the animals and the accuracy of the details. The design is technically quite radical for this period in American sculpture: Remington was very much interested in the way animals moved, and, by supporting the entire group on two of the horses' legs, he convincingly created a dynamic scene that emphasizes forward motion.

Robert Sterling Clark, a career soldier and horse breeder, was extremely impressed with Remington sculpture that he saw at the Metropolitan Museum of Art in New York. In 1946, the year after he acquired Remington's painting *Dismounted: The Fourth Trooper Moving the Led Horses* (see p. 120), he purchased *The Wounded Bunkie.* Five years later, in 1951, he bought a third Remington, the painting entitled *The Scout: Friends or Foes.* JGL

FOR FURTHER READING

Michael E. Shapiro, *Cast and Recast, The Sculpture of Frederic Remington* (Washington, D.C.: Smithsonian Institution, 1981).

Frederic Remington: The Masterworks, exhibition catalogue (Saint Louis: The Saint Louis Art Museum, 1988).

Margaret C. Conrads, *American Paintings and Sculpture at the Sterling and Francine Clark Art Institute* (New York: Hudson Hills Press, 1990).

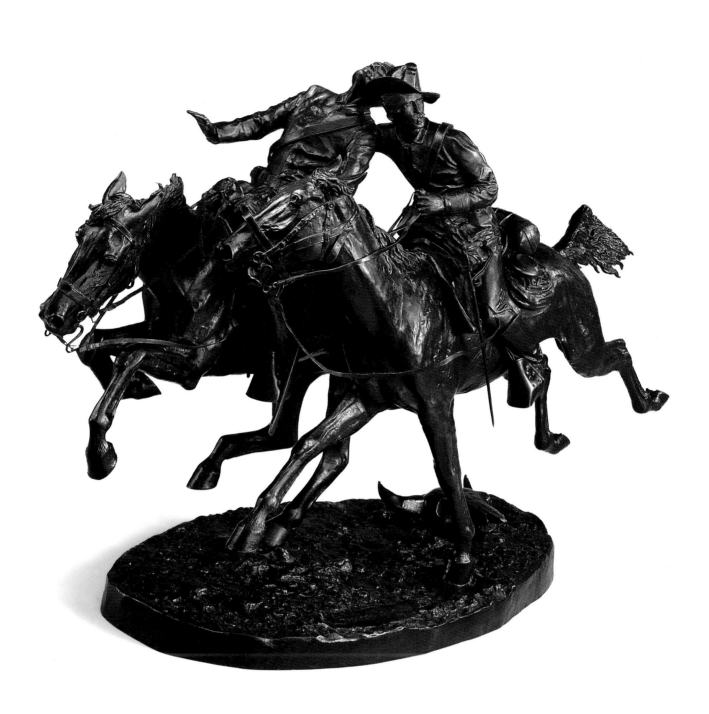

Henri de Toulouse-Lautrec

FRENCH, 1864–1901

Jane Avril c. 1891–92

Oil on cardboard, mounted on panel
24⅞ × 16⅝ in. (63.2 × 42.2 cm)
Signed upper left: HTL
1955.566

W it, intelligence, and artistic talent combined with physical deformity, addiction to alcohol and drugs, and death at a tragically young age made Henri de Toulouse-Lautrec a legendary figure in late-nineteenth-century France. He was born into an old noble family in Albi in southern France and developed an early interest in drawing. After completing his formal education, he moved to Paris in 1881. The following year, he studied art with Léon Bonnat (1833–1922) and Fernand Cormon (1854–1924). By the spring of 1884, Toulouse-Lautrec was working in the morning with Cormon and painting models of his own choice in the afternoon, often with fellow students. It was the human figure that most interested him, and the portrait is the cornerstone of his artistic production.

Before long, Toulouse-Lautrec had joined his fellow artists in documenting the everyday life of Paris. His special interest was the demimonde of Montmartre—actors, artists, prostitutes, and the people they attracted. One of the stars of the Moulin Rouge, Montmartre's most notorious and popular music hall, was Jane Avril. Dainty, charming, and graceful, she was quite unlike the other performers in Montmartre.

Jane Avril became one of Toulouse-Lautrec's favorite subjects. He produced many portraits of her in both formal and informal settings. Here, clad in a fashionable hat and cape, she appears silent and grave. Away from the footlights, there is none of the energy and exuberance that marked her performances. Only the eerie, artificial coloring of her face alludes to the limelight before which she spent so much of her life.

This portrait was a favorite of Robert Sterling and Francine Clark. They saw it for the first time in 1940 at Wildenstein and Company in New York. Clark wrote in his diary, "I could see that Francine was impressed and very much so. I asked how much. Felix Wildenstein said $45,000 to me, asking $55,000. Expensive, yes; but a fancy picture and probably worth it today. We got as far as the corner. Francine was very strong for buying the Jane Avril—a chef d'oeuvre she said. We returned and said we would take it."

SK

FOR FURTHER READING
Toulouse-Lautrec, exhibition catalogue (London: South Bank Centre, 1991).

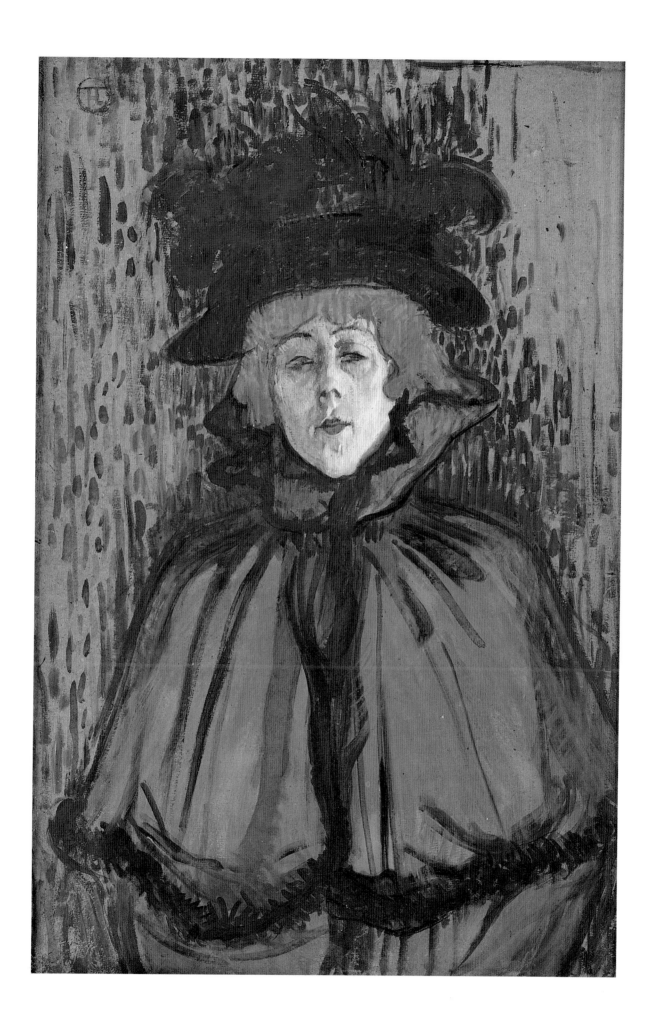

Pierre Bonnard

FRENCH, 1867–1947

Women with Dog 1891

Oil on canvas

16 × 12¾ in. (40.6 × 32.4 cm)

Signed and dated lower right:
PBonnard/1891

1979.23

Pierre Bonnard's *Women with Dog* probably portrays his sister Andrée Terrasse and their cousin, Bertha Schaedlin. Its simplified shapes, flat decorative patterns, and bright colors make it stand out in the nineteenth-century French painting collection at the Clark, which is dominated by impressionism.

Bonnard was one of a group of young artists who called themselves the Nabis and who reacted against the naturalism of impressionist painting. They were much influenced by the advice of Paul Gauguin (see p. 110) to paint in flat pure colors and to simplify forms. They were influenced also by Japanese art, a major exhibition of which was held in Paris at the Ecole des Beaux-Arts the year before this picture was painted. The Nabis attached great importance to subject matter, and Bonnard's paintings of the early 1890s evoke a world of innocence and apparent simplicity, where children and animals are often shown together in a kind of golden age. In this picture the two girls and a wonderfully human dog concentrate on what appears to be a bunch of chrysanthemums, while abbreviated heads and foliage in the background suggest a gathering in a garden. The dog, flowers, and chair are flat shapes on the surface of the painting—barely separated from the figures—that focus attention on Andrée's richly checked blue-and-white dress with its spotted collar; Bonnard was much attracted to fabrics.

DSB

FOR FURTHER READING

Pierre Bonnard, The Graphic Work, exhibition catalogue (New York: The Metropolitan Museum of Art, 1989).

Nicholas Watkins, *Bonnard* (London: Phaidon Press, 1994).

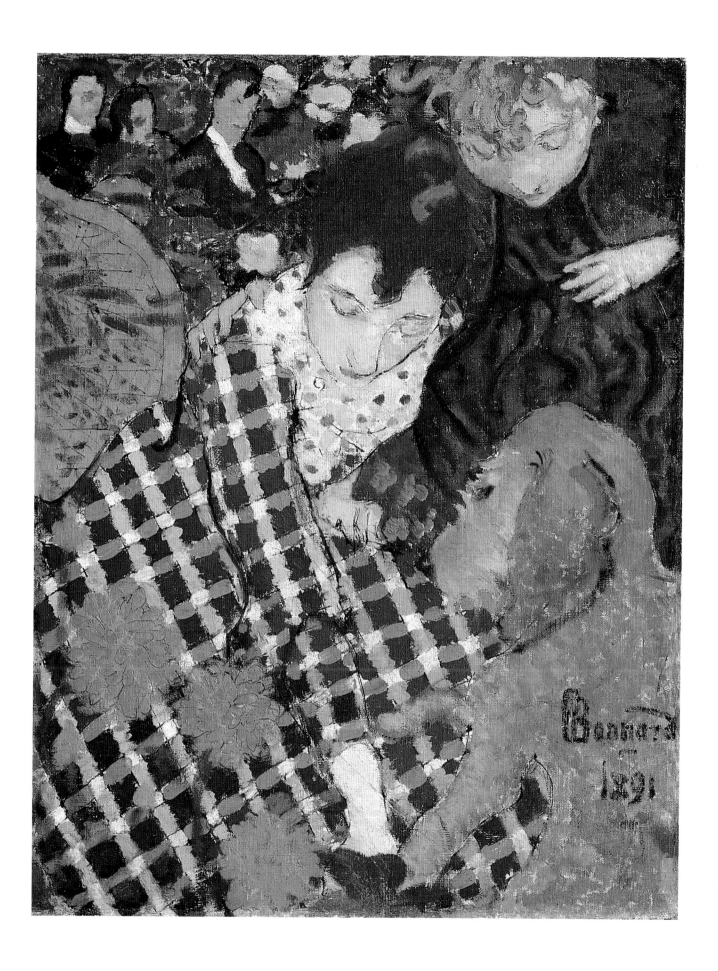

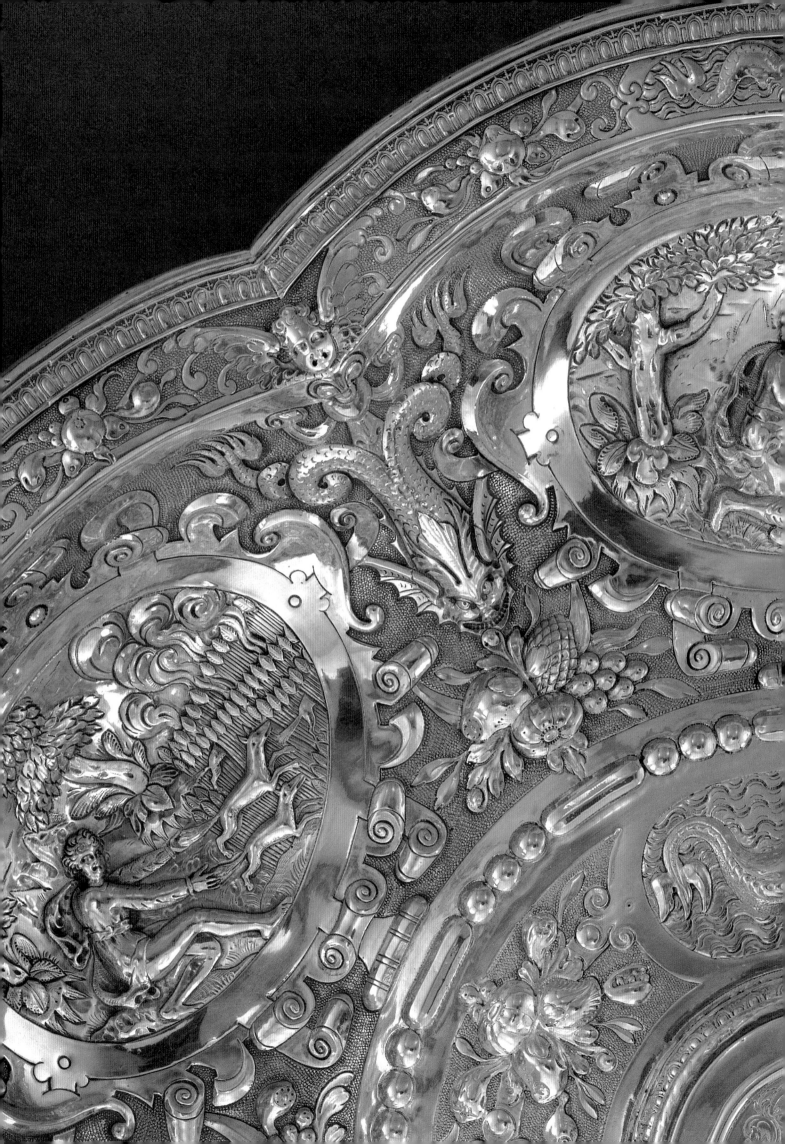

Decorative
Arts

Maker's Mark IV with a star below

PROBABLY DUTCH, 17TH CENTURY

Basin London, 1618

Silver

Height: 2½ in. (6.4 cm); diameter: 20 in. (50.8 cm)

Purchased in honor of Charles Buckley, Institute Trustee 1981–89

1989.2

Until forks came into widespread use, the washing of hands before, during, and after meals was both a necessity and an established ritual. In aristocratic settings, this ceremony involved large silver basins and matching ewers filled with scented water. Two servants carried these vessels to the host and then to his guests around the dinner table. When not in use, the ewers and basins were proudly displayed on the sideboard, where their beauty and costliness could be admired.

While most surviving basins are circular, the magnificent example in the Clark collection is a hexafoil. The Old Testament scenes, chased in high relief within its six lobes, and the twin-tailed sea creatures that separate them are quite rare. The sea monsters and fruit clusters in the center, on the other hand, are standard motifs. The biblical scenes, four from Genesis and two from Judges, are based on the designs of Etienne Delaune (1518/19–1583), a French designer and engraver whose prints were used extensively by goldsmiths, enamelers, and other metalworkers. Delaune's work was influenced by the school of Fontainebleau, evidenced especially in the beautiful strapwork cartouches that surround the biblical scenes.

The fine chasing on this basin suggests that the goldsmith was trained on the Continent, where craft practices were more highly developed than in England. He was very likely among the many goldsmiths who emigrated from Germany and the Low Countries and who, from the sixteenth century onward, played a significant role in enriching the craft in England. The goldsmith who used the mark IV with a star below is known by a number of surviving objects of extraordinary quality. He may be one of several craftsmen with the initials IV who were recorded in the register of aliens at Goldsmiths' Hall, London, in the early seventeenth century.

In the center of the basin are the arms of Edgcumbe of Mount Edgcumbe in the county of Devon. These appear to be considerably later than 1618, the date of the object itself. They are engraved on a small removable cap that could easily have been replaced when the basin changed hands through inheritance or sale. BCW

FOR FURTHER READING

Philippa Glanville, *Silver in Tudor and Early Stuart England* (London: Victoria and Albert Museum, 1990).

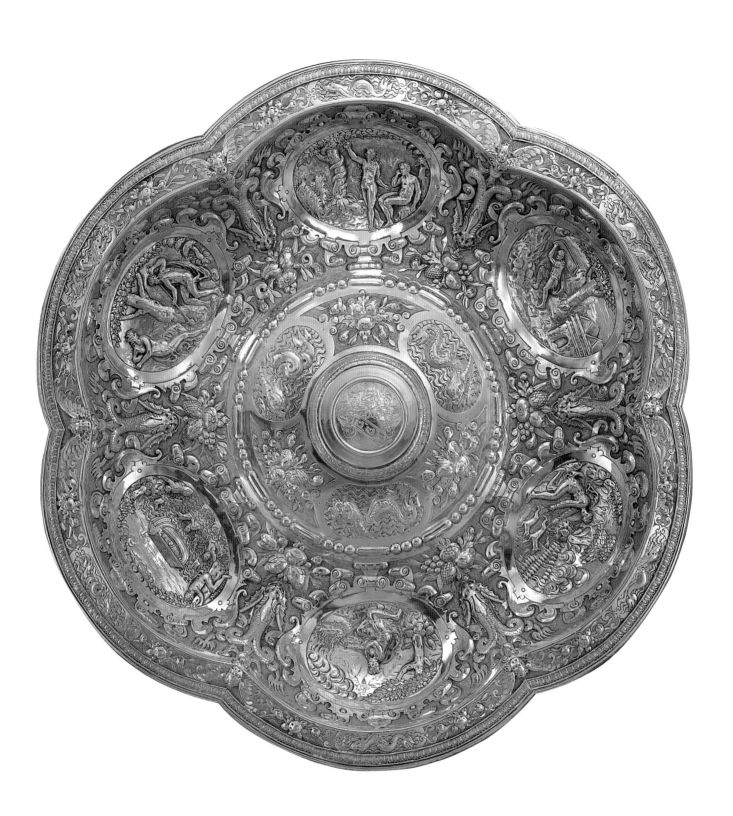

George Lewis

ENGLISH, ACTIVE FROM 1699

Basket London, c. 1700

Silver

Height: 3¼ in. (8.3 cm); diameter: 13¾ in. (34.9 cm)

1987.57

Pierced silver baskets for serving bread, fruit, or cake became increasingly popular during the eighteenth century. This octagonal example is both early and unusual. Its rich design, which incorporates a variety of fruits, flowers, leaves, and swags of drapery, revolves around a large boss engraved with the arms of Montagu, surmounted by an earl's coronet and flanked by scrolled acanthus leaves—all heavily worked in repoussé. The basket is stamped only with George Lewis's mark, struck once clearly and three or more times indistinctly to resemble the customary series of hallmarks. This may simply indicate that it was a commissioned piece and therefore exempt from the usual marking regulations. The presence of the earl's coronet suggests that the basket was made between 1699, the year in which George Lewis entered his mark, and 1705, when Ralph Montagu (1638–1709) was elevated to the dukedom. Lewis is known to have supplied other silver objects to the earl, as evidenced by payments recorded in the Montagu family archives.

The exuberance and lavishness of this basket amply reflect the lifestyle of its first owner. An ardent Francophile who served Charles II as ambassador to France, Ralph Montagu had markedly Continental tastes. Boughton House, his country estate in Northamptonshire, was transformed under his guidance into an extraordinary French palace, decorated by artists and craftsmen brought from France and by refugee Huguenot craftsmen living in England. The same was true of his London residence, Montagu House, which stood on the site now occupied by the British Museum. Ralph Montagu was both politically and personally ambitious. In addition to his role as ambassador, he served as Master of the Royal Wardrobe and member of the Privy Council. He also made two very successful marriages: the first to Elizabeth Wriothesley, the daughter of the earl of Southampton and widow of the earl of Northumberland; the second to Elizabeth Cavendish, the daughter of the duke of Newcastle and widow of the duke of Albemarle. With his wealth, charm, and magnificent homes, Montagu appears to have been a particularly engaging host. William III dined at Boughton House in 1695. The playwright William Congreve visited there in the summer of 1699 and later dedicated *The Way of the World* "to the Right Honourable Ralph Earl of Montague, &c." While this basket may not yet have been in the earl's possession, it is certainly characteristic of the showy silver objects that must have graced his sideboard at that time. BCW

FOR FURTHER READING

Philippa Glanville, "Boughton Silver," in *Boughton House, The English Versailles,* ed. Tessa Murdoch (London: Faber and Faber/Christie's, 1992).

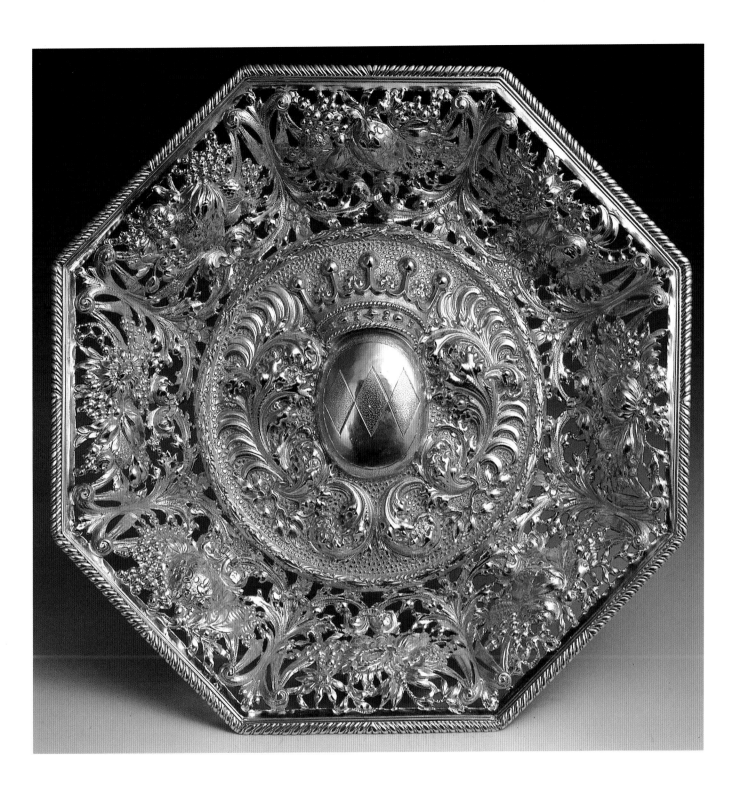

Peter Archambo I

ENGLISH, ACTIVE FROM 1720;
DIED 1767

Wall Sconce, *one of a pair*

London, 1730

Silver
16⅛ × 11⁹⁄₁₆ in. (41 × 29.4 cm)
1991.18

From the mid-sixteenth to the mid-eighteenth century, sets of silver sconces helped to illuminate England's royal and aristocratic homes. The most costly of these were the type known as picture sconces, which were chased with figural scenes. Although popular through the seventeenth century, picture sconces were rarely made by 1730. The sconces in the Clark collection, which are extraordinarily large and superbly crafted, represent the full-blown baroque style. Their backplates are cast with a profusion of putti, cornucopias, scrolls, and festoons of flowers, surmounted by an earl's coronet supported by winged putti. At the center of each backplate, chased in relief, is a scene from Greek mythology: the sconce illustrated here depicts Narcissus admiring his own reflection; the other, the death of Phaethon after losing control of the sun's chariot.

These sconces were originally part of a set of six, each chased with a different mythological scene. They were commissioned by George Booth (1675–1758), second earl of Warrington, for the Great Bedchamber of his home, Dunham Massey, in Cheshire. Lord Warrington was a major patron of several of the Huguenot goldsmiths working in London during the first half of the eighteenth century. His extensive silver holdings are recorded in the inventory he wrote in 1750, *The Particular of my Plate & Its Weight.* On the whole, his silver was quite plain, even old-fashioned, although always substantial and well made. The sconces are among the most extravagant objects that he bought, and it is perhaps revealing that they were intended for his own bedchamber rather than for the more public rooms at Dunham.

Upon the death of his father in 1694, George Booth inherited nearly devastating debts. He used a variety of means to raise capital, including marriage in 1702 to Mary Oldbury, the daughter of a wealthy London merchant. While the bride's dowry of forty thousand pounds helped to replenish the Dunham coffers, it did not ensure a happy marriage. According to a contemporary observer, Phillip Bliss, "Some time after my lady had consigned up all her fortune to pay my lord's debts, they quarrelled, and lived in the same house as absolute strangers to one another at bed and board." Their union produced one daughter, Lady Mary, who married the fourth earl of Stamford in 1736. At her father's death in 1758, she inherited his estate, including the silver, which remained in the family until its sale at auction in 1921 and 1931.

Lord Warrington's patronage of Huguenot goldsmiths may reflect his family's Protestant sympathies, but it also assured high-quality wares. Isaac Liger (active from 1704) was his primary goldsmith until 1728, at which time Peter Archambo began to supply most of his silver. In addition to the sconces and a good deal of standard domestic plate, Archambo produced for Dunham Massey a magnificent wine fountain, which now belongs to the Worshipful Company of Goldsmiths, London, and an immense wine cistern. BCW

FOR FURTHER READING
Dictionary of National Biography, s.v. "Booth, George (1675–1758)."
J. F. Hayward, "The Earl of Warrington's Plate," *Apollo* 108 (July 1978).
Sotheby's, London, *Important Silver* (May 3, 1990).
James Lomax, "Parsimony by Candlelight: Lord Warrington's Silver Lighting Equipment," *Apollo* 137 (April 1993).

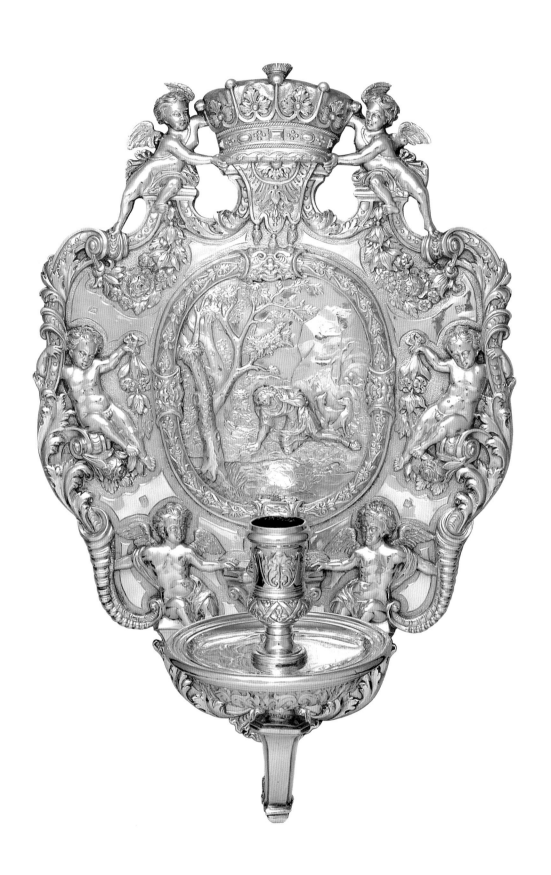

Paul de Lamerie

ENGLISH, 1688–1751

Two-Handled Cup and Cover London, 1730

Silver

Height: 10⅜ in. (26.4 cm); width at handles: 10⁵⁄₁₆ in. (26.2 cm); diameter at base: 4⅜ in. (11.1 cm)

1955.371

The ceremonial covered cup, still presented today to mark important occasions and accomplishments, first became fashionable in the early eighteenth century. Its form derived from the smaller two-handled cups known as porringers, caudle cups, or posset pots, which were used during the seventeenth century for various spiced alcohol-and-gruel concoctions.

This elegant and dignified example has the standard inverted bell-shaped body with cast S-scroll handles and a baluster finial. Cast strapwork and ninepin ribs have been soldered to the lower body and the cover. Particularly distinctive are the cast armorial cartouches applied to both cup and cover in place of the more usual engraved coats of arms. Amid the shells, scrolls, diapers, and floral festoons that comprise each cartouche is a central lozenge-shaped shield engraved with the arms of Martha Perris, the daughter and co-heiress of William Perris, esquire, of Hayes. The lozenge shape indicates that the arms are those of a single woman.

Both cup and cover bear the mark of one of England's best-known and most prolific eighteenth-century goldsmiths, Paul de Lamerie. The son of French Huguenot refugees who settled in London in the late seventeenth century, de Lamerie continued the tradition of fine craftsmanship in which he was trained by his master, Pierre Platel (c. 1664–1719). De Lamerie's work, which is particularly well represented in the Clark collection, encompasses both the elegant courtly silver of the early eighteenth century and the livelier, more fanciful rococo style of mid-century, with which he is most often associated (see p. 138). BCW

FOR FURTHER READING

Paul De Lamerie: At the Sign of the Golden Ball, exhibition catalogue (London: Goldsmiths' Hall, 1990).

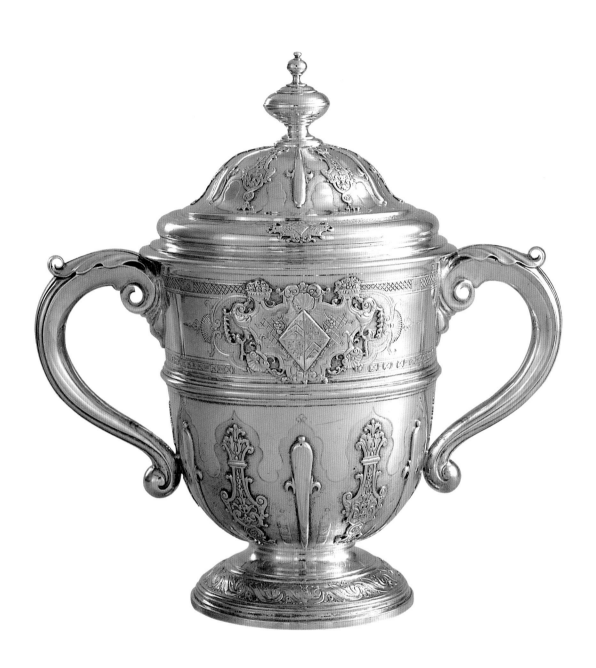

Paul de Lamerie

ENGLISH, 1688–1751

Two-Handled Cup and Cover London, 1742

Silver
Height: 15½ in. (39.4 cm); width at handles: 9³⁄₁₆ in. (23.3 cm); diameter at base: 5 in. (12.7 cm)

1955.413

Paul de Lamerie's mastery of the rococo style is abundantly apparent in this two-handled cup and cover. Related in form to the inverted bell-shaped cups made earlier in the eighteenth century (see p. 136), this example is enlivened with an energy and intensity characteristic of rococo design. The basic elements were raised and chased. Additional details—the infant Bacchus, grape clusters, scrolls, and flowers—were cast separately and attached with solder. Everywhere naturalism combines with fantasy. On the foot, two lions' heads are adrift in a sea of rococo scrolls. Handles in the form of stocky grapevines wound with leafy tendrils are capped with naturalistic snails. On the cover, a lizard perches atop the bunch of grapes that serves as the finial.

At least three other versions of this cup and cover are known. Each differs only in minor details of chasing. De Lamerie (or perhaps a designer in his employ) also used the same basic format for related cups and applied different cast elements where needed. The resourceful reuse of successful designs and individual cast elements was essential in a busy eighteenth-century goldsmith's shop. Ideas were borrowed from other goldsmiths' work, as well. The handles on this cup, for instance, may copy those used by the Paris goldsmith Thomas Germain (1673–1748) on a pair of ice buckets of 1727 now in the Musée du Louvre, Paris. BCW

FOR FURTHER READING
Rococo: Art and Design in Hogarth's England, exhibition catalogue (London: Victoria and Albert Museum, 1984).

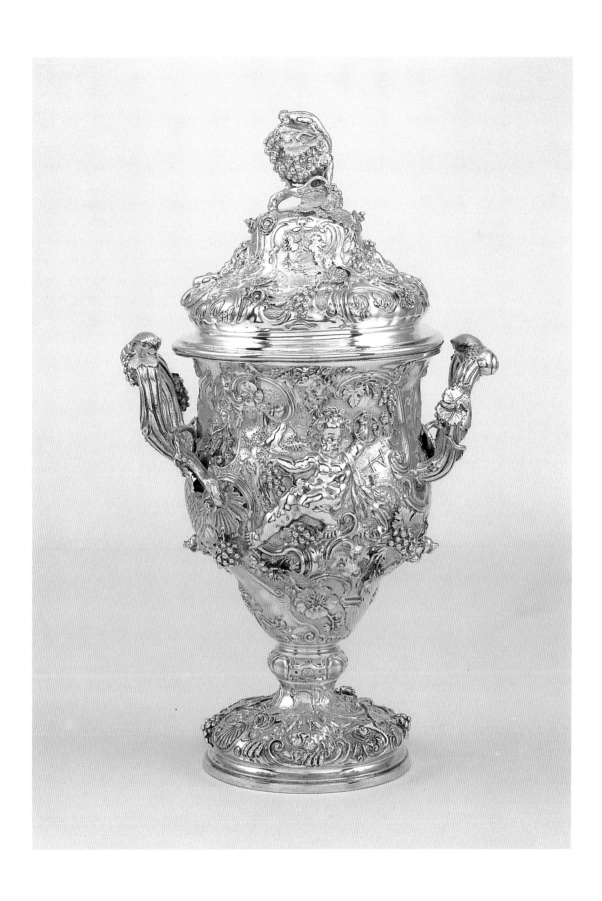

Paul Crespin

ENGLISH, 1694–1770

Pair of Sauceboats

London, 1746

Silver

Height: 6³⁄₁₆ in. (15.7 cm); length: 8½ in. (21.6 cm)

1986.21

By the 1730s a new range of dinnerware, including soup tureens, epergnes, and sauceboats, had been introduced into England from France. The earliest silver sauceboats had two handles and two spouts, but the advantages of a single handle and a broad pouring lip were soon apparent. Silver sauceboats in various sizes, accompanied by ladles and under-dishes, became standard items in the extensive dinner services amassed by noblemen and prosperous gentry.

The Crespin sauceboats are fashioned as deeply fluted shells, ornamented with panels of shellwork, which were cast separately and soldered in place. Such motifs are characteristic of rococo art. The term *rococo* derives from the French *rocaille,* referring to the rocky and shell-like materials used to construct the artificial caves and grottoes that were popular in gardens of the sixteenth and seventeenth centuries.

Paul Crespin, whose mark appears on these sauceboats and on several others of similar design, was one of the most talented of the Huguenot goldsmiths working in eighteenth-century London. He was patronized by numerous members of the English aristocracy, by Empress Catherine of Russia, and by the king of Portugal, to whom he supplied a huge silver vessel for bathing. Crespin's surviving oeuvre indicates business dealings with other Huguenot goldsmiths, such as the Liège-born Nicholas Sprimont (1716–1771). A number of sauceboats identical to the Clark pair are attributed to Sprimont; this suggests a shared design source if not a single maker. One unmarked set, now at the Museum of Fine Arts, Boston, is accompanied by matching under-dishes that are stamped with Sprimont's mark and with the London hallmarks for 1746. The oval under-dishes with radiating bands of shellwork are of a design later produced in porcelain by Sprimont, who by 1748 had abandoned goldsmithing to become a principal partner in the Chelsea Porcelain Manufactory. The relationship between Crespin and Sprimont, both of whom had workshops on Compton Street in Soho, has been the subject of considerable study but remains something of a mystery. Another goldsmith with whom Crespin appears to have exchanged goods and services is Paul de Lamerie (see pp. 136–138). Because subcontracting among goldsmiths was a common practice, the maker's mark stamped on any piece of silver must be understood to be that of the retailer and not necessarily that of the actual craftsman. BCW

FOR FURTHER READING

Arthur Grimwade, "Crespin or Sprimont? An Unsolved Problem of Rococo Silver," *Apollo* 90 (August 1969).

Rococo: Art and Design in Hogarth's England, exhibition catalogue (London: Victoria and Albert Museum, 1984).

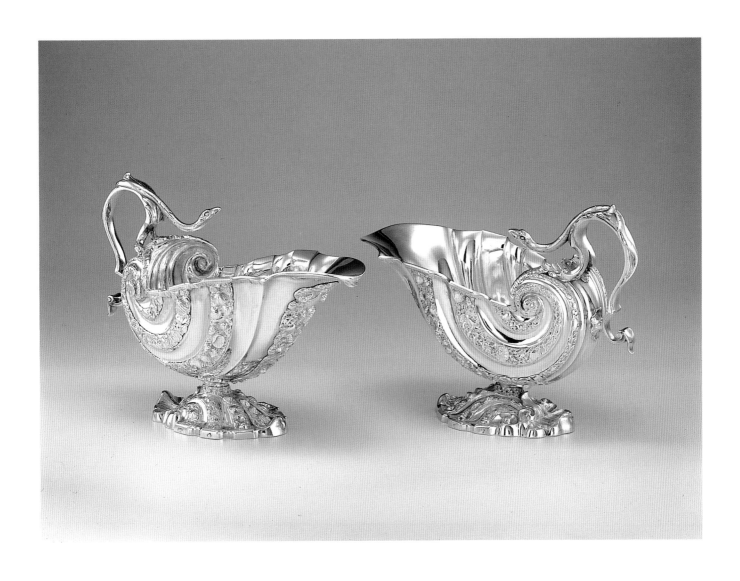

Paul Revere II

AMERICAN, 1735–1818

Sugar Urn and Cover

Boston, c. 1795

Silver

Height: 9½ in. (24.1 cm); diameter at base: 3⅜ in. (8.6 cm)

Acquired with funds donated anonymously

1987.108

The famed American patriot Paul Revere was an accomplished silversmith whose sizable oeuvre is well documented by the daybooks, or business ledgers, that he kept intermittently from 1761 to 1797. He was a successful and innovative entrepreneur not only as a silversmith but also as an engraver on copper plates, a dentist, and the owner of a hardware business, copper mills, and a brass foundry. Despite his many and varied activities, however, it was the craft of the silversmith that served as his primary occupation for over forty years. This covered sugar urn is a fine example of his neoclassical silver, characterized by clean lines, restrained ornament, and refined proportions. The shape was extremely popular in America toward the end of the eighteenth century, when allusions to the styles and virtues of ancient Rome held particular appeal for citizens of the young republic.

The body of the urn sits on a flared circular foot on a square plinth stamped with the silversmith's mark, REVERE. The tall cover, which contributes to the overall lightness and elegance of the form, terminates in a cast flame-shaped finial. Decoration is limited to simple reeding, fretwork, and the prominent acorn-and-leaf border engraved around the top of the body. Revere's daybooks record a number of "sugar urns" and "sugar vases" supplied to his customers during this period. Surviving examples are either plain, as here, or fluted.

The original owner of this urn is known to us through the monogram SSE, engraved in script on the body. Sarah Sargent Ellery was the daughter of John Stevens Ellery and his wife, Esther Sargent Ellery. Bearing the initials of Sarah's maiden name, the sugar urn was probably acquired before her marriage in October 1795 to her cousin Ignatius Sargent, a merchant in Gloucester and Boston. This monogram is found on other examples of silver marked by Revere.

Robert Sterling Clark recorded his high opinion of Revere's work in his diary on February 22, 1929: "Truly he stood all by himself as an artistic silversmith & really superior in these pieces to any of the same kind by English makers.... The other American makers were good but in no way superior to the English." BCW

FOR FURTHER READING

Paul Revere's Boston: 1735–1818, exhibition catalogue (Boston: Museum of Fine Arts, 1975).

Paul Revere—Artisan, Businessman, and Patriot: The Man behind the Myth, exhibition catalogue (Lexington, Mass.: Museum of Our National Heritage, 1988).

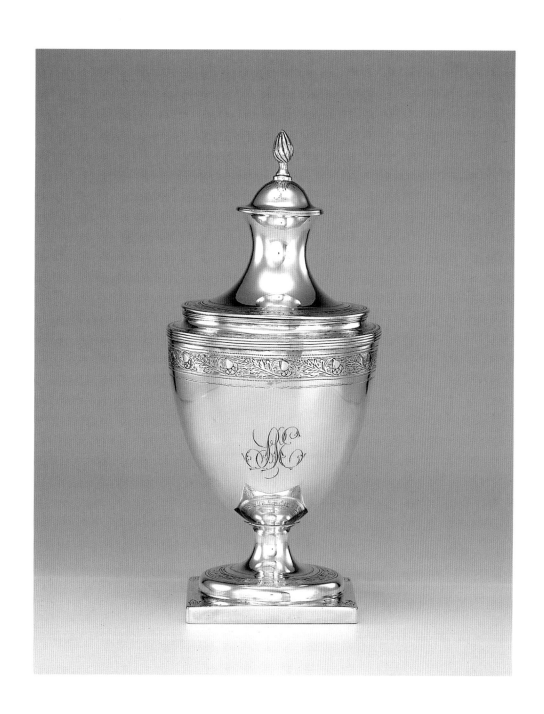

Vincennes

FRENCH

River God c. 1747

Soft-paste porcelain

Height: 11½ in. (29.2 cm)

1972.13

The magnificent figure of a river god in the Clark collection is one of the earliest surviving examples of sculpture produced by the royal porcelain factory at Vincennes. This ambitious work was modeled by hand, as indicated by the absence of mold marks and by obvious differences between it and other known versions. The bearded figure, crowned with a laurel garland and holding a paddle, is seated on a dolphin from whose mouth water flows into waves, metamorphosed into a large undulating shell at the back of the sculpture. In related models the river god reclines against an overturned urn from which water streams. Drying cracks beneath the right leg of the Clark's figure are masked by a cluster of naturalistic flowers, which were applied prior to firing and glazing. Although the piece is unmarked, it seems likely that it was modeled by the sculptor Louis-Antoine Fournier (b. 1720). Factory records show that in 1747 he supplied several figures of naiads and river gods.

The Vincennes porcelain factory, which would later become the French royal factory of Sèvres, was established in 1740 in the royal château of Vincennes. There craftsmen succeeded in developing a dazzling white soft-paste, or artificial, porcelain exceptional enough to compete with the "true" porcelain produced in the Far East and at the Meissen factory in Dresden. Porcelain flowers were among the earliest products manufactured at Vincennes and proved to be extremely popular. Figures like this river god were also produced in the early years of the factory. According to factory archives, over a thousand individual figures and groups were in stock in the fall of 1752, although very few are extant today. BCW

FOR FURTHER READING

Porcelaines de Vincennes: Les Origines de Sèvres, exhibition catalogue (Paris: Editions des musées nationaux, 1977).

Tamara Préaud and Antoine d'Albis, *La Porcelaine de Vincennes* (Paris: Editions Adam Biro, 1991).

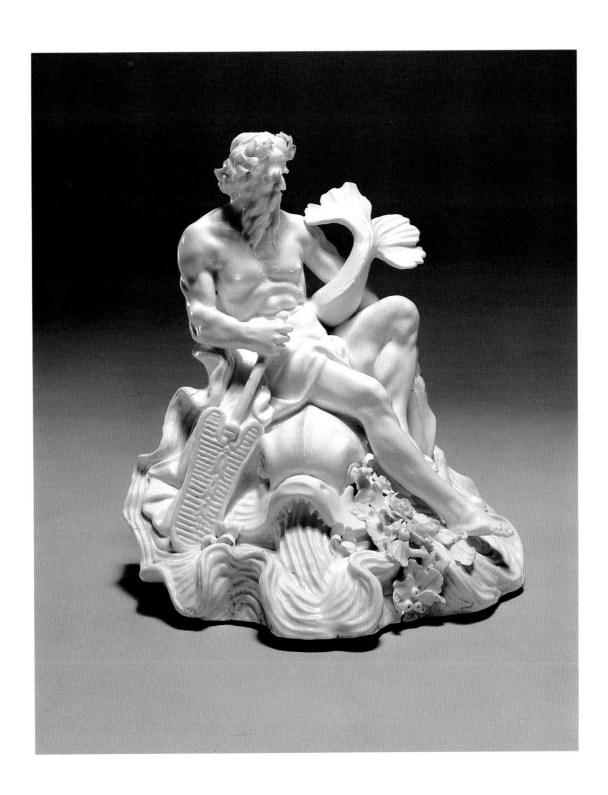

Worcester

ENGLISH

Covered Basket and Stand, *one of a pair* 1770–75

Soft-paste porcelain

Height, basket and cover: 5⅜ in. (13.7 cm); length, stand: 10⁵⁄₁₆ in. (26.2 cm)

Bequest of Herbert Heidelberger in honor of Minna and Frederick Heidelberger

1986.93

The Worcester Porcelain Manufactory was established in 1751 by fifteen subscribers, among them the physician John Wall, whose name is often applied to the first and most ambitious period of production (1751–83). Like other eighteenth-century English factories, Worcester attempted not only to compete with those on the Continent, such as Meissen and Sèvres, but also to offer alternatives to the sumptuous porcelains imported from the Orient. With his associate, the apothecary William Davis, Dr. Wall devised a formula for soft-paste porcelain made with Cornish soapstone (steatite), which produced a thin, durable paste well suited to utilitarian wares. Harder than traditional glassy soft-pastes, their product did not crack or craze when exposed to boiling water. Soapstone porcelain had first been made about 1751 at the Bristol factory, which was acquired the following year by Worcester.

The Worcester factory is best known for its dinner and tea wares decorated with underglaze blue, overglaze polychrome enamels, or transfer-printed designs. Among the most elaborate of these products are the oval covered baskets on stands often referred to as chestnut baskets. On the pair in the Clark collection, the molded pattern of honeycombs and flowers and the individually modeled and applied flowers and twig handles are painted in a varied palette of overglaze enamels. The inside of the basket and the center of the stand are painted in the famous Worcester scale blue, an underglaze ground color of deep blue patterned with darker overlapping scales, and with delicate polychrome bouquets.

The Worcester factory employed a number of different marks but rarely dated its products. Shards and wasters unearthed at the site, however, have assisted specialists in dating certain types of objects. For instance, the fretted square mark that is painted beneath the Clark's baskets and their stands has been found frequently on objects decorated in underglaze blue that can be dated to between 1765 and 1775. BCW

FOR FURTHER READING

Henry Sandon, *The Illustrated Guide to Worcester Porcelain 1751–1793*, 3rd ed. (London: Barrie & Jenkins, 1980).

Simon Spero, *Worcester Porcelain, The Klepser Collection* (Minneapolis: Minneapolis Institute of Arts, 1984).

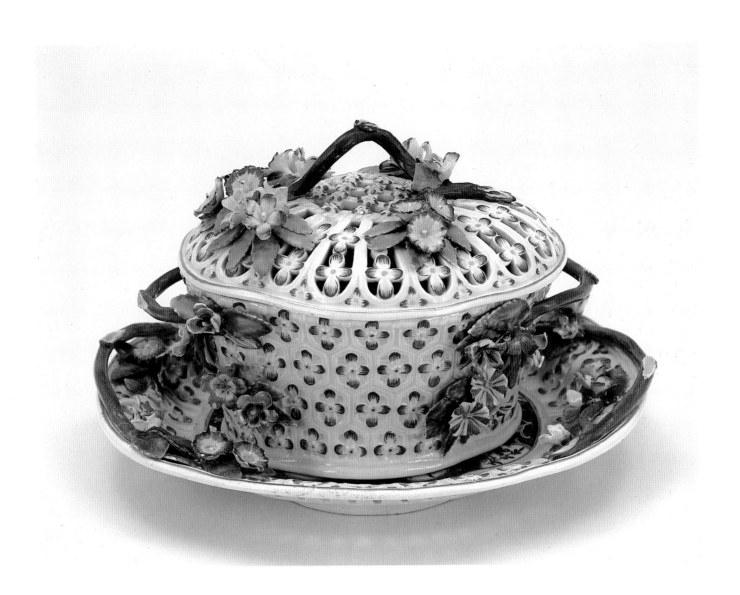

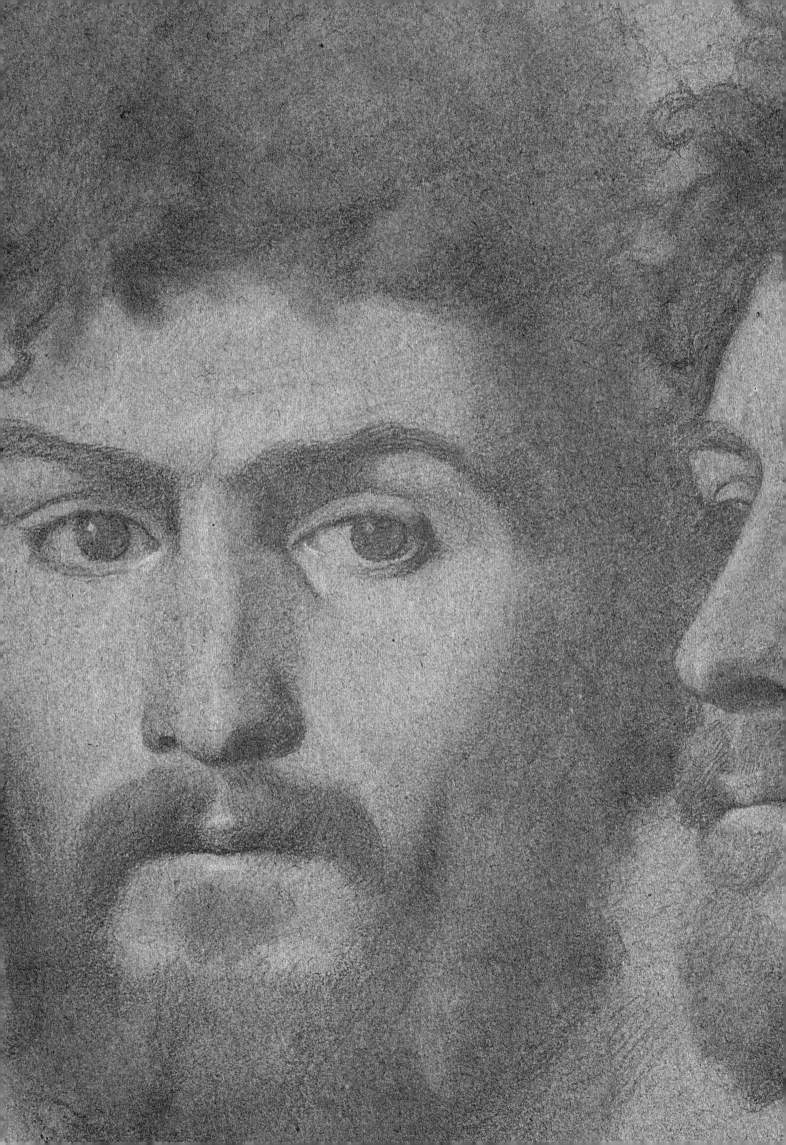

Prints
and
Drawings

Jean Bourdichon

FRENCH, ACTIVE IN TOURS
C. 1457–1521

Saint Mark c. 1510

Tempera heightened with gold on
parchment, laid down on panel

7¹¹⁄₁₆ × 5¹¹⁄₁₆ in. (19.5 × 14.4 cm)

Unsigned

1955.1873

J ean Bourdichon is recorded as having been a pupil and follower of
Jean Fouquet (c. 1420–c. 1480), perhaps the most famous painter
in Renaissance France. The evangelist Saint Mark, accompanied
by his symbol, the lion, was depicted by Bourdichon as a
youthful, beardless humanist in the act of writing his gospel. Bourdichon
retained the gravity and grandeur associated with Fouquet.

The creative energies of French artists during the late fifteenth century
were challenged by Italian novelties such as one-point perspective. It took
some time for them to master the difficulties posed by these new ideas.
Bourdichon had probably never visited Italy and had to rely on his imagi-
nation to depict the setting for Saint Mark. He coped rather tentatively
with the demands of producing a believable form of an unfamiliar scene.
The realism of the desk and its placement within a room filled with Italian
Renaissance elements and classical architectural details is impressive if not
entirely successful.

In the mid-nineteenth century, Bourdichon became recognized as a
definite artistic personality. A number of important manuscripts were
attributed to him and his workshop. This painting was originally created
as an illumination for a book of hours, an illustrated prayer book popular
in the fifteenth century. This sheet probably was detached from the book in
the eighteenth century in order to be mounted for display or sale. RF

FOR FURTHER READING

Paul-André Lemoisne, *Gothic Painting in France, Fourteenth and Fifteenth Centuries,*
trans. Ronald Boothroyd (Paris: Pegasus Press, 1931).

Egbert Haverkamp-Begemann, *Drawings from the Clark Art Institute* (New Haven:
Yale University Press, 1964).

Whitney S. Stoddard, *Monastery and Cathedral in France* (Middletown, Conn.:
Wesleyan University Press, 1966).

Master Drawings: Sterling and Francine Clark as Collectors, exhibition catalogue
(Williamstown: Sterling and Francine Clark Art Institute, 1995).

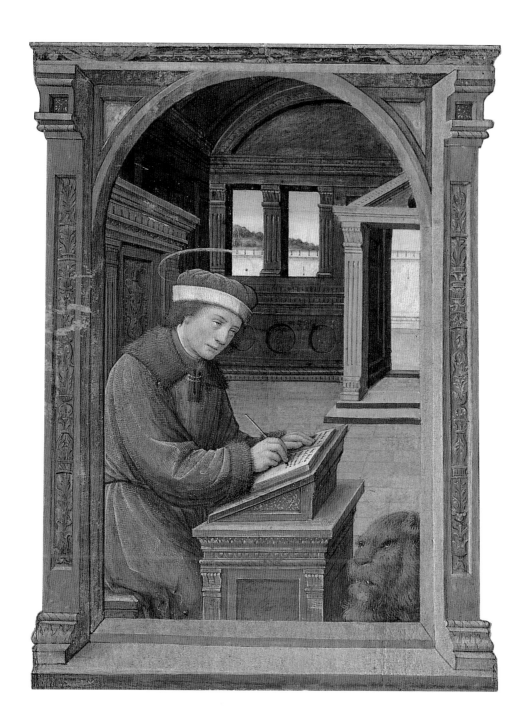

Attributed to
Giovanni Boltraffio

ITALIAN (MILANESE), 1467–1516

Head of a Woman

Undated

Silverpoint

5⅞ × 4⅞ in. (15 × 12.4 cm)

Falsely signed lower left: LEONARDO DA VINCI

1955.1470

This drawing is thought to be the work of Giovanni Boltraffio, a member of a rich and noble family from the country outside Milan. He was a follower of Leonardo da Vinci (1452–1519), who had come to Milan from Florence about 1482 and joined the court of Lodovico il Moro and Beatrice d'Este. In his Milan workshop, Leonardo had a host of followers and pupils. Their styles, which are decidedly imitative of the master's, are almost indistinguishable one from the other. Boltraffio was recorded as a pupil of Leonardo in 1490, and his name appears in Leonardo's notes until September 24, 1513. At that time, the final and perhaps most important mention states that the master left Milan for Rome with five followers, among whom is listed Boltraffio.

The inscription "Leonardo da vinci" in the lower left corner of the drawing is a later addition, dating perhaps from the eighteenth or nineteenth century. In the lower right corner is an authentic collector's mark. It identifies the drawing as having belonged to Sir Peter Lely (1618–1680), a Flemish artist who settled in London and became a successful portrait painter in the court of Charles II as well as an avid and distinguished collector. RF

FOR FURTHER READING

Egbert Haverkamp-Begemann, *Drawings from the Clark Art Institute* (New Haven: Yale University Press, 1964).

Giorgio Castelfranco, *Drawings by Leonardo da Vinci,* trans. Florence H. Phillips (New York: Dover Publications, 1968).

Master Drawings: Sterling and Francine Clark as Collectors, exhibition catalogue (Williamstown: Sterling and Francine Clark Art Institute, 1995).

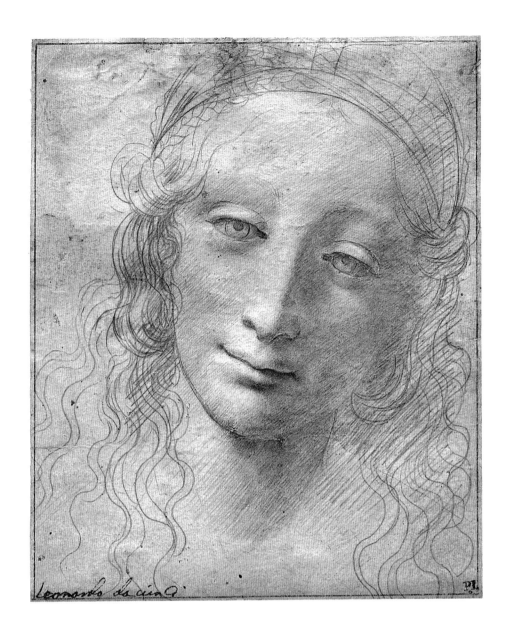

leonardo da cino

Albrecht Dürer

GERMAN, 1471–1528

Sheet of Studies with Sketches of Animals and Landscapes 1521

Pen and black ink with colored washes

10⁷⁄₁₆ × 15⅝ in. (26.4 × 39.7 cm)

Signed with monogram and dated upper right: AD 1521

1955.1848

In England in 1917, the earl of Pembroke sold at auction some of the treasures of his ancestral home, Wilton House. Among them was a print by Agostino Veneziano (1490–1540), *The Death of Ananias,* which had been repaired by attachment to a sheet of paper and placed in an eighteenth-century album. After the sale, the supporting sheet of paper was detached from the print and found to be this Dürer drawing. The surprise was great in the museum world, and the discovery was immediately published.

Albrecht Dürer visited the zoological garden in Brussels during a visit to that city in September 1520. He returned to the garden the following year when he was back in Brussels from July 3 to 12. This sketch page certainly dates to the second trip to Brussels. It is unlikely that Dürer had ever seen real lions before his 1520 visit to the Low Countries; those that appear in his earlier works are clearly not based on direct observation but look as if inspired by a household cat. The other animals in this drawing are a chamois, a lynx, and a monkey of the stump-tailed kind known as the Black Ape of Celebes. An inscription in Dürer's own hand in the upper right corner describes it as "a curious beast which I have seen weighing one and a half hundred weight." The landscapes, while not identifiable, are typical of the Rhineland, and the architecture resembles that of northern Italy. The building and bridge, in fact, also appear in an etching of 1545 by Augustin Hirschvogel (1503–1553).

The sheet is covered with drawings very much in the manner of a medieval sketchbook; each animal is viewed as a separate entity and no attempt has been made to depict their relative sizes. It was not uncommon for Dürer to reuse paper to save money; an examination of his notes and surviving statements shows that he was very careful in the use of his financial resources and artist's materials. It seems likely that the artist, reluctant to waste a large expanse of excellent blank paper, added the landscapes as an unrelated afterthought. RF

FOR FURTHER READING

Egbert Haverkamp-Begemann, *Drawings from the Clark Art Institute* (New Haven: Yale University Press, 1964).

Philip Troutman, *Albrecht Dürer: Sketchbook of His Journey to the Netherlands 1520–21* (London: Elektra, 1971).

Walter L. Strauss, *The Complete Drawings of Albrecht Dürer* (New York: Abaris Books, 1974).

Jane Campbell, *Albrecht Dürer: A Biography* (Princeton: Princeton University Press, 1990).

Master Drawings: Sterling and Francine Clark as Collectors, exhibition catalogue (Williamstown: Sterling and Francine Clark Art Institute, 1995).

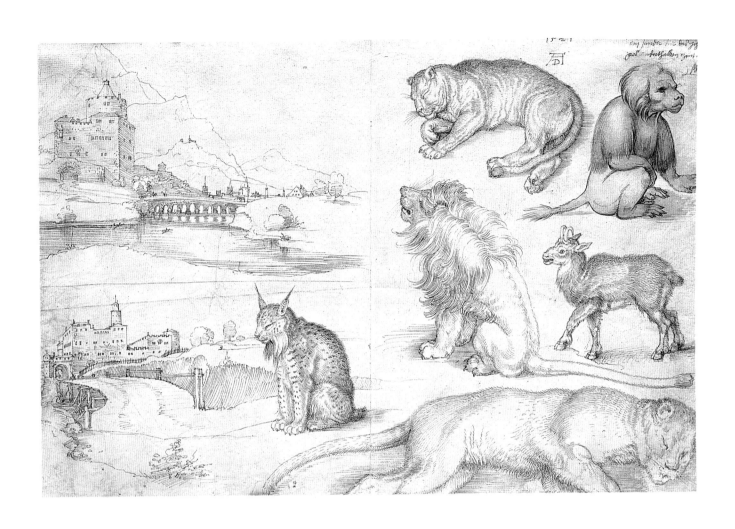

Peter Paul Rubens

FLEMISH, 1577–1640

Portrait of Thomas Howard, Earl of Arundel c. 1629–30

Ink, oil, and wash

18¼ × 14 in. (46.3 × 36.5 cm)

Unsigned

1955.991

In 1629 Peter Paul Rubens was sent to England on a diplomatic mission for Archduchess Isabella, the regent of Flanders, and King Philip IV of Spain. While discharging that responsibility, Rubens also found time to practice his art. He was awarded an honorary degree of Master of Arts from Cambridge University in September 1629, and Charles I recognized his brilliance and knighted him in 1630. The earl's portrait was certainly produced sometime during these two years.

Thomas Howard (1585–1646), the earl of Arundel, was one of the greatest English gentlemen of his day. He held the eminent position of Lord High Constable at the courts of James I and Charles I and traveled widely on the Continent, always on a grand scale. He was also a serious collector of ancient sculpture, which Rubens admired.

This drawing is a preparatory study for a portrait of Arundel that was probably commissioned in 1629. Today, the oil portrait is one of the treasures of the Isabella Stewart Gardner Museum in Boston. A smaller oil portrait showing only Arundel's head and shoulders is in the National Portrait Gallery in London. Both paintings depict a weariness and introspection in the sitter that are absent in the drawing.

While the lasting peace between England and Spain that had been Rubens's goal was not achieved, his trip to England had significant artistic consequences. Certainly, one of the grandest is his state portrait of this proud and powerful man. RF

FOR FURTHER READING

Egbert Haverkamp-Begemann, *Drawings from the Clark Art Institute* (New Haven: Yale University Press, 1964).

Stephen Longstreet, *The Drawings of Rubens* (Los Angeles: Borden Publishing Company, 1964).

Julius Held, *Rubens: Selected Drawings* (Oxford: Phaidon, 1986).

Master Drawings: Sterling and Francine Clark as Collectors, exhibition catalogue (Williamstown: Sterling and Francine Clark Art Institute, 1995).

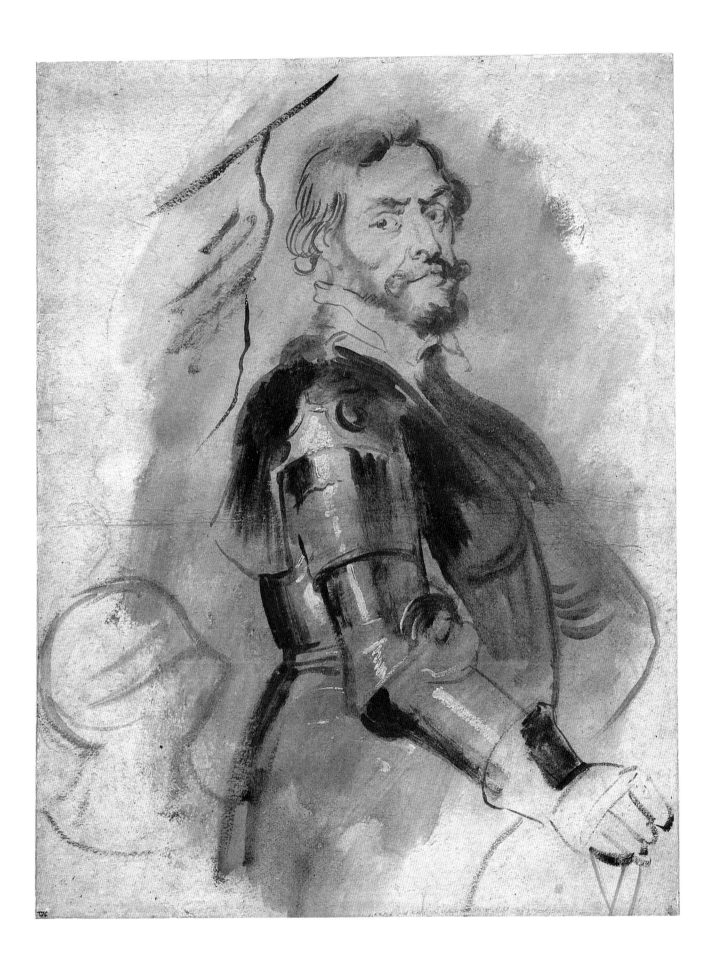

Rembrandt Harmensz. van Rijn

DUTCH, 1606–1669

Christ Finding the Apostles Asleep c. 1654

Pen and brown ink with brown and grayish brown wash

7¼ × 11 in. (18.3 × 28 cm)

Unsigned

1955.994

This drawing is a fine example of the mature style of Rembrandt Harmensz. van Rijn. By the 1650s his work had become increasingly monumental and less detailed. He also manipulated his washes with great care. The brown wash in this drawing is typical; the grayish brown wash has been questioned as a later addition.

On the eve of the crucifixion, Christ and his disciples went to Gethsemane, where he asked them to keep watch while he went a short distance away to pray. The artist chose to represent the moment when Christ returned only to find the disciples asleep. This subject is rare in Rembrandt's work. He set the scene by placing the figures in a broad landscape executed with powerful gestures and great economy of line. RF

FOR FURTHER READING

Otto Benesch, *Rembrandt as a Draughtsman* (London: Phaidon, 1960).

Egbert Haverkamp-Begemann, *Drawings from the Clark Art Institute* (New Haven: Yale University Press, 1964).

Seymour Slive, *Drawings of Rembrandt, with a Selection of Drawings by His Pupils* (New York: Dover Publications, 1965).

Master Drawings: Sterling and Francine Clark as Collectors, exhibition catalogue (Williamstown: Sterling and Francine Clark Art Institute, 1995).

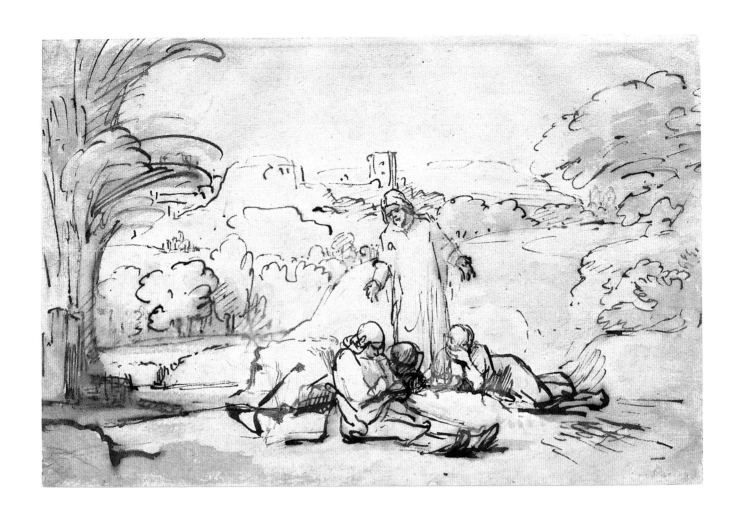

Antoine Watteau

FRENCH, 1684–1721

Woman in Black c. 1719

Black and red chalk
7¾ × 7¹/₁₆ in. (19.7 × 17.9 cm)
Unsigned
1955.1831

A lthough born in Valenciennes, part of Flanders in the seventeenth century, Antoine Watteau is considered a quintessentially French artist. During the last years of Louis XIV, who died in 1715, the formal seriousness of French classicism was attenuated, and the grand severity of the court artist Charles Lebrun (1619–1690) gave way to themes that emphasized the spirited and relaxed society of the Regency. Even the weary old king asked his artists to surround him with children. The passing of the austere art that had characterized the age of Louis XIV was beneficial to the artistic temperament of Watteau; he brought into French art the penchant for joy and gaiety that Flemish art had always possessed.

Watteau was admired as the inventor of a new category of painting, the *fête galante,* which depicted elegantly clad men and women flirting and dancing at garden parties. Indeed, many of his drawings are directly related to figures in his paintings. These figures are the result of carefully developed impressions derived from a well-observed reality. At the same time, however, they inhabit a world of poetic dreams that reveal hints of the contemporary musical theater. In the *Woman in Black,* Watteau created a fascinating character with the capacity to move the viewer. Her calm but sad expression is echoed in a number of drawings executed about 1719. At this time, Watteau, who had only two more years to live, was planning to seek help for his consumption from the famous Dr. Richard Mead in London. Watteau went to England, but after nearly a year he returned to France late in the summer of 1720 without having been cured. He died the following year. RF

FOR FURTHER READING

Egbert Haverkamp-Begemann, *Drawings from the Clark Art Institute* (New Haven: Yale University Press, 1964).

René Huyghe, *Watteau,* trans. Barbara Bray (New York: George Braziller, 1970).

Giovanni Battista Tiepolo

ITALIAN, 1696–1770

The Flight into Egypt

c. 1750–60

Pen, brush, and brown ink with wash over red chalk

9⅝ × 8 1/16 in. (24.4 × 20.5 cm)

Unsigned

1955.1466

The flight of the Holy Family into Egypt (Matthew 2:13–23) was a favorite subject of both Giovanni Battista and his son, Giovanni Domenico Tiepolo (1727–1804). The draftsmanship of Giovanni Battista Tiepolo follows in the tradition of Venetian artists. The convention of using the white of the paper for whatever is white in a drawing is also an important feature of his work. Tiepolo was incredibly gifted in his calligraphic handling of the brush and pen and also in his command of washes. His drawings appear to have been produced very quickly, always with a strong and certain touch. That skill was brought also to his many etchings and paintings. RF

FOR FURTHER READING

Egbert Haverkamp-Begemann, *Drawings from the Clark Art Institute* (New Haven: Yale University Press, 1964).

Joseph Mallord William Turner

BRITISH, 1775–1851

Brunnen, from the Lake of Lucerne 1845

Watercolor and body color

11¹¹⁄₁₆ × 18¹³⁄₁₆ in. (29.7 × 47.8 cm)

Unsigned

1955.1865

Turner first visited the Swiss Alps in 1802. The breathtaking beauty of the landscape drew him back on numerous occasions. From 1841 to 1844 he returned each year specifically to sketch in watercolor. These studies were shown to prospective clients in hopes of procuring commissions for fully finished watercolors, of which Turner produced nine in 1845, including *Brunnen, from the Lake of Lucerne*.

Turner began his career as a topographical artist, creating exact renderings of particular sites in pencil and/or pen and ink enhanced with watercolor. His imagination and skill brought the watercolor medium to new expressive heights. *Brunnen, from the Lake of Lucerne* represents his late style, in which watercolor and body color (opaque watercolor) are manipulated in every conceivable way. Paint is applied in washes, as well as in dry linear strokes. Highlights are created both by the application of opaque color and by the scraping away of wet paint. The detail, texture, and atmosphere that Turner achieves give watercolors such as this an appearance not unlike his oil paintings (see p. 42).

Brunnen, from the Lake of Lucerne is believed to have been commissioned by Turner's staunchest supporter, John Ruskin. An important and influential art critic, artist, and author, Ruskin owned many works by Turner, including several watercolors from the 1840s series. In this image Turner invites the viewer to contemplate the grandeur of the mountains that dwarf the figures and townscape and are enveloped in mist in the distance. If this is indeed the view of Brunnen that belonged to Ruskin, it caused him to remark that Turner spoiled it by including ugly hotels that did not appear in the preliminary sketch. PRI

FOR FURTHER READING

Egbert Haverkamp-Begemann, *Drawings from the Clark Art Institute* (New Haven: Yale University Press, 1964).

Andrew Wilton, *Turner and the Sublime* (London: British Museum Publications, 1980).

Andrew Wilton, *Turner Watercolours in the Clore Gallery* (London: Tate Gallery, 1987).

David Hill, *Turner in the Alps: The Journey through France and Switzerland in 1802* (London: George Philip, 1992).

Master Drawings: Sterling and Francine Clark as Collectors, exhibition catalogue (Williamstown: Sterling and Francine Clark Art Institute, 1995).

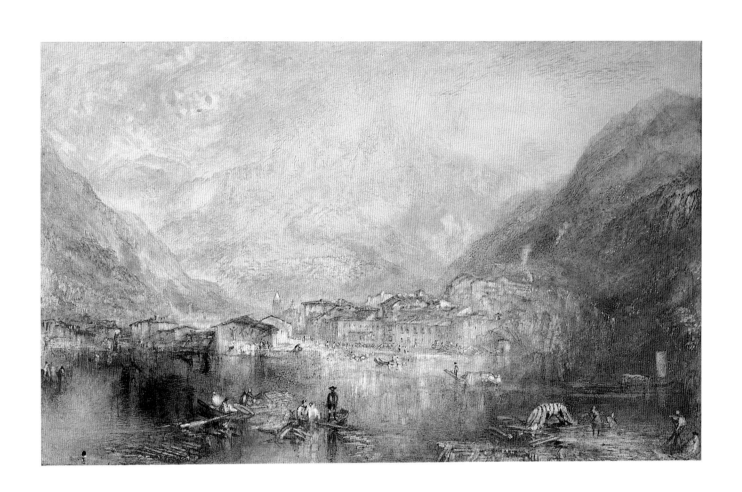

Hilaire Germain Edgar Degas

FRENCH, 1834–1917

Two Portrait Studies of a Man c. 1856

Pencil and stump heightened with white

17⅝ × 11¼ in. (44.8 × 28.6 cm)

Stamped lower right: DEGAS

1955.1393

D uring his stay in Italy in 1856, Edgar Degas carefully studied portraits of the High Renaissance. Later, in France, he copied works by fifteenth-century Italian masters, including Francesco Franciabigio (1482/83–1525) and Giovanni Cariani (c. 1485–c. 1547). The cool detachment that pervades these early portraits affected the way Degas looked at his own models. In the catalogue for the sale of the Degas estate, this drawing was incorrectly described as copied from a painting of the Italian school. It is actually a depiction of a professional model whom Degas hired in Rome. The same model appears in other drawings by the French master. These two studies are characterized by a dramatic dignity and a skillful manipulation of shadows and highlights that bring out a certain *sprezzatura,* a haughtiness and disinterest that have always been much prized in Italian portraiture. Degas, with his perceptive feeling for the Mediterranean culture, would have been no stranger to it. Although Degas did many paintings during his Italian sojourn, this drawing has not been found to be related to any of them. RF

FOR FURTHER READING

Egbert Haverkamp-Begemann, *Drawings from the Clark Art Institute* (New Haven: Yale University Press, 1964).

Stephen Longstreet, *The Drawings of Degas* (Los Angeles: Borden Publishing Company, 1964).

Drawings by Degas, exhibition catalogue (Saint Louis: City Art Museum of Saint Louis, 1966).

Degas in the Clark Collection, exhibition catalogue (Williamstown: Sterling and Francine Clark Art Institute, 1987).

Frank Milner, *Degas* (London: Bison Books, 1990).

Master Drawings: Sterling and Francine Clark as Collectors, exhibition catalogue (Williamstown: Sterling and Francine Clark Art Institute, 1995).

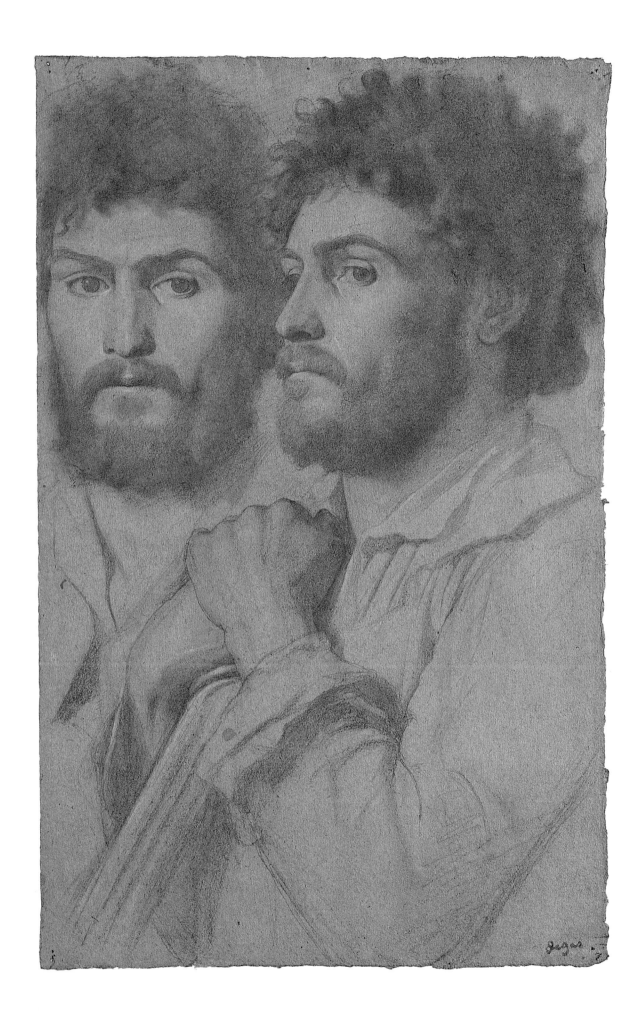

Winslow Homer

AMERICAN, 1836–1910

An October Day 1889

Watercolor

13⅞ × 19¾ in. (35.2 × 50.1 cm)

Signed and dated lower left: WINSLOW HOMER 1889

1955.770

By the 1880s Winslow Homer had attained a comfortable financial position through his art. He could afford to take vacations and often went to the Adirondack Mountains in upstate New York. He was part of a group of affluent and influential gentlemen who enjoyed fishing and the outdoors. Among these anglers were a number of New York businessmen, including Thomas B. Clarke, Homer's patron. In his Adirondack works, Homer appears to record nature from a viewpoint closer to that of the local guides and other woodsmen whom he met there than to that of his well-heeled companions.

By 1886 Homer and his brother Charles had become charter members of the North Woods Club, a private hunting and fishing preserve on a site known as Baker's Pond, close to Minerva, New York. In the space of twenty years, Homer visited the camp at least eleven times, and his stays lasted anywhere from one week to more than two months. *An October Day* is one of the best known of the approximately eighty-seven watercolors that Homer executed of Adirondack subjects. Most were painted or at least begun at the North Woods Club, and his greatest creative activity was from 1889 to 1894.

Hunting scenes were a favorite subject of Homer at this time. The autumnal view of a swimming deer, fleeing from the hunters in a boat, has great dramatic quality. The sylvan landscape contrasts with the terrible fate that awaits the swimming deer, while the red of the leaves seems to presage the animal's bloody end. RF

FOR FURTHER READING

Egbert Haverkamp-Begemann, *Drawings from the Clark Art Institute* (New Haven: Yale University Press, 1964).

Winslow Homer in the Clark Collection, exhibition catalogue (Williamstown: Sterling and Francine Clark Art Institute, 1986).

Winslow Homer Watercolors, exhibition catalogue (Washington, D.C.: National Gallery of Art, 1986).

Nicolai Cikovsky, Jr., *Winslow Homer* (New York: Harry N. Abrams, 1990).

Master Drawings: Sterling and Francine Clark as Collectors, exhibition catalogue (Williamstown: Sterling and Francine Clark Art Institute, 1995).

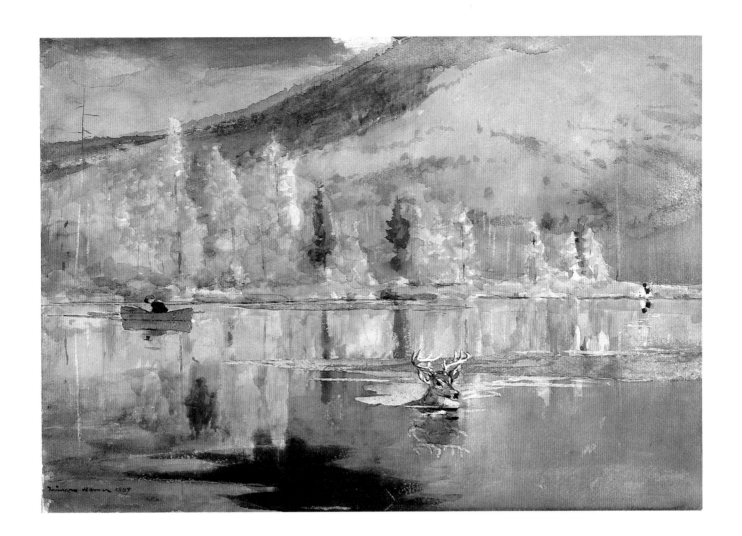

Edvard Munch

NORWEGIAN, 1860–1941

Madonna 1895

Lithograph with touches of gouache

26¹/₁₆ × 18⅞ in. (66.2 × 47.9 cm)

Signed and inscribed lower right in margin: E. MUNCH NO. 11

1962.83

While Edvard Munch's greatness as a printmaker was recognized in his lifetime, it is only in the latter part of this century that he has been acknowledged as a penetrating and articulate witness to his times. He had a strong impact on German expressionism, and his creative approach to the woodcut influenced artists in many lands.

One of the problems that Munch's work poses is its negative attitude toward women. His allusions to the relations between the sexes make the work often disconcerting. The theme of women as *femmes fatales*—corrupt and cruel users of men—attracted Munch as it did his close friend the writer August Strindberg, also a painter of some distinction. This negative concept, which had a long history in European culture, was revived in the romantic period and was still a living influence at the end of the nineteenth century. In this spirit, Munch created his Madonna as an icon of doom, surrounded by magnified spermatozoa, which underscore the sexual nature of the depiction. She is a bearer of illness and death, and the title can only be viewed ironically.

In his graphic works, Munch liked to experiment with different color schemes. The present lithograph was printed in black on greenish paper, touched up and accented with red gouache. Versions of *Madonna* exist in which Munch used other color schemes. RF

FOR FURTHER READING

Alfred Werner, *Graphic Works of Edvard Munch* (New York: Dover Publications, 1979).

Thomas M. Messer, *Edvard Munch* (New York: Harry N. Abrams, 1985).

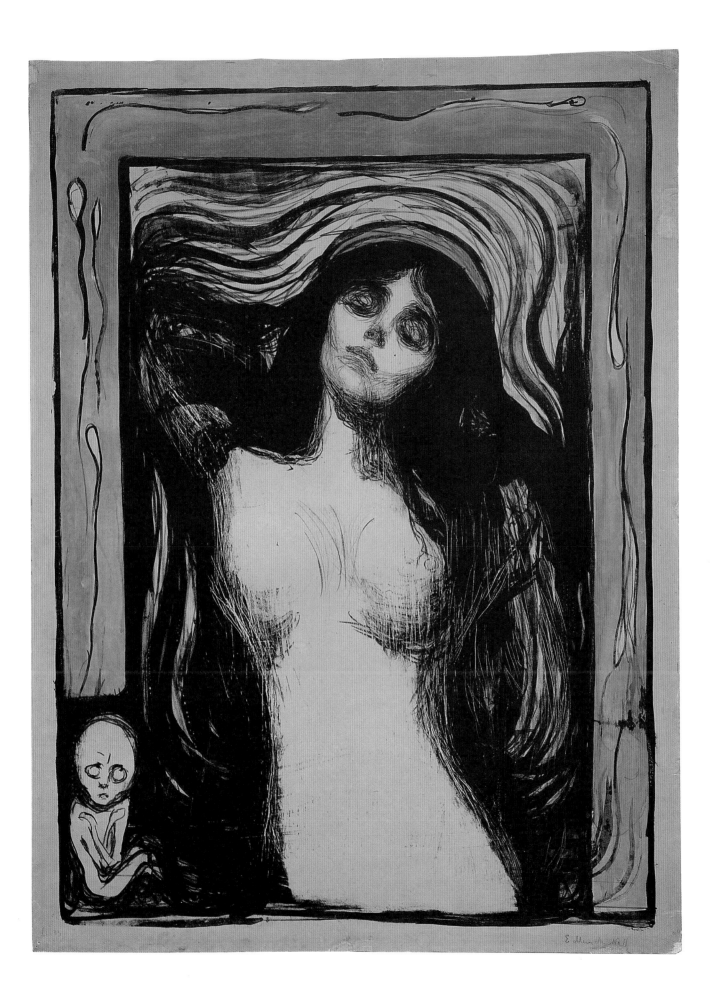

Pablo Picasso

SPANISH, 1881–1973

The Frugal Repast 1904

Etching

20¹⁵/₁₆ × 17⁷/₁₆ in. (53.2 × 44.3 cm)

Signed lower right in margin: PICASSO; **numbered lower left in margin:** NO. 4

1962.89

Pablo Picasso made only one rather small etching before *The Frugal Repast* in 1904. He had moved to Paris in 1900 and begun his Blue Period (named for both the predominant color and the mood of the works). The dramatic and troubling subject matter with its strong Hispanic realism, as well as the date, places this ambitious, large-scale etching in that period. Picasso used a zinc plate already etched and abandoned by Joan González (1868–1906), the brother of the better-known sculptor Julio (1876–1942), who had been working in Paris since 1901. The printer was not Picasso himself but the well-known and very capable Eugène Delâtre.

The size of the first edition, although not known, must have been small. Many of the surviving prints are signed and lack a number; others, like the one in the Clark collection, are signed and numbered; a few are inscribed for friends.

The subtle inking of Delâtre's impressions and the depressing subject matter give *The Frugal Repast* a strong mid-nineteenth-century feeling. These prints are remarkable in their affinity with prints produced by artists working within the naturalistic direction taken by some of the members of the Société des Aquafortistes in the 1860s—for example, the early Alphonse Legros (1837–1911) or François Bonvin (1817–1887).

After the plate left Picasso's hands, it was acquired by the famous Paris art dealer and publisher Ambroise Vollard, who proceeded to have it steel-faced, a process that prolongs the life of plates. In 1912 he issued another printing over which Picasso had no control. Vollard was cashing in on the fame of the young artist, who was just beginning to be recognized as a master. The 1912 edition is very different in appearance from the original one. The steel facing of the surface of the plate caused Gonzalez's work to print in certain areas where it had been insufficiently burnished out. Because the print in the Clark collection is part of the original 1904 edition, it has the special importance of presenting the image as the artist wanted it to look.

Picasso did not return to etching for many years, although he later produced many prints technically and thematically as ambitious as *The Frugal Repast.* RF

FOR FURTHER READING

Pablo Picasso: A Retrospective, exhibition catalogue (New York: Museum of Modern Art, 1980).

Picasso the Printmaker: Graphics from the Marina Picasso Collection, exhibition catalogue (Dallas: Dallas Museum of Art, 1983).

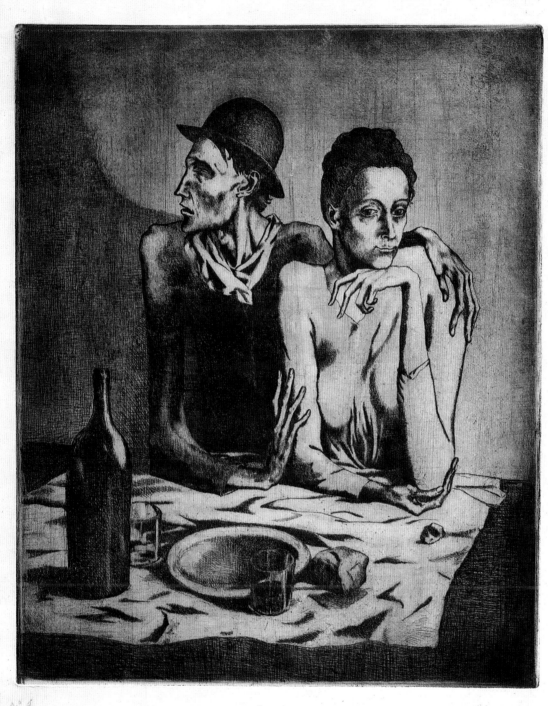

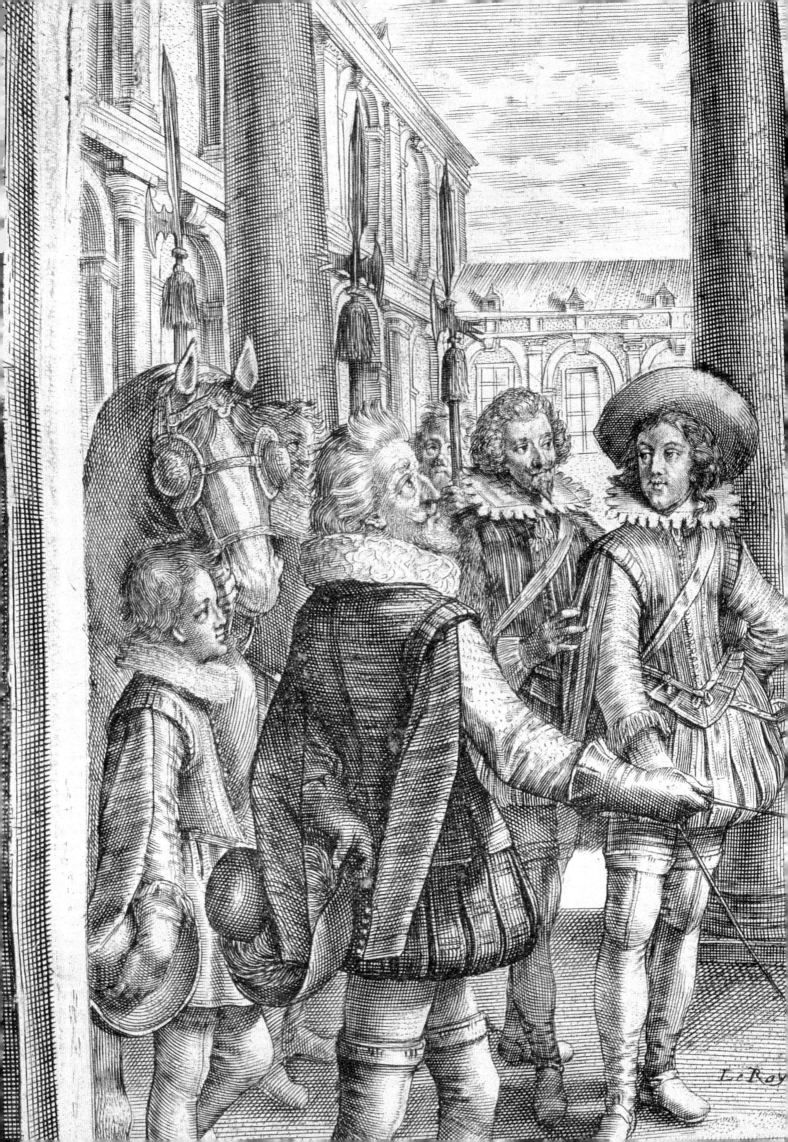

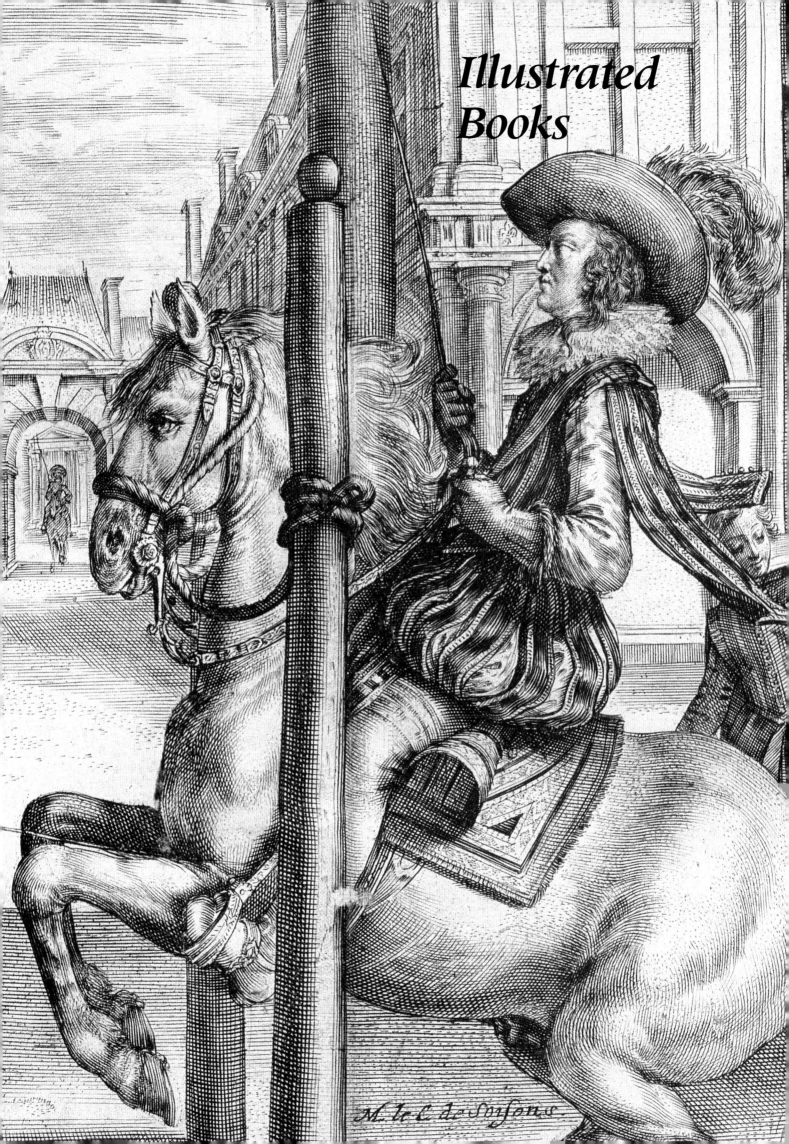

Illustrated
Books

M. le C. de Soyfons

Crispijn de Passe II,
illustrator

DUTCH, C. 1597–C. 1670

Antoine de Pluvinel, author

FRENCH, 1555–1620

L'Instruction du roy, en l'exercice de monter a cheval...

(The Instruction of the King in Horsemanship...), Paris: Michel Nivelle, 1625

Collation: [16], 207 pages, [62] folded leaves of plates

Illustrations: added double-page engraved title page, 3 engraved portraits, 61 double-page engravings by Crispijn de Passe II; an engraved portrait of the author by Simon de Passe; an unrelated page of geometric figures bound in following page 206

Page size: 14 × 9⅝₁₆ in. (35.6 × 23.3 cm)

Binding: full contemporary mottled calf gilt

Robert Sterling Clark Collection

This book is an exuberant and sumptuous portrayal of the finest arts of horsemanship from an age when such skill had become a metaphor for the successful exercise of public power. Indeed, the book may have served as a model for later equestrian portraits by artists seeking to emphasize the traditional association of power with mastery over the horse. The author, Antoine de Pluvinel, who had founded an equestrian academy for the aristocracy in Paris in 1594, was the most renowned riding master in France. Later appointed tutor of the dauphin, the future Louis XIII, Pluvinel ultimately became a state councillor, a chamberlain, and an ambassador to Prince Maurits of the Netherlands.

Written in the form of an imagined dialogue between Pluvinel and Louis XIII, the book is illustrated with engravings that depict horses executing the precise and difficult movements of dressage in much the same way that the famous Lippizaner stallions perform today at the Spanish Riding School in Vienna. The scenes, which take place at Pluvinel's academy, show the king, courtiers, and servants—many identified by carefully inscribed names. Illustrated here, for example, is Pluvinel, at the left, gesturing with his whip. The young king stands nearby, while his cousin, the Count of Soissons, demonstrates the levade in which the forelegs of his horse are off the ground. Pluvinel, perhaps to underscore his role of tutor acting in loco parentis, bears a striking resemblance to Henry IV, the king's late father. Each scene is set within a fanciful architectural framework of pillars and an entablature, abundantly decorated with swags, putti, coats of arms, and, as seen in the illustration, harnesses, curry combs, and other equine references. In the foreground is a delightful conceit, a pattern of horses' hoofprints in the dust.

The illustrations were designed and engraved under Pluvinel's supervision between 1617 and 1620 by Crispijn de Passe II. They were published in the 1623 edition of this book, entitled *Maneige royal* (Royal Academy of Equitation). Two years later, when the new edition was published, they were used again. Crispijn de Passe was a member of a peripatetic family of prolific engravers of Netherlandish origin who worked for a time in Utrecht, as well as in Paris. SSG

FOR FURTHER READING

John B. Podeschi, *Books on the Horse and Horsemanship: Riding, Hunting, Breeding and Racing, 1400–1941. Sport in Art Books: The Paul Mellon Collection* (London: The Tate Gallery for the Yale Center for British Art, 1981).

Liedtke, Walter, *The Royal Horse and Rider: Painting, Sculpture, and Horsemanship, 1500–1800* (New York: Abaris Books in association with The Metropolitan Museum of Art, 1989).

Book Illustrations from Six Centuries in the Library of the Sterling and Francine Clark Art Institute, exhibition catalogue (Williamstown: Sterling and Francine Clark Art Institute, 1990).

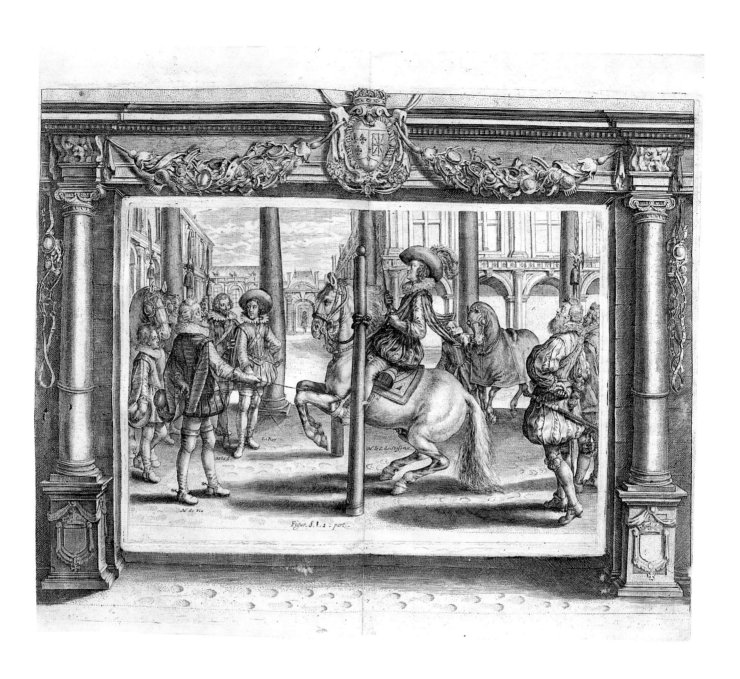

M de Vic Le Roy M. le C. de Soissons

Figur. 8.1.1 - part.

Eugène Delacroix, illustrator

FRENCH, 1798–1863

Johann Wolfgang von
Goethe, author

GERMAN, 1749–1832

Faust, tragédie de M. de Goethe, traduite en français par M. Albert Stapfer... *(Faust, Tragedy by Goethe, Translated into French by Albert Stapfer...),* Paris: Ch. Motte and Sautelet, 1828

Collation: [4], iv, 148 pages, [18] leaves of plates

Illustrations: lithographed frontispiece and 17 lithographed plates in the first published state on *chine collé* by Eugène Delacroix. Two versions of the original lithographed wrappers by Achille Devéria (1800–1857) and a pen-and-ink drawing by Charles Henri Pille (1844–1897) bound in

Page size: 16¹⁵/₁₆ × 11⅜ in. (43 × 28.9 cm)

Binding: full black morocco gilt, by Henri Noulhac (1866–1931)

Purchase, 1989

In Goethe's retelling of the old legend about a man who sells his soul to the Devil, the keynotes are obscurity and mystery, the emotions are strong, the action is violent, and the images are strange. Mephistopheles, the Devil who guides Faust, gains entrance to the scholar's study disguised as a poodle, surprises carousing students by turning wine into fire, and takes Faust to a witches' sabbath full of monstrous apparitions. Faust kills a man in a duel, and Marguerite, whom Faust has seduced, becomes insane with guilt and kills her newborn child. Underscoring human weakness in the face of the powers of evil, Goethe's *Faust* presents a multitude of experiences and emotions well outside the rational.

Lithography is, in many ways, the perfect choice for illustrating this dark and violent drama. It allows the artist to draw directly onto the printing surface or onto paper that can transfer the image directly to the lithographic stone or plate. The prints thus retain Delacroix's vigor and spontaneity, qualities often diminished when a design is translated by a reproductive engraver onto copper or wood. In the plate showing Marguerite in church, the rapid marks and loosely defined forms are reproduced exactly as they were drawn. Also visible, in the robe of the evil spirit whispering to Marguerite, are the white lines created when the artist deftly scraped through the black he had already put down. Delacroix's style—full of energy, immediacy, and vitality—is perfectly suited to lithography, while his tendency toward the dramatic and the emotional is perfectly suited to Goethe's *Faust*.

The copy in the Clark collection is of particular interest. The illustrations, on very smooth, thin paper fixed to heavier paper (a technique called *chine collé*), are wonderfully strong and fresh. The turn-of-the-century binding is impressive with its rich colors and complex gilding. Bound in are the book's original wrappers with lithographed designs by another romantic artist, Achille Devéria, and a fully developed drawing of Faust in his study by the illustrator Charles Henri Pille. With these additions, an earlier owner turned a fine illustrated book into a sumptuous object. JDW

FOR FURTHER READING

The Art of the French Illustrated Book, 1700–1914, exhibition catalogue (New York: The Pierpont Morgan Library, 1982).

Book Illustrations from Six Centuries in the Library of the Sterling and Francine Clark Art Institute, exhibition catalogue (Williamstown: Sterling and Francine Clark Art Institute, 1990).

Delacroix inv.^t et Lithog:

Ch. Motte, Imp.^r Editeur, à Paris.

Marg.—Malheureuse ! ah ! si je pouvais me soustraire aux pensées qui se succedent en tumulte dans mon ame et s'élevent contre moi .
Le mauvais Esprit.—La colère de Dieu fond sur toi ! la trompette sonne Malheur à toi .
Chœur.—Judex ergo cùm sedebit ,
quid quid latet apparebit .
Nil multum remanebit .

Pierre Bonnard, illustrator

FRENCH, 1867–1947

Longus, author

GREEK, ACTIVE LATE 2ND–EARLY
3RD CENTURY

Les Pastorales de Longus, ou Daphnis et Chloé *(The Pastorals of Longus, or Daphnis and Chloe)*

Paris: Ambroise Vollard, 1902

Collation: x, 294, [3] pages

Illustrations: lithographed title-page vignette, 143 lithographed 2/3-page vignettes, 11 lithographed head- and tailpieces, and 1 lithographed decoration (title page verso) by Bonnard, printed by Auguste Clot

Page size: 12 × 9⅝ in. (30.3 × 24.5 cm)

Binding: full green morocco gilt, by Stierli (20th century)

Purchase, 1989

The well-known Parisian art dealer and print publisher Ambroise Vollard (1865–1939) was one of the earliest patrons and publishers of *livres d'artistes*. His initial offering was an edition of the poet Paul Verlaine's *Parallèlement* (1900) for which he commissioned lithographs from Pierre Bonnard. The work was a commercial failure. Critics condemned Bonnard's free compositional style: his illustrations floated throughout the margins and in and out of the text. And in an era in which bibliophiles preferred woodcut illustrations, they also criticized his use of lithography. Vollard persisted in his venture, however, and over the next forty years he published deluxe editions illustrated by Raoul Dufy (1877–1953), Maurice Denis (1870–1943), Odilon Redon (1840–1917), and Pablo Picasso (see p. 172), among others.

In 1902 Vollard's second offering appeared, again illustrated by Bonnard. It was the ever-popular pastoral *Daphnis et Chloé*, written in the second or third century by Longus. This work had a long tradition of illustration in France. This time Bonnard chose to contain his images within the traditional, rectangular format. The book was only slightly more successful than *Parallèlement*, yet today both are considered among the finest published by Vollard.

Daphnis et Chloé displays all of the characteristics of Vollard's deluxe editions: the roman typeface was carefully chosen and, in this instance, printed in the same ink as the illustrations; the paper was specially prepared, bearing the watermark "Daphnis et Chloé"; and the illustrations were printed with extreme care by Auguste Clot, who was a master of lithography.

Though today Bonnard is known primarily as a painter (see p. 126), his early successes were also in the graphic arts. As is evident in his illustrations for Longus's story of Daphnis and Chloe, Bonnard was a superb draftsman whose freely composed images were well suited to lithography. The illustration shown here of Daphnis swimming nude appears to be sketched right onto the page. This spontaneous quality perfectly captures the innocence and unabashed sensuality of Longus's pastoral. SR

FOR FURTHER READING

Albert Skira, *Anthologie du livre illustré par les peintres et sculpteurs de l'Ecole de Paris...* (Geneva: A. Skira, 1946).

Una E. Johnson, *Ambroise Vollard, Editeur: Prints, Books, Bronzes* (New York: Museum of Modern Art, 1977).

The Art of the French Illustrated Book, 1700–1914, exhibition catalogue (New York: The Pierpont Morgan Library, 1982).

Book Illustrations from Six Centuries in the Library of the Sterling and Francine Clark Art Institute, exhibition catalogue (Williamstown: Sterling and Francine Clark Art Institute, 1990).

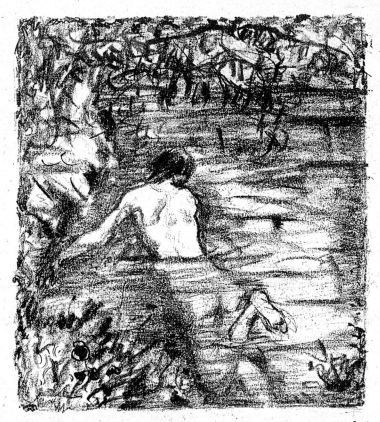

dans la caverne ; si accouroit incontinent et, lui
ôtant sa couronne qu'il baisoit d'abord, se la mettoit
sur la tête, et elle, pendant qu'il se baignoit tout nu,
prenoit sa robe et se la vêtoit, la baisant aussi pre-
mièrement. Tantôt ils s'entre-jetoient des pommes,

Works Listed Alphabetically by Artist

Lawrence Alma-Tadema, 76

Peter Archambo, 134

Attributed to Giovanni Boltraffio, 152

Pierre Bonnard, 126, 180

François Boucher, 34

William Bouguereau, 60

Jean Bourdichon, 150

Mary Stevenson Cassatt, 106, 108

Claude Lorrain, 26

Camille Corot, 50

Paul Crespin, 140

Honoré Daumier, 52

David d'Angers, 44

Hilaire Germain Edgar Degas, 68, 70, 72, 74, 166

Eugène Delacroix, 178

Albrecht Dürer, 154

Jean-Honoré Fragonard, 38

Thomas Gainsborough, 36

Paul Gauguin, 110

Théodore Géricault, 48

Jean-Léon Gérôme, 58

Domenico Ghirlandaio, 22

Vincent van Gogh, 112

Francisco José de Goya y Lucientes, 40

Winslow Homer, 78, 80, 82, 83, 168

Paul de Lamerie, 136, 138

George Lewis, 132

Maker's Mark IV with a star below, 130

Edouard Manet, 66

Hans Memling, 20

Jean-François Millet, 54

Claude Monet, 86, 88, 90, 92

Berthe Morisot, 94

Edvard Munch, 170

Crispijn de Passe II, 176

Ammi Phillips, 46

Pablo Picasso, 172

Piero della Francesca, 18

Camille Pissarro, 62, 64

Adam Pynacker, 28

Rembrandt Harmensz. van Rijn, 158

Frederic Remington, 120, 122

Pierre-Auguste Renoir, 96, 98, 100, 102, 104

Paul Revere II, 142

Peter Paul Rubens, 156

Jacob van Ruisdael, 30

John Singer Sargent, 114, 116, 118

Alfred Stevens, 56–57

Giovanni Battista Tiepolo, 32, 162

James Jacques Joseph Tissot, 84

Henri de Toulouse-Lautrec, 124

Joseph Mallord William Turner, 42, 164

Ugolino da Siena, 16

Vincennes Porcelain, 144

Antoine Watteau, 160

Worcester Porcelain, 146

Joachim Wtewael, 24